Performance in an Age of Precarity

Maddy Costa started writing about theatre by accident after attending the National Student Drama Festival on a whim. She has written for *Time Out* (London), the *Guardian* and *Exeunt Magazine*, but also works closely with theatre-makers to create unusual documentation of and critical responses to their work. She has a developing practice as a dramaturg, and hosts a pop-up Theatre Club – like a book group, but for performance – across London. Occasionally you'll find her making fanzines, and performing synchronised go-go with amateur dance group the Actionettes.

Andy Field started writing about theatre when he first moved to London in 2006 on a very earnest blog called *The Arcades Project*. This led to semi-regular work writing about live performance for the *Guardian*, the *Stage*, *Exeunt Magazine*, *This Is Tomorrow* and others. His writing practice has always sat (sometimes neatly, sometimes awkwardly) alongside his primary work as a performance maker and the co-director of Forest Fringe, an artist-led project that for ten years from 2007 to 2016 ran an award-winning free venue at the Edinburgh Fringe Festival.

Performance in an Age of Precarity

40 Reflections

Maddy Costa and Andy Field

methuen | drama

LONDON · NEW YORK · OXFORD · NEW DELHI · SYDNEY

METHUEN DRAMA
Bloomsbury Publishing Plc
50 Bedford Square, London, WC1B 3DP, UK
1385 Broadway, New York, NY 10018, USA
29 Earlsfort Terrace, Dublin 2, Ireland

BLOOMSBURY, METHUEN DRAMA and the Methuen Drama logo are trademarks
of Bloomsbury Publishing Plc

First published in Great Britain 2021

Cover design by Charlotte Daniels
Cover image © Getty Images

A catalogue record for this book is available from the British Library.

Library of Congress Cataloging-in-Publication Data

Names: Costa, Maddy, author. | Field, Andy (Artist), author.
Title: Performance in an age of precarity : 40 reflections / Maddy Costa, Andy Field.
Description: London ; New York : Methuen Drama, 2021. | Includes bibliographical references and index.
| Summary: "An anthology of critical essays that draw on a decade of the authors thinking, writing about
and working within contemporary performance as critics, producers, dramaturgs, makers, archivists and
more. Together, the 40 essays sketch a map of the contemporary performance landscape from
avant-garde dance to live art to independent theatre, tracing the contours of its themes, aims, desires
and relationship to the wider worlds of mainstream theatre, art and politics. Each essay focuses on a
particular artist and these include Bryony Kimmings, Dickie Beau, Forced Entertainment, rashdash,
Scottee, Selina Thompson, Tania El Khoury and Uninvited Guests. Reflecting the radical nature of the
work considered, the authors attempt to find a new vocabulary and a non-conventional way of
considering live performance in these essays. As both a fresh survey of contemporary performance and
an exploration of how to think and write about upstream and avant-garde work, this book should be an
essential resource for students, artists and audiences, as well as an accessible entry point for anyone
curious to know about the beautiful and strange things happening beyond the UK's theatrical
mainstream"— Provided by publisher.
Identifiers: LCCN 2020045171 (print) | LCCN 2020045172 (ebook) | ISBN 9781350190641 (paperback) |
ISBN 9781350190634 (hardback) | ISBN 9781350190658 (ebook) | ISBN 9781350190665 (ebook)
Subjects: LCSH: Arts, Modern–21st century. | Arts–Experimental methods.
Classification: LCC NX460.5.E95 C67 2021 (print) | LCC NX460.5.E95 (ebook) | DDC 700.9/05—dc23
LC record available at https://lccn.loc.gov/2020045171
LC ebook record available at https://lccn.loc.gov/2020045172

ISBN: HB: 978-1-3501-9063-4
 PB: 978-1-3501-9064-1
 ePDF: 978-1-3501-9065-8
 eBook 978-1-3501-9066-5

Typeset by RefineCatch Limited, Bungay, Suffolk
Printed and bound in Great Britain

To find out more about our authors and books visit www.bloomsbury.com
and sign up for our newsletters.

CONTENTS

ACKNOWLEDGEMENTS

Thank you to George Spender for early encouragement, Chris Campbell for commissioning us, Andrew Neal for close reading, Alice Saville for further reading, all the artists and readers who have supported, challenged and inspired us through the process of writing, all the artists we've written about and all the artists we haven't, because the book wouldn't exist without any of you. Thanks also to the writer Max S Gordon, whose essay on Beyoncé and Jay-Z, particularly the line 'Criticism, when done well and responsibly, is a form of love', was a key inspiration behind this work. (MC and AF)

Thank you to Beckie, for sharing a single desk so patiently and being the most generous reader imaginable. Thank you also to Sausage for your committed indifference to this whole project and for taking me on so many bracing walks. (AF)

Thank you to Leila and Ben: think of this as 1,518 goodnight kisses. (MC)

About this book

1. This book begins off the beaten track.

2. You are standing by the entrance to a not-quite-theatre in an unfamiliar part of town: by the metal shutters of a giant brick warehouse perhaps, or the small wooden door of a half-converted church, seeking cover from the rain with smokers of thin rolled-up cigarettes, wondering if investing in some decent signage wouldn't kill them, wondering what the best way home might be from here, wondering what wonder the evening may hold.

3. Perhaps you are holding this book in your hand as you stand there. Perhaps as you read you have that strange feeling of being at once in this world and that world. In a place that is real and a place that is imagined. A place, in other words, like performance itself.

4. Or perhaps this book is the means of transporting you to that strange not-quite-a-theatre. Or it's a map. A map that attempts to describe a world that exists most fully, but not exclusively, at the margins of the mainstream.

5. It is a world of intimacy and experimentation, of hope and defiance; an underground, overlooked, intangible place, somewhat at the edge of things. We – Maddy and Andy – have known this world for roughly a decade. We have drawn this map of it by hand from little more than our memories of it, and the journeys we have taken through it.

6. You could say that such a map is unreliable. We're OK with that.

7. Each of the places on this map is an artist. Not all of the artists know each other. How they're connected is part of the journey.

8. Some of the work these artists make might be called theatre, other parts might be called dance, live art, music or cabaret. The categorization of the work is less important than its spirit.

9. While the artists in this book are all very different, what unites them is that they are not usually employed by, or working on behalf of, any one

major theatre or gallery; instead they produce their own work, in the same independent spirit as guerrilla film-makers or musicians who self-release their own albums. By controlling the means of their own productions, these artists work in ways that are at once precarious and exhilarating, equally constrained and liberated by their limited resources; always ploughing forward into the darkness along whatever idiosyncratic route they have charted for themselves without the light of institutional power to navigate by.

10. The book isn't written chronologically, but most of it takes place after 2008 and hence it can't help but tell a story of art-making in the age of austerity and everything that socio-economic crisis has entailed. While most major art institutions have been insulated from the worst consequences of austerity, their budgets supplemented by corporate sponsorship and the largesse of private donors, for the inhabitants of the world described in this book the situation is considerably more complicated.

11. These artists have been attempting to survive and to make work with increasingly limited resources, in cities scarred by political division, widening inequality and a hollowed-out welfare state. Migrant artists have found themselves brutalized by the hostile environment policy, intolerance further legitimized by the violent rhetoric of Brexit, and the inability of major art institutions to decolonize or decentralize their practices and their management structures. Black artists, long excluded by institutional racism, continue to be ignored as the language of diversity is exposed as a sham. Queer artists, and especially transgender artists, are living with the day-to-day threat of physical attack, as anti-LGBT hate crime continues to rise. All the while ecological disaster looms ever more concretely.

12. Many of these artists, in one way or another, are living in close proximity to the threats posed by these issues, and their work is a cumulative, collective attempt to address that fact. How do we live in such circumstances? What can we do to try and make things better? Where do we start from? Where might we go? And how might theatre, or dance, or live art, or music, or cabaret, create an opportunity within which to rehearse together other ways of living?

13. This is the geography that this book is navigating, telling a story about how some people have tried to answer those questions. Even in the telling, the geography changed: the final essay was written in March 2020, as the threat of ecological disaster took the immediate form of a pandemic. COVID-19 has brought the brief era we had been writing about to an abrupt end, casting the inequalities and traumas that this book describes in a harsh new light, and requiring the acts of community and resistance that flare in response to be remade in new and unforeseen ways.

14. You've made it inside the not-quite-theatre and are sitting on a temporary rake in a small black box studio, or on folding chairs scattered in random patterns across a concrete warehouse – or perhaps there are no

chairs at all and you are sat cross-legged on the beer-licked floor – or perhaps there was never a building and in fact you are sitting in the midst of a forest, within a circle of trees – or perhaps you're not even sitting but walking, on a beach, or a busy city road, chasing someone, something. Here, in this theatre that isn't quite a theatre, expected conventions appear not to apply. Everything is, or can be, different.

15. We are romanticizing. Of course we are. These are romantic situations.

16. Part of the romance of these encounters comes from how intimate and fleeting they frequently are. When we describe being part of an audience in this book, we are mostly talking about gathering with no more than a hundred or so people, sometimes far fewer, around a performance that probably happened only a handful of times.

17. Intimacy is important here. It is as much part of the work as its precarity.

18. As a result, critics might (and often do) argue that the place we're describing is less a whole world than it is a narrow echo chamber: not just obscure but exclusory and intimidating. We acknowledge that (and, at times, have felt it too). We also acknowledge the likelihood that you have neither seen nor even heard about a significant amount of the work that we describe in this book. We know this because the same is true for us: Maddy has seen only a handful of the things that Andy is writing about, and vice versa. We – you reading, us writing – are venturing together into the unknown.

19. We're aware too that there's an irony to writing about this work. People make it because it's ephemeral, and here we come with our conservation kits, embalming everything for enduring preservation. Often this is work that – intentionally – leaves nothing behind it: no playscript or film recording that can neatly stand in for the live performance in its absence. We preserve it despite the irony, despite misgivings, because the work is important to us.

20. Let's talk for a minute about importance.

21. There is an old argument that we could make that this work is worthwhile because of its influence upon bigger, more popular things. This is the forever-myth of the so-called avant-garde: that its value lies not so much in what it is as in what it precedes. Undoubtedly, much of this work has been influential and its recurrent trends, from a particular kind of lo-fi 'DIY' aesthetic to the explicit use of autobiographical storytelling to a preoccupation with stock characters and cliché, have increasingly pervaded the mainstream of UK theatre. By the end of the 2010s you were as likely to see Bryony Kimmings, Selina Thompson or Dan Canham at the National Theatre or the Royal Court as you were in some obscure venue at the Edinburgh Fringe.

22. This, however, is not the argument we want to make.

23. We believe this work is interesting not for its influence on the so-called mainstream, but on its own terms: because of the things it has to say about

the ways in which artists (people) are attempting to live within this world, and the different kinds of relationships and social structures – between people, between species – that might make this world more liveable.

24. As your journey through this book will make apparent, the work we're writing about is often deeply personal, frequently autobiographical, concerned with the politics of identity and with the potential of theatre as a place of possibility, community and individual and social transformation.

25. As audience to, or participants in, this work, we dance, we share secrets, we have our DNA tested, bear witness, pretend to be cowboys, pretend to be an audience. We consent to being held, to being cared for and taking care ourselves, to giving attention, to carrying with us into the world those questions the work itself refuses to answer.

26. In this world the audience are not impartial observers, but rather active, subjective participants in making meaning out of a shared experience. This role does not easily lend itself to the presumed distance of conventional theatre criticism. Historically this has made the kind of work covered in this book somewhat unsuited to being written about in newspapers, like trying to photograph the flare of a sunset, or describe the feeling of a dream you once had.

27. But then, this isn't a book of theatre criticism. At least, not exactly.

28. Instead it's a record of moments that refuse to be forgotten; of artists we have met, things we have felt, ideas we have seen unfurl over time, experiences that have consumed us all at once and then just as quickly disappeared; wild imaginings of things we haven't done at all. It begins in the theatre but quickly slips out of the fire escape and finds itself roaming through secret subterranean nightclubs, alternative beauty pageants, the overcrowded streets of Edinburgh, an island in the middle of the Seine, through forests, hedgerows, skyscrapers, circuses, on a bus tour of Sheffield in the mid-1990s and a gig by the band The Fall in the late 1970s, into private conversations, protest marches and romances real and unrequited. In writing about these moments, we hope to create a record of this work that reflects not just what the work was but how it existed in the world; all the different ways that it connects to the other things we have seen happening around us.

29. (Memory is fallible. It blurs, distorts, merges, makes things up. It's worth remembering that.)

30. There is a passage in John Berger's *And Our Faces, My Heart, Brief as Photos* where he describes the difference between poetry and stories. Stories, he says, are always about 'battles, of one kind or another, which end in victory or defeat. Everything moves towards the end, when the outcome will be known.' Theatre criticism, at least as it is practised in this country at the time of writing (mostly 2018–2019), can feel a bit like this: a succession of small battles pitting each individual writer against each individual show,

demanding that they wrestle with each other until a verdict is delivered, after which stars can be awarded to the gallant and the great.

31. Both of us have written criticism of this kind in the past and recognize the demands it makes on you as a writer: concision, precision and at least the semblance of separation from the subject of your writing. This book is not intended as a critique of this kind of writing.

32. Or at least, it is not only that.

33. Instead, it is an attempt to write about this work with all the expansiveness and open-hearted subjectivity that the work itself demands of its audience. These are artists that share so much of themselves, and that invite us to share something of ourselves in turn.

34. And so this book is a sharing of ourselves, the things we have felt, the things we believe and the lives we have lived. It is an analysis grounded in the intimacy of personal feeling and the contingency of the present, haunted by the vast and looming spectre of contemporary politics, and inflected at all times by the knowledge that even as we try to describe it, this work and its meaning is changing, and changing us. It is an extension of the work we have both already been doing over the decade or so that we have known each other as we have moved through and around the world that this book describes. In that time we have written about this world for newspapers, art magazines, festival programmes, and on our own personal blogs, we have conducted interviews and hosted conversations, we have worked as dramaturgs, sometimes as artists, we have run events, even whole festivals. In our own individual ways, we have both been engaged in similar attempts to find another way of writing and thinking about live performance.

35. This book, then, is also a conversation between us, between Maddy and Andy, about the different ways in which we think about and exist as part of the world we are describing. It is an attempt to meet this work and these artists in the place where we collectively want to live. To understand them on their own terms, which might also be our terms, rather than attempting to comprehend them through the prism of contemporary theatre criticism. To escape the battle, in other words, and find another way of encountering and describing the experiences we have had.

36. If stories are battles, Berger writes, poems 'cross the battlefields, tending the wounded, listening to the wild monologues of the triumphant or the fearful. They bring a kind of peace. Not by anaesthesia or easy reassurance, but by recognition and the promise that what has been experienced cannot disappear as if it had never been.'

37. This, fundamentally, is what we hope this book might be – an attempt to ensure that what has been experienced cannot disappear as if it had never been. A criticism that aspires to the condition of poetry.

38. And because we also love these artists, this is a record of loves. Let's call it that.

39. This book contains thirty-nine essays, each about a different artist. Almost all of these essays were written individually, by one or other of us. Three of them we wrote together. Then we assembled them all and began arguing about how to group them, all too aware of the kinds of groupings-by-identity that happen across the conservative, normative, white-dominant industry that is theatre, and how much we wanted to avoid that.

40. There is a danger in this kind of project that all our decisions will appear to be definitive, competitive and hierarchical. That the people we have written about are those we deem to be the 'best' or the 'most significant'. This is not the case. We each made our own decisions as to who we wanted to write about and those decisions were not easy. At every stage – and we changed our minds quite often – the choices we made were as idiosyncratic, subjective and deeply personal as the writing itself.

41. We began by drawing up a long list, and here are some – not all – of the artists and companies on that long list. Annie Siddons. Ant Hampton. Augusto Corrieri. Caroline Williams. Chiron Stamp. Chris Thorpe. Claire Cunningham. Demi Nandhra. Emma Bennett. FK Alexander. French and Mottershead. Ira Brand. Igor and Moreno. Jamal Gerald. Jamal Harewood. Jamie Wood. Jo Bannon. Le Gateau Chocolat. Leo Kay. Little Bulb. Lucy McCormick. Mamoru Iriguchi. Melanie Wilson. Paul Hughes and Rohanne Udall. Paula Varjack. Peter McMaster. RashDash. Rhiannon Armstrong. Richard DeDomenici. Rosana Cade. Search Party. Sh!t Theatre. Sleepwalk Collective. Split Britches. Tourettes Hero. Unfolding Theatre.

42. We love them too, but we wanted this to be a book you could carry around, like a map, not an encyclopaedia that keeps you pinned to a chair.

43. But perhaps this is not a map. Perhaps it's a manual. A book of strategies and tactics. A catalogue of survival attempts, of emergency procedures, of escape plans, of ways of living under capitalism at its most egregious – even of living in the face of slow collapse. Sometimes these strategies are overtly (structurally, ideologically) political, other times they are about more fundamental things, like care and empathy, like community, like hope. This book tries to understand how such things are present not just in each individual show, or even each individual artist, but how they are threaded through this whole artistic world, and through the audiences who are also a part of that world, binding us all together. Including you, reading this now.

44. The collection of artists included here are thus probably best understood as a small wooden door onto the fullness of the world we are describing.

45. What you choose to do when you enter is entirely up to you.

(AF and MC)

PART 1

Reckoning with history

Rachael Young

Dickie Beau

Breach Theatre

Tania El Khoury

Uninvited Guests

Rachael Young

moving black / feeling black

It's a dangerous thing, the white gaze. It judges, reduces, demands, suffocates. It is the gaze that classified and colonized and is yet to account for its claims to this power. Oh no, you might frown, as a person of pale or olive skin, not me, not my gaze. Leaning into this or that otherness, this or that sympathy or understanding. But as academic Barbara Applebaum argues in her book *Being White, Being Good*, a study of white complicity and moral responsibility, this 'not me' of the self-defined 'good white' is typical of the 'distancing strategies' used by white people when they don't want to 'consider the subtle ways (subtle for white people) they are perpetuating a racist system and shielding the system from challenge'. Whiteness, says Applebaum (quoting an essay by Sara Ahmed), is 'sticky; [race] sticks to us, or we become "us" as an effect of how it sticks'. As long as you're a white-figured person sitting in a room of white-figured people looking at a black performer – a black female performer – your gaze is subsumed in the enduring violence of the white gaze.

Rachael Young presents herself to that gaze with an arched eyebrow and dismissive flick of the wrist.

In *Out* she performs half-naked: big black pants that stretch from waist to upper thigh; nipple patches; black spike heels. In *Nightclubbing* her legs are bare and her torso sparkles silver like the Milky Way. Her skin is luminous, not as some external quality but with the radiance of self-belief that defies everything in the world, structural and social, that would diminish her.

This is the luminosity that the white gaze has sought (still seeks) to extinguish.

I'm sorry, says Rachael, standing in heavy platform shoes that tether her feet to the floor, waist looped by a hula-hoop. I'm sorry for being too outspoken / laughing too loudly / for looking good in neon pink. I'm sorry for taking myself too seriously / having a chip on my shoulder / for questioning your authority. I'm sorry you feel uncomfortable, sorry for my vulnerability / for your fragility. I'm sorry for taking up space. Sorry for breathing. Light bounces from her body as though it's a mirror.

seeing black / speaking black / seeing through black eyes

I took a friend – white, cis male, queer in the pre-twentieth-century sense of peculiar or eccentric – to see *Nightclubbing* and it perplexed him. I recognized that feeling, felt a sliver of it watching *Out*. Rachael created *Out* with dancer Dwayne Antony; dressed identically, moving with synchronicity, their bodies consistently resist gender definitions and with that the very concept of classification. They have skin, muscle, blood; they tremble, pulse, writhe. *Out* speaks to misogyny, homophobia and transphobia in Caribbean communities, and does so with a culturally specific soundtrack and movement language I couldn't always translate but felt drawn to, interest in. Careful in its choice of dancehall tracks to strut against and vogue moves to emulate, it speaks with precision and acuity of queer radicalism, pride in identity, sexuality and ancestry, camaraderie and strength in chosen community.

In *Nightclubbing* Rachael performs with two musicians (Leisha Thomas and Mwen) who make the air around her crackle and hum as she slips between multiple storylines: a brief but scintillating history of iconic singer Grace Jones; a moment in 2015 when three black women were refused entry to a nightclub for being too dark; an unattributed biography that might be Rachael's own; and a sci-fi fantasia of resurgent black power, harnessing the gravitational influence of black holes as a power capable of transforming the universe, or at least its social order.

'My face was just not understood,' Grace Jones says of her younger self, recalling encounters with the white gaze of late-1960s New York. Rachael risks not being understood but within the frame of an assertive ask: that her audience follow close, be attentive, take up the threads of story she offers, hold tight to them, not so much with the intellect perhaps as the heart.

reclaiming black / claiming space black

In *Nightclubbing*, Rachael describes melanin as a 'complex polymer' whose effect on the skin makes a person 'super invisible or hyper visible' – the wrong kind of magic, both at once.

'There are certain structures in place within society which means that some people are simply not visible,' she elaborated in an interview with online magazine *Cuntemporary*. 'My work has a focus on making the space for those voices to be heard.' The movement here from visibility to audibility is crucial: it's not enough simply to see black performers in stories made and framed by white people. Rather: 'it is important that marginalized people are given the opportunity to tell their own stories. Sometimes the things that we have to say

are uncomfortable for both the person telling the story and the audience that may come to see the work, but despite the discomfort, representation matters . . . it is a reminder that you, and people like you, matter.'

There is a sequence in *Nightclubbing* when Rachael pulls on a series of thin black rubber tubes, first of all to rest around her neck like a choker that spills over her shoulders and down to her waist, tied in place with a long snaking thread, and then more over her hair to form a regal headdress. She looks weighed down but imperious, equal parts Grace Jones and African queen, and the more I try to hunt down images online to explain what I mean, the more I realize these are generic comparisons (that white gaze strikes again). The music rises up behind her and she begins to move her head so that the tubing begins to sway, to soar, as though animate, imbued with life, with the energy and power of a horse rearing on its hind legs before bolting its way to freedom. The weight of the loops slips from her shoulders, motion makes them straighten like braids, like locs, flashing in the stage lights like bolts of lightning. I can't tell you what the sequence means, but I can tell you how it felt: a surge of electricity through my veins, blood rising to meet the fury of her movements.

Within queer club culture, Rachael tells us, Grace Jones found 'whole new ways of being in the world and in her skin'. And the question burning beneath the surface of *Nightclubbing* is: what does it mean when black women are locked out of spaces in which they might redefine themselves – and indeed that they might redefine? Spaces such as nightclubs. But also such as theatres.

Racism, writes Reni Eddo-Lodge in *Why I'm No Longer Talking to White People About Race*, 'isn't about good and bad people'. It's about systems and structures that have 'the power to drastically impact people's life chances'. That includes their chance to work in theatre, an institution I started describing as structurally racist the same year I saw *Nightclubbing*. 'The covert nature of structural racism is difficult to hold to account,' adds Eddo-Lodge. 'Structural racism is dozens, or hundreds, or thousands of people with the same biases joining together to make up one organization, and acting accordingly. Structural racism is an impenetrably white workplace culture set up by those people, where anyone who falls outside of the culture must conform or face failure.' Those people will balk at the suggestion that they are racist, and yet will not see the problem in saying things like:

'We don't have a black audience and would struggle to sell this.'

'We already have a black artist in our programme this season.'

'Could we programme you in Black History Month?'

All sentences that function as no-entry signs.

moving through space and time black

In the silences of *Out* and *Nightclubbing*, a knowledge. A knowledge arising from shared experience, arising from a look, a gesture of understanding. Or what Rachael says: 'How a nod could give the unseen a moment of visibility.'

When the music and the catwalk vogue strut stop, *Out* shifts register: Rachael and her co-performer take off their heels and sit down together, either side of a vat of oranges. They begin to peel, and from that silent activity – perplexing at first – my memory summons a series of images. Of walking past cafes with my family in Cyprus, seeing men seated outside, hugging the shade, slapping down backgammon counters as vigorously as Rachael slaps orange pieces to her mouth. Of travelling on my own for the first time, to Manhattan, and seeing men in the knot of streets where Houston meets Sixth Avenue, seated at scrap-rough tables, also playing backgammon or hammering down domino tiles. Of my grandfather at his kitchen table, flicking worry beads, click click. Sitting silently with both my grandparents, cracking almonds together, fresh almonds, feeling their love for me in the unaccustomed softness that emerged from hard shell.

This is what performance can do: build relationships between unconnected people, events, memories. Reveal the self in unexpected places. I rarely encounter the stories of Cypriot people, the reasons Cypriots had to emigrate, their struggles to assimilate in a racist country. I rely on the stories of other diasporas for these unseens to become, for a moment, visible.

black that stops the clocks and leaves time suspended

So slow, this peeling of the oranges. These movements of wrists, thighs, calves, shoulder blades in *Nightclubbing*. Deliberate, precise, taking time, slowing time. Making space, new space, to consider, to rethink.

I think of my grandparents with love and resignation: their values are not my values. The same feeling, molten, at the core of *Out*. When I saw *Out*, I had recently interviewed a Lebanese singer, Hamed Sinno, from the band Mashrou'Leila, about speaking out as a queer man in the Middle East, the death of his father, and our shared feeling that there is a whole generation of grandparents who have taught fathers and mothers, who have taught sons and daughters, to fear difference, whose values will be slow, so painfully slow, to die out.

That change comes not with violence but with the building of new connections. Rachael and Dwayne, handing out pieces of orange to their audience. The room becoming fragrant with the juice of them. It isn't a solution. But it's a start.

dreaming black

All these phrases – moving black, feeling black, seeing black, speaking black, seeing through black eyes, reclaiming black, claiming space black, black that stops the clocks and leaves time suspended – are spoken over a shimmering nightclubbing soundtrack that gains pace and breath with boldness. The final words before Rachael strides offstage, leaving the musicians to extend the shimmer, are dreaming black.

Unspoken: dream of a world in which it isn't anyone's business what anyone else chooses to do with their body: who they choose to fuck, who they choose to be.

Implied: dream of a world in which hierarchies based on the colour of people's skin no longer exist.

Unvoiced and yet heard: dream of a world in which normal is understood to be plural and otherness cherished as strength.

'After a lifetime embodying difference,' writes Eddo-Lodge, 'I have no desire to be equal. I want to deconstruct the structural power of a system that marked me out as different.' Her aim is not assimilation but liberation, 'from all negative assumptions that my characteristics bring. The onus is not on me to change. Instead, it's the world around me.'

The black hole on the stage from which Rachael emerges at the start of *Nightclubbing* is turned inside out, transformed into a glittering gold-foil sun. 'No, I have the last word,' says Grace Jones majestically. (Is it actually Grace Jones? Does it matter?) 'And you don't get in unless you go through me.'

Dream of power redistributed. Eventually, better still, power dismantled. Challenging the white gaze as good a starting place as any.

(MC)

Further reading

'It is from failure that we learn to be truly amazing, instinctual artists': interview with Rachael Young by Sarah Gorman, on readingasawoman.wordpress.com

Dickie Beau

1

The performance is eleven minutes long and it begins with a spotlight. Into the spotlight walks Dickie Beau in an immaculate white sailor's uniform, cheeks rouged, hair slicked back, resembling more than anything a porcelain figurine, the kind you might find in the window of a high street jewellers.

Someone begins speaking. It is the actor Kenneth Williams, waiting briefly for a pause in the audience's ovation to launch into another long anecdote. I can tell it is an old recording by the grain of the sound and the dated quality of the accompanying laughter and because I know that Williams died thirty years ago. In the spotlight Dickie wraps himself around the words as if he is not simply lip-syncing but instead summoning each word himself, with the extension of an arm or the slight sideways tilt of his head, moving always with the clockwork grace of a vintage Disney cartoon, a fantasia of gestures and expressions; a representation not of the person but simply of his voice, animated into vivid technicolor life.

2

The recording of Kenneth Williams is taken from a television special called *An Audience with Kenneth Williams*, first aired four days before I was born on 23 December 1983, five years before Kenneth Williams would die from an overdose of barbiturates in his central London flat. In it, Williams tells a long and delightfully meandering story about his time in the Combined Services Entertainment Unit at the end of the Second World War; a glorious pantomime of stiff-backed generals and mischievous entertainers barely holding it all together in the stifling heat of the South Pacific.

Williams' storytelling is immaculate, full of meticulously planned digressions and murderous one-liners; a joyous send-up of military officiousness and a subtle celebration of the subversive power of camp. But

if the story is wonderful it is in part at least made wonderful by the telling. By the voice. It is a voice I grew up with in the *Carry On* films that my mum adored and through endless reruns of *Just a Minute* we would listen to together on the radio. A voice that is completely unmistakable once you know it. As flexible as a gymnast; a riot of accents and exclamations, feather-light asides and machine-gun punchlines. It is a voice of precision musicality.

I found a copy of *An Audience with Kenneth Williams* on YouTube, buried among numerous chat-show appearances and the occasional documentary special. Williams is in a neat charcoal-grey suit. Occasionally the camera cuts to the audience of early 1980s television personalities guffawing in their seats. There is Michael Parkinson, hair parted smartly to the side, there a young Matthew Kelly chuckling toothily in a brightly coloured knit sweater.

3

In his white sailor suit and without leaving his spotlight, which must be no more than a couple of metres wide, Dickie creates from Williams' voice a silent ballet of subtle complexity, beautifully composed and faultlessly delivered. I have seen this act four times and it is probably the closest thing to a perfect performance I have ever seen.

Watching Dickie perform is like listening with your eyes. In our visually fixated and aurally sloppy culture he silently honours the power of voice by translating it into movement and colour, by giving it shape and body, rendering visible the subtle nuances that we might not otherwise be able to pick out any more: the perfect curvature of a sentence, the lingering traces of menace or regret, the tiniest of slips, the point where the voice cracks or breaks, the exhale of a breath held just that half a second too long.

It is perhaps for this reason that Dickie is drawn again and again to voices of practised finesse. Voices that are used as instruments, or occasionally as weapons. Voices that are as controlled as he is; that conceal, in that dazzling control, the fragility of the person beneath. People capable of projecting power from a position of relative powerlessness. By communing with such voices, Dickie can celebrate their strength and skill while troubling the hairline fractures that play across them, finding those hidden notes of sadness, or weakness, or vulnerability. He haunts these voices, revealing as he does so the other ghosts already contained within them.

4

Williams' voice was undoubtedly both an instrument and a weapon. The working-class son of a van driver and sometime apprentice draughtsman, his cultivated accent was a performance of gentility, a disguise he stitched

for himself and then seemingly never took off. And while the memory of his exaggerated effeminacy has been defanged over time, softened into the acceptably depoliticized camp of the *Carry On* films he so famously detested, this story speaks of something more dangerously subversive: a queerness troubling the establishment from within, ridiculing the protocols of British military discipline at a moment of wartime emergency and post-imperial vulnerability, all taking place some twenty years before homosexuality would even be partially legalized.

As Dickie lip-syncs and mimes his way through Williams' eleven-minute anecdote, watching him feels like a kind of synaesthesia. He makes everything implicit in the story explicit. The sailor may initially have seemed a sweetly doll-like costume choice but he is also of course a subversive icon of gay eroticism, like the similarly stylized sailors in Fassbinder's outrageous erotic fantasy *Querelle*, all clean white uniforms and striking queer symbolism.

In this way Dickie imbues Williams' seemingly flippant after-dinner routine with a grandeur and grace that belies its context. He invites us to listen to it with a concentration we don't normally dedicate to the chat-show anecdotes of once-famous light entertainers. And what we hear among the polished skits and clownish impressions are stories of death and war, of suicide and shame and desperation, of illness and ageing. It is all quite fantastically sad, and not even in a hidden way; it is right there in story. But Williams' verbal sleight-of-hand makes us believe those parts aren't important. Michael Parkinson, Matthew Kelly and the rest barely notice.

Dickie does though. He listens with the same diligent care with which he performs, and encourages us to do the same. He holds Williams' story up to the light, letting the jewels sparkle, and the hints of darkness spill into long shadows, his arms twirling in precision patterns, his mouth closing silently around each careful syllable in turn.

(AF)

Further reading

This Is Not A Dream, a film by Gavin Butt and Ben Walters
'A re-memberment of Jacques Minette, female impersonator (1928–2001)', by
 Dickie Beau at vimeo.com

Now, years later,
I try to recall this
event, reconstruct
it from uncertain
memory

Breach Theatre

Here's something I ask myself regularly: what is the point of theatre?

I mean, really?

Some things that happened in the world in the four weeks before I sat down to write about Breach Theatre:

Brett Kavanaugh was sworn in as the 114th Justice of the Supreme Court, a lifelong role, despite allegations of sexual abuse against him and his readiness to limit abortion rights in the US.

Jair Bolsonaro was elected President of Brazil, despite expressions of homophobia and misogyny and his readiness to raze the Amazon rainforest, killing indigenous populations through displacement in the short term, future generations through climate destruction in the longer term.

The *New York Times* reported that Donald Trump wants to create a legal definition of sex as 'a biological, immutable condition determined by genitalia at birth', erasing trans identities.

As reported in the *Guardian*, the IPCC (the UN's Intergovernmental Panel on Climate Change) warned that humans have twelve years left to limit temperature rises 'to a maximum of 1.5°C, beyond which even half a degree will significantly worsen the risks of drought, floods, extreme heat and poverty for hundreds of millions of people'.

The *Guardian* also reported that 'humanity has wiped out 60% of mammals, birds, fish and reptiles since 1970' (figure provided by WWF).

A white-supremacist man opened fire in a synagogue in Pittsburgh, killing eleven Jewish people aged between fifty-four and ninety-seven.

Another white man was filmed verbally abusing a black woman on a Ryanair plane, later claiming, erroneously, that he is not a racist person.

And that's just skimming the major headlines.

*

There's a show by Breach called *The Drill*, from 2017, in which the three performers – Ellice Stevens, Amarnah Amuludun and Luke Lampard, directed by Billy Barrett, with video by Dorothy Allen-Pickard – take part in a series of training courses, sold to the public, to learn what they might do in the event of a terrorist attack, a bomb threat, a shooting, etc. 'Everything feels very uncertain right now,' says Luke. 'So we wanted to do something to make ourselves feel safer.' And so they attend workshops, imagine, improvise, role-play, act. Time and again the instructors impress on them the importance of realism. 'Realism is everything,' says one. 'If it's not realistic, if the training's not realistic, then people don't have the fear.' If you've felt that fear, stress, pressure in a training environment, it won't shock you when you feel it in a real environment. You need to immerse yourself, really take part, more effectively to learn. 'The way people learn best is in a safe and controlled environment,' says another. 'So while we will make it as realistic as we possibly can in this circumstance, it will be safe and it will be controlled.'

These are at once rehearsals and acts of theatre; as theatre they are events with the potential to produce catharsis, a safe and controlled experience of fear in a safe and controlled environment. Which, for Aristotle, was really the point of theatre. The growing feeling through *The Drill*, however, is that all this training is pointless: not only does it not diminish fear, it exacerbates a latent suspicion of other humans, and with it a latent othering and racism. And if the training is pointless, maybe theatre is pointless too. Certainly – and this might be a delicious in-joke – 'realistic' theatre.

There's a show by Breach called *The Beanfield*, from 2015, in which the six performers – Billy Barrett, Grace Holme, Anna Himali Howard, Max Kennedy, Ellice Stevens and Tom Wright, directed by Billy and, on video, film-maker Dorothy Allen-Pickard – re-enact but also investigate the ethics around re-enacting the clash between police and military on the one side, and on the other a motley convoy of people including activists, non-violent protesters and peaceful worshippers of the solstice heading for the Stonehenge Free Festival in June 1985. The clash was a climax reached after months of aggression directed at the travelling community camped there. The performers were students at the University of Warwick at the time, and had been involved in their own clash with police, called in to break up student protests against the neoliberal profit drive of education.

The group wanted to make this show, Ellice says early on, to do something real. 'So real.' A specialist in historical re-enactment warns them to 'be careful' because the real of performance can all too quickly become the real of life: pretend violence becoming actual violence, pretend hate becoming actual hate. The man who now owns the field where the clash happened refuses to let them perform there, because he's afraid of what trouble – real – they might stir up. They find a field and go ahead anyway; Grace gets hit and tells her friends: 'This is really fucking painful.' There

is video playing of the re-enactment and it looks really fucking painful, feels actually painful to watch. 'It's really fucking horrible,' Grace says again. And it is. I mean, it's only theatre. But it feels horrible. Because it's also, as Dorothy says on the video, 'a real event'. Historical real. Present real. Now real.

There's a show by Breach called *Tank*, from 2016, in which the four performers – Ellice Stevens, Victoria Watson, Joe Boylan and Craig Hamilton, directed by Billy and Ellice, again with video by Dorothy – question what of historical events can really be pieced together from the documentary material and memories that remain. The story of *Tank* is of a research centre on the US Virgin Island of St Thomas in which, during the early 1960s, a series of experiments was conducted in teaching dolphins to speak English. It's also a story about what a particular dolphin, Peter, might have been thinking, feeling, trying to communicate during these experiments. Because who can know? Dolphins have an 'alien brain', it's said at the beginning; that's why they were chosen for the research. Perhaps if this alien brain could be taught English, so could all the aliens who might be discovered during the space race – but so too should all the aliens who live on the earth itself, all those other, foreign people whose customs are, within the dictates of xenophobia, so unfamiliar and terrifying.

There's a book by academic Nicholas Ridout called *Theatre and Ethics* that considers how theatre 'participates in a process of managing the way people think about their relationships with one another and their potential for creating societies in which everyone can enjoy freedom as well as social solidarity'. He begins with Plato, who lambasted theatre because 'it peddles dangerously pessimistic illusions that encourage a fearful audience to submit to inexorable fate rather than struggle to imagine the world differently'. Throughout, Ridout raises the question 'How shall I act?', but always with the caveat that theatre might be an odd place to come looking for that, given the relationships between ethics and truth, theatre and pretending. He resists theatre that presents a 'universal concept of "human" which ... can easily lapse into "humans like me"', seeking out instead performance that challenges 'our conception of what it is to have a human body, and to have intentions that make it do things ... challeng[ing] the human spectator to consider what it is that allows him or her to recognise another as a fellow human'. He searches for that 'moment of ethical encounter' in performance that can 'be the basis for thought, feeling or action within the sphere of politics'. That, for him, is the point of theatre.

*

A full list of the work I encountered in a theatre in the four weeks before I sat down to write about Breach:

Risk Lab, by Ada Mukhina, a participatory performance that invites its audiences to consider their complicity in systems of inequality.

The Malady of Death, written by Alice Birch, directed by Katie Mitchell, contemplating the mesh of relationships between masculinity, emotion (and emotionlessness), pornography and misogyny.

Summit, by Andy Smith (twice, for work), a brief rallying cry for better talking, and better listening, and more readiness to do the work of social/political/economic change.

ear for eye, by debbie tucker green, an elegant, poetic, fierce survey of black lives within white supremacy.

Fallen Fruit, by Katherina Radeva of Two Destination Language, in which she traces the complex experiences of herself, as a seven-year-old child, and the adults around her in Bulgaria before and after the fall of the Berlin Wall.

Lock Her Up, three audio works, by Sabrina Mahfouz, Rachel Mars and Paula Varjack, each responding to aspects of women's experience in prison.

Plus *I'm a Phoenix, Bitch* by Bryony Kimmings, *Burgerz* by Travis Alabanza, *No One Is Coming To Save You* by new company This Noise, a merging of *Othello* and *Macbeth* by Jude Christian, Paper Cinema's *Macbeth*, a musical version of *Twelfth Night* (you bet it was too much fucking Shakespeare), Andy Smith's *The Preston Bill* for the sixth time (for work), two R&D rehearsal sharings and two work-in-progress performances of *#thebabyquestion* by Paula Varjack, Luca Rutherford and Catriona James (with me as dramaturg), *Mouth Open Story Jump Out* by Polar Bear, *The Day I Fell Into a Book* by Lewis Gibson, *Charlie Ward* by Sound and Fury, *Frankenstein* by BAC's Beatbox Academy, *Chekhov's First Play* by Dead Centre for the second time (for joy), and yes, you're right, I do see an awful lot of theatre. I'm choosing the word awful for its double meaning.

In the midst of all that, I also saw *It's True, It's True, It's True* by Breach.

<div align="center">*</div>

It's True is another re-enactment play, of the trial, in 1612, of Agostino Tassi, the older man and established artist accused by painter Artemisia Gentileschi (a teenager at the time) of rape. The word accused there should not imply I don't believe her. It's quite different from Breach's other work: there's no video, and the three performers – when I saw it, Ellice Stevens, Kathryn Bond and Harriet Webb, directed by Billy Barrett, Dorothy Allen-Pickard joining them as dramaturg – never slip out of character to speak as themselves, so there is no metatheatrical discussion of how or why they're making each dramatic choice, or what the effect of those choices might be. This time the lines between verbatim speech transcribed by court notaries and imagined text are entirely blurred. So what is true, exactly?

It's certainly not true that the three women never slip out of character, because they are constantly slipping into and out of a series of characters: Artemisia is played by Ellice, Tassi by Harriet, and Artemisia's female

neighbour Tuzia by Kathryn, but they also take turns to play the judge, Tassi's friends, other witnesses in the case, Bible characters painted by Artemisia, and more. Nor is it entirely true that they never play themselves: in the presentation of a woman struggling to be believed, fighting against a patriarchal system that sets man's word above woman's, that internalizes misogyny to such an extent that women become the judge and jury of each other, Ellice and Harriet and Kathryn never stop playing themselves.

Another thing that's not true is that they don't question or justify their artistic choices: it's just that their choices snap into focus through an astonishing speech Artemisia makes explaining why her painting *Susanna and the Elders* is different to depictions of the story by male artists of the day. In men's eyes Susanna was courting the male gaze, asking for it. Asking for it. Whereas in Artemisia's eyes Susanna was unable to escape that gaze; she might turn away from it, push back against it, but such is the aggression of masculinity she is subject to it none the less.

How did the relationship between Artemisia and Tassi begin? Tassi was asked by her father to teach his daughter perspective. Perspective. The word is like a punchline – or, as performer Hannah Gadsby intones it, a *punch line* – to a really bad joke.

*

There's a book by Rebecca Solnit called *Hope in the Dark* in which she describes world events as taking place on the stage of a theatre. 'The traditional versions of history, the conventional sources of news encourage us to fix our gaze on that stage,' she says. But she draws her readers' gaze to the 'shadowy spaces' offstage, to 'the aisles, backstage, outside, in the dark, where other powers are at work'. What she's particularly interested in is 'the power of a story and of a storyteller' to move across these hidden places in the margins, because 'politics arises out of the spread of ideas and the shaping of imaginations', and what better way to spread ideas and shape imaginations than through stories?

For Solnit, writing is no different from activism: both are acts of faith, because their effects are indirect, delayed and often invisible. 'An essay, a book, is one statement', she writes, 'in a long conversation you could call culture or history; you are answering something or questioning something that may have fallen silent long ago, and the response to your words may come long after you're gone and never reach your ears, if anyone hears you in the first place.' And while 'changing the story isn't enough in itself . . . it has often been foundational to real changes'.

Now I'm no Solnit, however much I wish I were. And when I ask what the point is of theatre, what I'm also or possibly really asking is: what is the point of (me) being there and (me) writing about it, and beneath that I guess what I'm really asking is what is the point (of me)? That theatre of world events is on fire right now and always has been, the gaze of the audience drawn not by the limelights as Solnit suggests but by blazing flame, and the

response my words make to it keeps feeling so fucking paltry. Whatever I'm writing about, I repeat and repeat the same words – patriarchy, capitalism, neoliberalism, inequality are some of the key ones – as though chanting a mantra might do anything to dismantle their power, might do any kind of good in the world.

As I muddle through identity crisis number 17,962, there's something in Solnit's description of the long conversation, the call and the response, that I want to hold on to – hold faith in – not least because it's echoed in the final section of Ridout's *Theatre and Ethics*. Quoting a text by Adrian Heathfield, Ridout describes that 'moment of ethical encounter' as 'a reciprocal and unending cycle of call-and-response, of gift and counter-gift'. And 'the act of critical writing about performance' is part of that: a recognition of 'response-ability'. The ethical encounter couldn't happen without the witness, the spectator, the person in the audience 'called upon to recognise that there is a relationship between what is shown in the theatre and their own experience of the world', and 'invited to do something about it'.

I have to keep returning to ideas like this because it's all the self-justification I have for the amount of time I spend, physically and mentally, in theatre, and for the fear that all I'm really doing is entertaining myself and hiding from life, never participating in 'action within the sphere of politics'. I have to keep reminding myself that I share Solnit's belief in stories, and belief in the need for different stories, and that's what I'm doing with the response-ability theatre encourages in me, trying to tell different stories.

It's True, It's True, It's True is a story of a rape. It is a story of a woman who would have married her rapist to maintain her dignity. He refused, and so she was able to do something better. She was able to paint. To paint stories told by men from a female perspective. At the end she enters another of her paintings, one of her many versions of the slaughter of Holofernes by Judith. Here's what the stage directions say about her entrance: 'Judith appears in a golden dress. She is a rockstar, a guardian angel, the embodiment of rage.' And here's what the character says: 'The names of my foremothers may be forgotten but yours and mine will never be.' Because it's not true that *It's True* is the story of a rape, a story that seeks to be a silencing and a full stop. It's the story of female anger, female defiance, female strength.

It's a story that needs to be told and retold and retold because patriarchy too is angry, defiant and strong, but more than that, patriarchy is powerful, in power, perpetually in power. And none of us know when this will change.

*

I've never asked or read why Billy, Dorothy and Ellice chose the name Breach for their company, but it makes me think of that rallying cry Shakespeare has Henry V deliver on the point of battle: 'Once more unto the breach, dear friends.' Only here, the breach is not a site of war but a space in which to rage, yes, argue, yes, confront, yes, but also care, speculate,

listen, think, see things from a different angle, reshape ideas around community. All of which, really, is the point of theatre. Isn't it?

(MC)

Further reading

The Beanfield, Tank and *It's True, It's True, It's True*, all published by Oberon

Tania El Khoury

1

I first met Tania El Khoury nearly a decade ago. In 2009 my friend Deborah
and I had just finished our first year running a venue called Forest Fringe
together in Edinburgh and Tania had just completed an MA at Goldsmiths
in London. Somehow she had heard about Forest Fringe and emailed us to
say she was interested in being involved. We met in Shoreditch in a dimly lit
pub and got on well enough that Tania came up to Edinburgh with us the
next summer, and the following two summers as well, entwining herself in
the DNA of Forest Fringe as it emerged from out of those earliest years.
Tania and Deborah even lived together in London for a while, in a tall red-
brick building surrounded by other similar red-brick buildings a handful of
steps from the pub where we first all met.

Despite this it was only earlier this month that I first visited Tania in her
other home city of Beirut, where she was born and grew up and where she
currently lives. I was there for a short residency with the local performance
collective that Tania runs with urbanist Abir Saksouk-Sasso. We talked
about cities, about their patterns and their histories, their rhythms and their
failings. We ate fresh fish and drank ginger-thyme martinis amid the bustling
noise of downtown. We toured the over-renovated half-ruins of war-
damaged mansions and the decaying remnants of an abandoned international
fair, vast abstractions of modernist concrete crumbling in the baking sun.
We drove in Tania's car down the coastal highway to Tripoli, balding
politicians staring down at us from giant billboards, white shimmers on the
deep blue of the Mediterranean. On my last day we took a boat out into the
sea so that we could look back and see the whole city in front of us, splayed
out along the coast like a sentence with too many clauses.

It's a five-hour flight from Beirut back to London, half of which I spent
watching *Paddington 2* and half of which I spent trying to write this essay. I
tried thinking of the distance between these two cities and what it must be
like to live across that distance, but I couldn't really do it. I am too much of

London and not enough of Beirut. Just about able to recognize the painful gap between Britain's sociopathic self-regard and the way the rest of the world actually sees us, but not able to stop myself crying when all the nice people on Paddington's street chip in to buy his elderly aunt a trip to Portobello. As we started our descent into Heathrow the sky was clear enough that I could pick out my house in the toytown London below me, and Lebanon was already more than 2,000 miles away.

2

It is perhaps no surprise that Tania's work is about distance; not only the distance between London and Beirut but distance in general, and the potential for performance to bridge that distance. I think if I were to try and distil the complexity of that work into just one sentence, I would describe it as a series of attempts to translate one life into another across profound distances; distances not just of geography but also of gender, religion, sexuality, class, race and culture. It is, more than anything else, an exercise in empathy.

The first piece Tania made for Forest Fringe was called *Fuzzy*, an encounter for one audience member at a time in one of the dingiest of our dingy basement rooms in our first Edinburgh venue on Bristo Square. Tania sat in front of you on a patterned sofa in an identically patterned dress, rendering her seemingly invisible or perhaps just transparent, disappearing into the colours and shapes of the material like she herself was fading away. She was going through a difficult and protracted break-up and the piece invited each audience member in turn to play the role of counsellor to this disintegrating relationship. As with all of Tania's work, the piece was an exercise in listening and responding. You listened to her stories and responded with questions and whatever advice you were able to give. In this way the ruins of Tania's love life became not simply the subject of an intimate confessional, eliciting sympathy or even pity, but rather the basis for a more active, engaged kind of empathy; an exercise in finding a shared language to reflect on how love falls apart, and what might be done to mend it.

Perhaps this piece could be seen as something of a blueprint for what would follow: a belief in the value of listening and of asking an audience to physically step out of their own lives and move tentatively towards somebody else's. The rooms that Tania creates are spaces of enactment in which I am invited to be someone other than myself. I am sitting in a busy café reading an Arabic newspaper, or I am shouting to a lover from an open window. I am lying on the cold earth of a shallow grave, head pressed gently against the damp soil, listening for the sound of a voice rising from the ground beneath me. In these spectral moments my body gently cradles the memory of another body, another person in another place or time; an empathy drawn in muscle and sinew, in the inhale and exhale of breath that doesn't feel entirely my own.

3

There is a lot of contemporary work, often described as 'immersive' or 'site-specific', that attempts to place you into foreign situations, enabling you to experience them in a visceral and embodied way. There is Badac Theatre's *The Factory*, which according to their website 'follows the final journey of victims destined to die in the gas chambers at Auschwitz-Birkenau', or Lucien Bourjeily's *66 Minutes in Damascus*, which recreates the brutality of a Syrian detention centre, or iNK Stories' *Hero*, a virtual reality experience of an air raid, again in Syria, that won the 2018 Storyscapes Award at the Tribeca Film Festival. All these works, along with many others, foreground the seriousness of their moral endeavour: justifying their theatrical simulations of real human trauma as a kind of humanitarian mission.

Such claims, however, often lead to a situation in which the supposed authenticity of the experience is both the main justification for the performance and its only real dramaturgical idea. From here it is easy to end up trapped in your own verisimilitude, fetishizing the cruelty and violence you are attempting to portray and losing yourself in ever more saturated layers of detail for fear the audience's attention might drift and they will notice how artificial and frequently unintentionally ridiculous the whole situation is.

The pursuit of this kind of reality effect in art has a very long history. Early Christian icons, like many other kinds of non-Western art, were a play of symbols and surfaces; a complex and fragmentary rendering of a complex and fragmentary world. The role of viewer was to read and interpret, to assemble these fragments and in so doing generate a meaning specific to that viewer and her place in the world.

In the fifteenth century, however, Italian artists began to develop what would become known as 'linear perspective', a single vanishing point towards which everything in the painting raced, creating in their images an illusion of realistic depth and space. But this reality effect was exactly that – an effect; a deception reliant on an abstracted horizon and the assumption of a static and singular viewer. As the artist Hito Steyerl describes it, linear perspective manufactures for itself an imaginary world, 'a mathematical, flattened, infinite, continuous, and homogenous space, and declares it to be reality'. Steyerl argues that even as it locates the viewer at the centre of vision, linear perspective undermines and constrains them. Where once the images in the painting existed in a fluid and multifaceted relationship with the viewer, now both are subservient to a set of supposed scientific truths; truths not unrelated to the justifications offered by the same enlightenment societies for the abuses of imperial conquest and subjugation.

Perhaps this might serve as a useful lens through which to understand the oppressive aesthetics of so much 'immersive' work, which pursues an abstracted and artificial realism at the expense of plurality and complexity.

As with linear perspective, this immersive work makes great play of placing the audience at the centre of the theatrical experience, but in doing so strips us of our subjectivity, rendering us mere objects within a predetermined operation: five minutes of being shouted at by this performer, then marched down this corridor, then five minutes in this dark room, and so on. Our individual agency and ability to critically engage with the subject are sacrificed to a set of administrative procedures. And just as linear perspective spoke to the imperial excesses of Western rationality, perhaps the popularity of this new theatrical approach is indicative of an era of bureaucratized violence in which, in the West at least, everything from warfare and migration to buying a new book are controlled by vast and impenetrable infrastructures and algorithmic abstraction.

4

If such work is defined by its suffocating wholeness, Tania's is best understood through its gaps and its absences. It is performance made out of fractured pieces; small gestures and objects of symbolic significance that float evocatively in pools of literal or figurative darkness. A seashell containing voices from another continent, a backpack seemingly abandoned in an anonymous basement, the shout of a possessive lover from an open window, a trail of ink figures drawn on the underside of my arm. These ambiguous fragments are more like icons than props. They are echoes of another existence, referring to lives very different from our own while at the same time speaking of our distance from those lives; of the desire for understanding and the longing of separation.

In the first part of the last decade, when living and making work in London, Tania used this constellation of objects to assemble delicate encounters haunted by the distance between her own life and that of the majority of her audience in the UK. In pieces like *Fuzzy* and *Jarideh* Tania created situations in which we can lean in to her experience, and through it explore the misogyny and racism that lurk perpetually beneath the skin of British society, all too frequently rushing to the surface. In *Jarideh* a game of spies in an ordinary café quickly unravels into a complex examination of Western surveillance, both individual and systemic, and its perpetual readiness to police the behaviour of brown bodies in public space. In *Maybe If You Choreograph Me* it is women's bodies that become both the subject and object of the piece, as Tania employs her relationship with each individual male audience member to unpick the myriad ways men have of restricting women's space to move and to be.

In her more recent work, perhaps not coincidentally since she moved back to Lebanon, Tania has used these same empathetic strategies, these same half-broken gestures of enactment, to explore a different kind of distance.

5

I remember sitting on a bunk bed in a basement gallery somewhere in Seoul, the room dark except for a series of shaky camera images projected on the wall in front of me which bathed the beds in softly flickering, reflected light. I'm listening on headphones to the story of a Syrian man describing his life in a refugee camp in Munich, while a video he filmed on a camera smuggled into the camp is projected on the wall in front of me. The piece is called *Stories of Refuge* and Tania made it with her Dictaphone Group collaborator Petra Serhal while on a residency in the city in 2013.

In the video the man shows us around the cramped interior of his room, metal lockers and brown blankets, a pair of sunglasses resting on an old CD player, an incongruous blue duvet cover and then, out of the window, children playing on the steps of the building opposite. Later he stands on a bridge over the River Isar, the water pixelly white in the sunshine. The camera zooms in close on the love locks attached to the bridge, a hand reaching out and picking one up briefly before disappearing again. His face is never shown. I can see through his eyes but not into them.

The bunk bed on which I sit echoes the plain metal bed in the man's room, but it is a deliberately faint echo. Another version of the piece might have attempted to simulate this environment through a greater level of realism: discarded clothes, bags, the detritus of everyday living in these overcrowded, inhospitable circumstances. Tania resists doing so, acknowledging our estrangement from the man's experience and allowing the beds to become imbued with my own entirely subjective set of meanings: the bunk bed I used to share with my brother, the dorm rooms I stayed in on school trips to Yorkshire and Berlin, the fuggy air of backpackers' hostels and the sound of other people sleeping. As the camera pans across the man's bed he talks about being trapped on a boat sinking in the Mediterranean, of how he managed to get out and the sixty other people that didn't. Memory shimmers in the bedframe, familiarity and distance. My experience wrapped around his, or perhaps his wrapped around mine; my past haunting his present, his present haunting my past.

(AF)

Further reading

Gardens Speak, by Tania El Khoury, published by Tadween Publishing
'Maybe If You Choreograph Me You Will Feel Better', by Tania El Khoury in
 Forest Fringe: The First Ten Years, published by Oberon
'In Free Fall: A Thought Experiment on Vertical Perspective', by Hito Steyerl,
 published in *e-flux Journal* #24 (April 2011)

Uninvited Guests

Past

I have a lot of memories of taking part in *Love Letters Straight From Your Heart*. My pounding twisting insides as I clicked send on the email to Uninvited Guests with my potential contribution to the show: a story I've shared with literally nobody else who knows me. That internal discombobulation churning again as Richard Dufty read out my story and played the song connected to it, trying to keep my face impassive as I glanced across the room, as though curious who might have written it. Trying not to cry as people around me had their stories read out, of love lost and found, consummated and unrequited, of lives and deaths and longings and accidents and mistakes; trying not to laugh if I thought the song they requested was terrible. The couple who dedicated the Smiths' *There Is a Light That Never Goes Out* to each other and stood up holding hands as it played. The bit when Richard ran around the room as though being hounded by love.

But my strongest memory is of the woman sitting opposite me, long ash-blonde hair, soft blue eyes, and how we looked directly at each other, as instructed, for the duration of a song. Giggling with embarrassment at first. Vision misting with the concentration. Feeling at one point as though I might leap across the table, take her hand, and lead her into the unknown future. Remembering how it feels to fall in love. We sat opposite each other on Valentine's Day 2012 and she has been clear as a dream in my mind ever since.

On their website, Uninvited Guests describe *Love Letters* as 'somewhere between a wedding reception, a wake and a radio dedication show'. And it is all of those things, but it is also a container for the best of humanity. A space in which it is possible to lay down emotional burdens, acknowledge another's role in making your life what it is (for better and indeed worse), wonder at the rapture of love but also its difficulty, speak courageously knowing that someone else will say the hard words for you. It is performance as kindness, performance as gift. Sharing, attention, and gratitude.

Present

Love Letters is the constant present I would like to live in. *Make Better Please* is the reality. Uninvited Guests performed an early draft of the show in 2010, the same month David Cameron became Prime Minister. I saw it in 2012, by which time rioting had broken out across several UK cities, the savage reduction in public spending of Austerity was cemented by the Welfare Reform Act, the Arab Spring and Occupy movements had mostly been quashed and the Syrian civil war had begun. There was a lot, so much, to want to make better. There's a review of the show by Matt Trueman – who saw the early draft as well as a 2012 performance – in which he imagines the company 'watching and waiting for the right moment to unleash it. That is, for things to get this bad. I picture them peering conspiratorially over the *Guardian* each day: Not yet. Not quite yet. OK, now. Go. Go. Go.' We had no fucking idea what was coming up next.

As with *Love Letters*, *Make Better* is as much gesture of generosity as performance. It starts with everyone in the room sitting down with pots of tea and plates of biscuits and reading the day's newspapers together. Imagine that: actually talking to people about the headlines, communing with strangers instead of ranting into the social media void. (Although I will pause here to acknowledge the prejudice of that thought, the lack of appreciation for the ways in which social media has also given people access to community and public expression – particularly people isolated by a disabling capitalist society, moulded to the desire lines of the narrowest representation of humanity.) It ends with the headlines chosen by the audience being ritualistically burned, as a simple prayer is intoned: make better please. Make better. Words instead of worlds going up in flames.

In between Richard takes all the sickness and cruelty of the world into his body like some towering hip priest witch doctor, Jessica Hoffmann roars and carouses with a spirit equal parts Patti Smith, Kathleen Hanna and Pallas Athena, goddess of war, and everyone in the room is asked to empathize with – more than that, identify with – the subjects of the news stories, eliding the distance between them and us. Every single thing that is happening in the world is done by people, to people. The only way for any of this to be made better is by people deciding that it will be so.

Future

Around the time I saw *Make Better Please* I was reading John Holloway's *Crack Capitalism*, and holding tight to his description of those explosions of community – whether in the form of street parties, protests or indeed performances – that cause a momentary 'crack in the patterns of domination'. These cracks, he wrote, operate 'Like a flash of lightning, they illuminate a different world, a world created perhaps for a few short hours, but the

impression which remains on our brain and in our senses is that of an image of the world we can (and did) create. The world that does not yet exist displays itself as a world that exists not-yet.'

Holloway connects this thought to the writing of Ernst Bloch, for whom 'the present existence not-yet of the world that does not yet exist is the source of hope'. Rebecca Solnit quotes from Bloch in the first chapter of *Hope in the Dark*, to underscore her assertion that 'To hope is to give yourself to the future, and that commitment to the future makes the present inhabitable.' Bloch is named again in some notes I took during a meeting with Uninvited Guests, in which we talked about the company's upcoming twenty-fifth anniversary (they've been working together since 1998), finding a through line from where they've been to where they're at and where they might go; Bloch's book *The Principle of Hope* is a key inspiration for the company, along with José Esteban Muñoz's *Cruising Utopia* and Zygmunt Bauman's writing on 'liquid modernity'. Together these writers galvanize the company's interest in 'fuelling the critical and potentially transformative imagination of the community', and 'measuring life as it is by life as it should be': looking back to the past to rethink the future, imagining the future to critique the present.

I should admit at this point that I've been on the board of Uninvited Guests since 2014, and that all such declarations of interest make me abrasively, aggressively defensive: it's not that I'm more biased in Uninvited Guests' favour – certainly no more so than anyone else in this book – but lucky enough to have more of an insight into how they work. I know, for instance, what a struggle it is for them to carry on as a company given their geographic and temporal constraints: Richard based in London, Paul Clarke and Jess in Bristol; Richard and Paul both with full-time jobs (theatre producer and academic respectively), Richard and Jess both parents with two kids each. Their work takes a long time to make because before they can make work they have to make time. I am increasingly touched by their ongoing commitment to each other, their investment in the hope their work generates and interrogates.

It has been harder and harder – for me anyway – to hold on to hope as the 2010s have progressed. The idea I cling to now is another one from *Hope in the Dark*, this time borrowed from Eduardo Galeano: 'Utopia is on the horizon' – and as such, is always in the distance, somewhere in the evocative blue where sky meets land or sea. However much we walk towards it, it never gets any nearer. 'So what is utopia for? It is for this, for walking.'

Each new work by Uninvited Guests is another step on the path. They know it won't actually change the world, but it might just help people imagine that change, and feel that the times are more liveable as a result. One night in Malvern I watched them perform *This Last Tempest* to a handful of people, dizzy with rapture at the ways in which it spins out the story of Caliban and Ariel after all the other characters leave Shakespeare's enchanted island. Richard and Jess describe an island that has been allowed

to rewild: here a different kind of love finds breath to blossom, in a landscape reconfigured and a language reshaped by song. Towards the end, Richard and Jess move into the audience space and shed the characters of Caliban and Ariel to speak more as themselves – but weaving in the vision of the commonwealth of contraries described by Gonzalo in the second act of *The Tempest*. Together these fictional characters and real speaking bodies collaborate to imagine a place in which there is:

> no name of magistrate;
> riches, poverty, and use of service, none;
> all things in common nature should produce
> without sweat or endeavour:
> nature should bring forth,
> of its own kind, all foison, all abundance,
> to feed my innocent people.

Shakespeare has his other characters scoff at Gonzalo; they're the ancestors of people today who condone the school-to-prison pipeline, unfathomable wealth and ever-widening divide between the one per cent and the rest of humanity, environmental catastrophe, the rising use of food banks. But Gonzalo knows. And Uninvited Guests know.

Sometimes going to the theatre feels like a preposterous act of escapism, sometimes a reprehensible act of privilege reinforcement. And just occasionally, it feels like a step towards possibility, a necessary pre-figuration of what could be.

Time ruptures, time loops

This chapter was the last in the book to be written, the words coming together as the COVID-19 pandemic forced people apart. I finished the final draft in the week of 13 March 2020, as theatres, cinemas, galleries closed their doors and schools wrote to parents explaining that children would need to stay at home. The months of quarantine have been so cruel, exposing the inequality of our society more starkly than ever, but also giving a surge of energy to the mutual aid movement, networks of care flourishing into existence, bringing that vision of Gonzalo/*This Last Tempest* tantalizingly into view.

Gradually, the artists in this book have been reconceptualizing their work for this unsettling era, finding new ways to create community online. One evening in April I sat in my kitchen and took part in *Love Letters Straight From Your Heart* again, this time performers and audience sharing a space on Zoom. People in different houses across the UK, gathered together to hear each other's stories of people they love – their partners, siblings, parents, friends – and the songs they associate with those relationships. Laughing

and crying anew. It wasn't the same. But it helped me feel the possibility in difference, and in those early frightening weeks, that belief was a thing to cherish.

(MC)

Further reading

'Doing it Yourself: Profaning democracy, the news media and political consensus', by Paul Clarke, in *DIY Too*, edited by Robert Daniels, published by University of Chichester
'Labour: Participation, Delegation and Deregulation,' in *Fair Play: Art, Performance and Neoliberalism*, by Jen Harvie, published by Palgrave Macmillan

PART 2

In search of new languages

Verity Standen

Nigel Barrett and Louise Mari

Ellie Dubois

Alexandrina Hemsley and
Jamila Johnson-Small

Verity Standen

How far did you make it through childhood before an adult – probably an adult you respected, loved even, a parent, or a favourite teacher – said either directly or indirectly you couldn't sing?

*

Enter the room with a blindfold and sit down. Sound follows you into the room, carried by bodies, emerging from mouths. One of those bodies comes and places a hand on your arm, gently lifts you to your feet and, still singing, hugs you. Sound becomes feeling: the feeling of a note moving through the chest to the throat, the feeling of volume rising like wings beating against your skin. The feeling of a melody feather-soft, embers-warm, the feeling of a rhythm like the pounding of your lover's heart. It's like the sound itself is holding you, suspended inside itself; it becomes a part of you, and so you become part of it.

Have you ever sat in a dark room listening to a song, a piece of music, thinking: this is the safest place I know? For the time-stretching minutes of being inside it, being held by it, Verity Standen's *Hug* was the safest place I knew.

*

When my daughter was three months old she would lie in her cot and sing. Syllables rising from a place beyond language but of it, doo and da and goo and ga and ba and bu and other simple sounds. She would lie in her cot and fill her lungs with air, curl her lips around circles and ovals, stretch and compress her tongue, and I would think of Ella Fitzgerald singing scat, a honey stream of joy pouring from her mouth. And really, the only thing ruining this idyllic scenario was the fact that my daughter's favourite time to lie in her cot singing was between the hours of two and four in the morning, as though her cot were a club in Vegas where time never sleeps. Her voice was a bat flying across the room, a nocturnal creature restless and busy, unconcerned by anything more than its desire to explore.

My daughter turned eleven a few weeks before I wrote this. I haven't heard her sing with that kind of freedom and pleasure in years.

*

At school I knew someone with perfect pitch. While I struggled to construct just the three basic chords needed to write a punk song, she could hear a note – in the wail of a fire engine or a radio jingle emerging from a car window – and sing it straight back with mystifying ease.

In a review of Steven Mithen's book *The Singing Neanderthals*, published in the *Guardian*, writer Peter Forbes describes this mystery as 'the crux of the relationship between language and music'. Apparently, many babies – perhaps even all – are born with perfect pitch, but by the time humans reach adulthood only one in 10,000 people retain this magical ability. 'Why', Forbes asks, 'would we lose something so useful?'

For the simple reason that perfect pitch could be a hindrance, interfering with the more important business of 'learning language. In learning language we have to recognise words from the stream of sound even though they come in different accents and pitches. Perfect pitch would be like a digital scanner that could only read letters presented in the correct typeface.' Language needs a different flexibility.

*

There are so many clichés that attach to writing about music: I know because I used to review an album a week, and probably lapsed into most of them. Cathedrals of sound. Sound like a warm bath, a flotation tank, a sunlit turquoise sea. I once lost a job reviewing albums because I described a melody cascading like a waterfall. Or maybe it was diamonds. Or maybe a waterfall of diamonds.

I don't have synaesthesia but I do see sound: I hear certain note progressions within major or minor scales I don't have the basic musical knowledge to name, and see picnics in a sunlit glade, bottles of lemonade opened after shaking, long drives on empty desert roads in Texas (even though I've never been to Texas), the shadows cast on clear-sky nights, the glint of a sharpened blade, the shatter of broken glass, the jewel-box colours of dusk. Music becomes through these images a story I can tell.

*

Nine singers stand in a row in a side room in Bristol Cathedral with their tongues stuck out as far as they can push them. What a weird and unsettling muscle the tongue is. Each one emerges from its owner like a mole from dark ground, curious but tentative as it tests the air. The tongue-creatures curl, reach to one side then the other, then take turns to retreat back to their caves: slurp, slip, slup, puh. And then one of the singers starts making sounds like a wail, like a question, like a baby who can't speak yet, sounds wandering and wondering, rising with anxiety, subsiding with a sense of reassurance.

There's humour in *Undersong*, but also a different way of thinking about how humans make song. Its singers come from a variety of musical

backgrounds: some classically trained, some from folk or non-western musical traditions, some are actors who also sing. Genre, style, the labels of false compartmentalizing are irrelevant: what matters is that the human body makes sounds. And Verity plays with those sounds as though they are Plasticine, mushing the colours together irreverently, then pulling it into intricate shapes, delicate in detail.

*

The singers in *Hug* aren't necessarily professionals: many are recruited locally to the venue, people who sing in amateur choirs, for fun. 'For want of a better word there's a lot of snobbery around voice,' Verity says in a trailer video for the work. 'I don't really believe in any of that. Everybody has a voice, everybody can create noises and everybody can hear those noises. I think it's very much an openness I'm creating around voice, where there's no judgement. I think that is important and definitely is in the heart of *Hug*.'

But it's not only with the voice that Verity encourages openness: it's also with hearing beyond ears. *Hug* is a work that's possible to hear through the whole of the body: through the breastbone, through the throat, through the cheek, through the arms. It offers a different way of listening, and within that the beginnings of an appreciation of how D/deaf people differently hear not often encountered in music.

*

'Whereas in language it is usually possible to specify the subject of an utterance with some precision, this is almost never the case for music,' writes academic Ian Cross in a paper titled 'Music and meaning, ambiguity and evolution'. Music is malleable, ambiguous, open to interpretation according to the sensibility and politics of the person who is listening – 'gathering meaning from the contexts within which it happens and in turn contributing meaning to those contexts'. He quotes another academic, Lydia Goehr, who argues that, since 'music has no meaning to speak of, [it] can be used to envision an alternative culture and political order while escaping the scrutiny of the censor'. The phrase he offers for this ambiguous quality is 'floating intentionality': music's 'aboutness' drifting on a breeze.

*

The context in which I've seen all Verity's work so far has been theatre: even if the venue itself hasn't been a conventional theatre building, she's been programmed by one, or by a festival (Forest Fringe, Mayfest) that has theatre among its tools for creating temporary communities and communicating ideas of social change. She's cherished because of her playfulness (and because she's brilliant, obviously); and yet the relationship is surprising in a way because theatre, in the UK, still privileges text above any other language.

So she's not only disrupting musical hierarchies and ideas around what constitutes music, what counts as song, who has permission to sing and who doesn't; she's also expanding what constitutes dialogue within theatre. She understands, to quote Salome Voegelin's *Listening to Noise and Silence: Towards a Philosophy of Sound Art*, 'the radical value of sound to shift not the meaning of things and subjects, but the process of meaning making and the status of any meaning thus made'.

Even when language is used in *Undersong*, it doesn't impose meaning. The few words that appear are no more indicative of the scope of human expression than the snatches of beatbox, scat, gospel, or the sound patterns that – as with major and minor, chromatic and diatonic scales – I'm not knowledgeable enough to identify except vaguely as emanating from somewhere within Africa. My dictionary defines the word undersong as 'a subordinate or subdued song or strain, especially one serving as an accompaniment or refrain to another; an underlying meaning, an undertone'. What Verity explores in *Undersong* are the sounds that refuse to be claimed by language, the modes of expression hidden beneath it, some of the possible ways in which one body might express itself and communicate with another.

*

In *Hug* one singer holds you and the music wraps itself around you like a blanket, the music dips you into a warm bath, the music finds that magical spot in the sea where warmth rises from deep below the sandy bed to make it warmer than the spot just a metre away. I felt the music lift me up and lower me down in waves; felt suspended in the moments before orgasm, every muscle quivering. It's that intense, that overwhelming.

In *Undersong* nine singers swirl around you, their voices falling like cartoon raindrops, first slowly splash plink one by one, then fast, a shower; the music bounces like springs uncoiling; soars like a flock of birds taking flight and in its soaring it picked me up too, so that at points listening felt like levitating, the notes' graceful arms holding me aloft, the feathers of my own new-sprung wings. I saw – heard – attended, that's the right word – *Undersong* twice: the room in Bristol was relatively small and the music pressed me tighter even than the singer's arms in *Hug*. It was a force to be reckoned with but not aggressive, the force of the wind at the shift of the seasons, strong enough to get under my skin, to course through my veins. The room in London, the chapel of one of my local churches, was much bigger and the music had more space to roam, but far from escaping from me into the altitude of the domed high ceiling it danced like a winged sprite holding tight to my hand, my elbow, my hips, keeping contact all the time.

*

Before there was language, there was music. I know Twitter isn't a particularly reliable source of information but there was a wonderful thread about this on the account *Real Scientists* written by Sarah Faber in 2018, looking at

the relationship between language and music from the perspective of evolution and brain development. 'Music relies on a very widely distributed network of brain areas working together,' she explained, and the areas needed for music-making 'have existed for longer than the necessary pieces for language' – supporting the theory of some scientists that 'music may have evolved as a kind of proto-language, something that had limited communicative capacity, but facilitated social bonding'.

Given that music does the job of expressing feeling, but language can do that and convey facts, it could be argued that the human brain doesn't actually need both for its continued survival, that gradually all capacity for making music might have been shed along with the skill of perfect pitch. Why didn't this happen? 'One current theory,' Faber offered, 'is that we need language to be precise, but we need music to be imprecise.'

*

In a sense there is nothing imprecise about Verity's work. Choreographically, for instance, *Undersong* is meticulously arranged: Verity and frequent collaborator Ellie Showering stand at the centre of the room hurling a 'ha' into each other's mouths; there are moments of competition, singers in stand-off on either side of the room raising their voices up the scale to soprano heights; the singers lie down and lean back and move in figures of eight and the effect on the sound with each movement feels absolutely intended.

But in terms of what it means? I couldn't tell you. All I have are feelings, images, stories. Like this:

When my daughter was six weeks old she would cry and cry and I would have no idea what to do. One day I pursed my lips and drew a golden thread of sound, the quasi-Buddhist omm I'd felt both reassured by and slightly foolish chanting at pregnancy yoga classes, up from the depths of my lungs. Her eyes widened as though the sound were a mysterious creature only she could see and she stopped crying instantly. It worked that once and never again. But I remembered that moment in the middle of *Hug*, except now the singer holding me was the mother, and I was the baby, helpless, bewildered by life, suddenly startled, enraptured, content.

(MC)

Nigel Barrett and Louise Mari

1

The story of how much I love Nigel Barrett and Louise Mari begins about thirty years ago in the quiet village eight miles north of Cambridge where I grew up; ancient cottages and new-build estates, a crossroads, a shop, a pub, a garage. We went to Sunday school in the vicarage and played football on the recreation ground, in the woods by the railway line we shot at pigeons with air rifles and then once or twice a year my parents would take us on a daytrip to London.

On the train from Cambridge, London appears gradually from a fog of suburbia, high brick walls tattooed with graffiti and beyond them neat rows of narrow gardens; there is a football stadium, an industrial estate, new office blocks and old office blocks and with a final flourish the Victorian grandeur of King's Cross station. From there we would be shuttling down an escalator towards howling tube trains and then to the Christmas decorations on Oxford Street or the performers in Covent Garden or a birthday visit to the London Dungeon or HMS *Belfast* or Madame Tussauds; we'd eat McDonald's in Leicester Square and drink in the bright lights through a plastic straw thinking how big it all was and how wondrous, a ravishing phantasmagoria of a city barely concealing beneath its glittering skin all the unnameable wonders that we had been told the big city, and indeed adulthood itself, would contain.

When years later I moved to London I carried this version of the city with me; placed it on the windowsills of rented rooms in Tooting and Walthamstow and Bethnal Green where those seductive surfaces no longer appeared like gateways to a hidden world of glamour that I would surely now be welcomed into. They were just surfaces, like the blinding glare of a Piccadilly Circus Pepsi ad, or the digital rendering of a new skyscraper on a building-site hoarding, concealing only compromises and inequalities. Boring men and their equally boring dreams. To me, London appeared to be a city of locked doors.

Apart from one door.

The door stood in London Bridge station, it was small and black and if not secret then at least very discreet; no sign, no branding. On the other side of the door was the Shunt Lounge: the one place in the entire city that seemed to belong more to my childhood idea of London than the grey reality of the rest of the city.

Shunt were, and still sort-of are, a theatre company made up of ten core members and a sprawling community of associates, collaborators and friends. They made shows of feverish energy and extravagant visuality in unlikely locations around the city, including the space behind the small black door in London Bridge station. I never saw those shows though; I didn't move to London until 2006, by which point they were over and the space behind the door was called the Shunt Lounge. The Lounge was not a show exactly, but neither was it a venue or a bar; you could instead perhaps describe it as an immersive light and sound installation, a cavernous art-dungeon smelling of railway-arch damp and looking like the mines of Moria if the Dwarves had all been really into techno; a vast subterranean labyrinth filled with lights and noise and people, carrying in its huge crocodile jaw an ever-changing line-up of performances, encounters, interventions, live bands, DJs and numerous other uncategorizable goings-on. There was a giant zip-line at one point I think, and a temporary lake with its own rowing boat, and a caravan, and a forest of antique pinball machines. Then unexpectedly in its quieter corners you would find smaller, more delicate things; intimate shows in dusty rooms for a handful of people. Shunt founder-member Mischa Twitchin's hands moving very slowly for half an hour in near total darkness; the writer and actor Simon Kane covered in rice pudding and carrying a giant dead fish, leading us out into the late-night emptiness of London Bridge station.

What I am trying to say is that the Shunt Lounge was audacious, perhaps the most audacious place I have ever been; a defiantly unsustainable, borderline uncontrollable theatre-grotto of wild fantasies and improbable spectacle built by a group of people just about holding it all together, and doing it for us, for anyone, for the people who came and paid £5 or whatever preposterously negligible price the entry fee was. In its warm bear-hug of an embrace, its cavernous depths, its unconcealed workers and workings, its invitation, implicit or otherwise, to be a part of it all whoever you might be, it was the literal opposite of the opaque surfaces I saw everywhere else. And if you stood in the middle of the packed bar on the right night, you could look up and see Nigel Barrett, his face obscured by thick wet mud, his naked arse silhouetted by the blinding white lights, staring down at all of us; a maniacal manifestation of everything weird and grandiose and right about this delirious fever dream of a place.

2

In my mind and in my heart, Nigel and Louise remain the living embodiment of the Shunt Lounge: its apostles, its torch-bearers, its designated mourners.

Which is not to diminish the importance of other Shunt artists like Gemma Brockis, Hannah Ringham and David Rosenberg, who share its spirit in other ways and whose work I also continue to love. But there is something of the messy, subterranean spirit of the Lounge that finds its ultimate expression in Nigel and Louise and the wilfully idiosyncratic, endlessly unpredictable, fearlessly audacious work they continue to make.

Such audacity has always been the thing that excites me more than anything else in live performance: those acts of staggering chutzpah and swaggering wonder that go off like a firework or a hand grenade, dazzling you initially and then burned into your memory, recounted to friends and colleagues, recalled even years later with a half-smile and a shake of the head – the forest of real pine trees planted in a Wapping warehouse, the choir concealed by darkness for over an hour only to appear for a single minute of sublime harmony, the moment all the walls fall down, the moment the doors open and the light comes in, or the moment when the curtain rises and the orchestra soars and you expect all the spectacle and pageantry theatre can provide but what you get this time is nothing, silence, a single body stood all alone, floating in a wide ocean of stage. All the moments when artists, through stubbornness or arrogance or demented grace, have opened a window that I couldn't even see and made me feel like a child again, staring upwards in bewildered exhilaration at the world and all its infinite possibilities. I will forgive almost anything for a moment of theatre like this.

Nigel and Louise are far from arrogant, but they are stubborn and they definitely move through the world with a demented grace. They are willing to experiment when no one wants them to, embracing the possibility of failure in a way few artists actually do, committed always to the dream of creating something genuinely amazing, something that will amaze you. They believe absolutely in the power of grand gestures in confined spaces, in bewildering conceits of painful complexity undertaken on the tightest of rehearsal schedules, in ideas of sweet absurdity and borderline impossibility.

Nigel and Louise have always been concerned first and foremost with what is possible. Or rather, they are interested in the limits of possibility. If the Lounge was a laboratory built to test such limits, they were its weird scientists and even in its absence their work has the maniacal energy of a supervillain's lair or some giant steampunk robot; ornate and absurd theatre machines that we are literally invited inside of.

In *Party Skills For the End of The World*, for example, where they converted the labyrinthine basement of Shoreditch Town Hall into a literal workshop in which we could learn to pick locks, throw knives, start fires and make crossbows, or at their *The Festival of Adventures* in 2012, where primary school children visiting Redbridge Arts Centre in Essex were whisked through a secret door behind their teacher's back, entering an elaborate world of hidden experiences taking place in the normally forbidden

parts of the building before being safely returned to the theatre's classroom without the teacher even noticing they had gone.

Each show is a clockwork fantasia that functions like a magic trick performed inside out, with all the trapdoors and palmed cards and secret compartments proudly on display. In *The Body* the audience were wired up to heart-rate monitors and their own internal mechanics formed the soundtrack of the show in which a cavalcade of other mechanical bodies – tiny, immensely sinister wind-up dolls – swept across the small stage in a seemingly infinite collage of micro-scenes, each only a few seconds long but almost all of them astonishingly beautiful: a mechanical doll swimming endlessly in a tank of water; a microscopic camera reducing Nigel to a collage of colours projected on to the wall behind him; a doll sitting on a mound of sand while seaside holidays flicker in the background; the back wall of the theatre pulled away to reveal a vast warehouse full of dolls, at least three times the size of the entire room the rest of the show happened in, and in the centre of it a violinist playing, almost lost in this sea of artificial bodies.

I will probably remember forever that moment when the doors opened and the world expanded; its audaciousness, its ridiculousness, all these hundreds of tiny figures arranged backstage in a matter of minutes for a moment lasting mere seconds. It was not only beautiful, not only completely improbable, it was filled with an uninhibited, uncontrollable love of theatre and its myriad possibilities; their love definitely but also ours.

Dissecting, dismantling, lovingly breaking things apart and putting them together again to see how they work, Nigel and Louise are the people my childhood-self hoped I'd one day meet. They opened hidden doors onto secret rooms full of joy and violence and sex and chaos, onto a version of the city I wanted to believe in and a version of adulthood I hoped it one day might be possible to live.

(AF)

Further reading

The Shunt Lounge, a film by Susanne Dietz at vimeo.com

The theatre felt suddenly like a space. A space for uncertainty, for longing and curiosity

Ellie Dubois

I've been trying to work out when people first started using the phrase 'run away and join the circus' but the answer is proving appropriately elusive. It's unlikely to date back to 1770, when Philip Astley decided the 'feats of horsemanship' performances he held in his London riding school needed sprucing up, so introduced acrobats, aerialists, jugglers and clowns to bulk out the programme. It's a little more possible that it emerged in the early 1800s, as different circus companies started criss-crossing the settled parts of North America. Pursuing that thought, I wondered if it might have been coined by Mark Twain, but that search just sifted up the writer James Otis Kaler, whose story of Toby Tyler, serialized in 1877, features a ten-year-old boy who does indeed run away with the travelling circus. It's meant to be a cautionary tale. As if.

Circus doesn't behave. It evades authority, resists the rules of ordinary existence. And it embraces the unbelievable, dazzling the eyes of its audiences until everything we know about human bodies, gravity, mass, energy, motion, seems false.

I've been wondering how old Ellie Dubois was when she decided to run away and join the circus.

*

A woman's hand, chalky. Sequins, jewel-hued make-up. A dark room, a spotlight. The chill.

These memories of Ellie's work *Ringside* are incidental, mostly called forth by corresponding images in other people's writing. What I remember is the trapeze.

It hangs, mere inches out of reach. I am standing where the woman has led me, directly beneath the pole of it, no more glamorous in its material construction than a toilet-roll holder or broom handle. It hangs and if I stretched my body to its fullest extent it would still be a few inches out of reach. Could I jump? As in, am I allowed? As in, if I did, would my fingertips touch it? How would that feel? Frustrating? Electric?

I have never been particularly agile. My cartwheels are wonky and when I was a child my cousins mocked me for being too afraid to throw somersaults

over a pole in the playground. My mother was a gymnast until she broke her wrist and even now I sometimes think, if I just practised, if I just stretched each muscle in turn, with determination and care, if I lifted weights rather than bags of flour and sugar to make biscuits, maybe I too might be able to dart across the monkey bars and tumble out of a handstand. A dream that hovers, just out of reach.

The woman guides me a few steps away from the trapeze, stands beneath it herself. Stretches up her arms, jumps, catches its pole. Lifts herself up. I can see the strain in the muscles. The frown inside her eyes. She turns, hangs from her knees. These memories are incidental. What I remember is the leap.

*

There are some weird things I know about Ellie: weird in that I don't actually know her much at all, except through knowing her mum. I know, for instance, that she refused to sleep through the night when she was a baby – in fact, until she was four years old. I know she hated theatre well into her teens, because it kept stealing her mum away. I know she had her first baby in her early twenties, and got a dog at the same time, and absorbed both into her life unproblematically, whereas I, old enough to be her mother myself, struggle endlessly to figure out how these volatile pieces fit into the disjointed jigsaw of life. I know she had a horse for a few years, and that her mum wrote one of the best fairy stories I've ever read, from bedtime stories she'd previously weaved for her daughters. I think all of this has something to do with my wispish impression that Ellie is different to most people, a difference that feels like resistance.

The first time I met her, a shy slip of a teen, was at Forest Fringe, my first visit there. I felt nervous myself, and vaguely rattled (the way jealousy will rattle, both the feeling itself, and recognition that the feeling is ugly and pathetic) that Ellie had so quickly found a way to belong in this misbehaving space evading authority. It was the night Action Hero performed *Watch Me Fall*, a one-brow-raised dissection of daredevil entertainment and the stuntmen – mostly men – who execute it, which ends with a tragi-comic re-enactment of the kind of trick Evel Knievel would devise, only here instead of a motorbike hurtling itself over a queue of cars or Las Vegas fountains, Action Hero's James Stenhouse rode a ridiculous child-sized bicycle up a wooden plank, falling off in a heap.

The peeling back of a glamorous facade; irony and pathos; the relationship between daredevil performer and their audience; the skin and muscle and bone, so vulnerable, so easy to pierce, bruise and break, that go into a trick. I suspect *Watch Me Fall* was pretty formative for Ellie.

*

It took a tiny while for her to find her form. I remember another show at Forest Fringe, *I hope you never love anyone as much as I love you*, in which Ellie and her friend Kim Donohoe spoke of their guilty-pain love for country

music. There was something about line dancing and some anxiety about
how racist the country music scene is, but what I really remember are the
handstands. Ellie, in an act of self-punishment for this terrible misdeed of
love, throwing handstand after handstand, breath snapping short with the
effort, face growing redder and redder as blood flooded down into forehead
and cheeks, pooling beneath her scalp.

<p style="text-align:center">*</p>

Alice Gilmartin, red in the face, stands on her hands on two tiny platforms,
legs split over her head. She wants to talk to the audience, say hello, introduce
herself, but she just keeps being told to shut up and smile. Make yourself
look pretty, Alice. The audience are getting bored, Alice: can't you do
something a bit more complicated? Very good, Alice: now just lower those
legs a little more, contort that body even further, and all the while pretend
this is as easy as taking a shower. Smile, Alice. Smile.

There are two sets of words that chime like competing church bells in *No
Show*, directed by Ellie and performed by five female circus artists. In one set
are grace, elegance, beauty, gentleness, fragility. That's what's expected of
women in circus, and of women out in the world. In the other set are strong,
powerful, dynamic, professional. For men to be most fully those things – in
circus and, again, in life – women must necessarily be defined as none of
them.

The women of *No Show* will have none of it. They bring out a Cyr wheel
and detail meticulously its weight and how many bones it could crush if this
or that trick went wrong, if Camille Toyer or Lisa Chudalla weren't strong,
powerful, professional in performing with it. They're not po-faced about it:
the Cyr wheel is an object of pleasure. You can spin like a coin in it, whirl as
on a waltzer, and the more dangerous the trick, the more they enjoy it.

They don't bother describing the pain of hair-hanging: at this proximity –
and *No Show* is designed to play in a small room – the prickle of Francesca
Hyde's follicles is all too apparent. They're too busy having fun: Hyde's hair-
hanging routine becomes a delightful game of tag, the three performers gleeful
as they dance and skirt the water-filled tub that acts as her counterbalance. At
one point the five of them sit down and pass each other a fabric bag, from
which each woman extracts a plump, sugar-drenched doughnut. Which they
eat, licking at the oozing jam, slowly, with glorious relish.

There is so much in that moment: not least an acknowledgement that
grace, elegance, beauty, fragility, all that language of femininity, are also
expectations that fuel anti-fatness. *No Show*'s performers don't have
stretched-elastic bodies, like snip-snap Olympic gymnasts: they have ample
thighs and curved shoulders and muscles that thump and slap and make
them strong enough to somersault across the stage and spin inside a ring of
metal and balance each other's weight. In most circus, Kate McWilliam says,
female performers have to keep that strength, that power, locked up inside –
or use it only to give an impression of weightless, effortless movement,

gossamer as French silk tulle billowing. *No Show* rips away that veil and begins to make the dynamics visible.

And then, in a delicate final sequence, it doesn't. Michelle Ross is an aerialist, a specialist in the swinging trapeze, but this room is too small for such equipment. So instead of performing her best trick, as she might if money were no object and capitalism weren't the defining power in human lives and these women, these circus artists, could genuinely pursue their pleasures, Ross describes the routine and asks the audience to imagine how it might look. Her swing through the air, gaining speed. The hurl of her body around that broom-handle pole. The strength in her arms, holding the ropes; the power in her legs, gripping. Imagine. Just imagine.

<div align="center">*</div>

In Angela Carter's *Nights at the Circus*, the masculine foil to the female protagonists – a journalist called Jack Walser – declares: 'It's the ambition of every red-blooded American kid to run away with the circus.' I thought Carter might provide a scintillating description of circus, its gaudy colours and sawdust grit and heart-stopping feats of daredevilry, but what she gave me instead was this line, as fitted to Ellie Dubois as a spangled bodysuit:

Once the old world has turned on its axle so the new dawn can dawn, then, ah, then! all the women will have wings.

<div align="center">(MC)</div>

Alexandrina Hemsley and Jamila Johnson-Small

too complex to contain in a single image / too complex to reduce to one motion, one scene

marking or not marking the difference between

in the publicity for *Voodoo* Jamila Johnson-Small and Alexandrina Hemsley talk about the 'responsibility of being a single subject who is also a symbol of many long-persecuted people'

pulling away but the tension is /

their collaboration is multiple / contains multitudes / they inhabit and insist on multiplicity on being dancers who also write who also make film who also exhibit who also who also who also / dance like there's no difference between the stage and the nightclub and the house party

dance like there's no difference

multiple differences, coded into skin and limb, the body's curves and openings

multitudes too complex to contain in a single image

/ just like there wasn't one version of *Voodoo*, that work always in flux, each of the three different versions I saw an attempt at reconfiguring the power dynamic between performer (black) performer (mixed-race) and audience (mostly white), a power dynamic caught in a fishing net strung above the stage, scattered with tiny bones lost lives / and the scroll of dates and events detailing racism and persecution of black people hours and months and decades and centuries of it

feeding into *Black Holes*, Alexandrina's collaboration with Seke Chimutengwende, the way it played on the words dark matter

matter

dark

this matter

this skin or its perception

what darkness does matter

what matters

it matters when Alexandrina is groped by someone invited only to apply paint to her body in O / it matters when a reviewer (white, male) of *SWAGGA* describes performer Kay Hyatt as a 'hefty, pugnacious lesbian' and Alexandrina needs to email him patiently once, twice, to explain that words carry stereotypes carry assumptions carry offence (it matters too when he listens, and asks his editor to switch the word 'lesbian' for 'performer')

/ it matters when Alexandrina begins to question the word holistic and finds it was coined by a white man who condoned segregation / it matters when just one image is isolated as representative symbol from a body of work constantly shifting

between movement text dance image choreography collaborators minds

matter

dark matter

shifting minds

we mind that society is like this that culture is like this that even the small world of performance we move in is like this / we mind the use of we / we mind we read we absorb we think and we laugh l a u g h in O as lithe limbs writhe to the pulse of Zebra Katz's 'Ima Read', peeling back the rug to a pile of books / I see feminist classics / I see Simone de Beauvoir

and in writing this the wry read of 'Self' by Noname: come here with your objectifying eyes? you want to see what her pussy been doin/

/

 /

 /

and this is all too complex to contain in a single image

and yet this image, searing:

Jamila – performing as Last Yearz Interesting Negro – is trying to move forward. Her arms are moving (dance), her legs are moving (forward / dance), her mind is moving (/), but her body is tethered by a thick elastic rope and no matter how far she tries to move (forward /), leaning into the /

into the /

 into the /

it holds her back. The rope holds her back. The rope and everything it represents holds her back. And the tension is visible. Tension in the rope, taut, tight, holding. Tension in her body / arms / legs / her body slanting forward with the energy of trying to move, straining to move, t o m o v e but she can't. Locked in / locked by / just for a moment / no way to slip from the grip of

/ break /

this tension.

<div align="center">(MC)</div>

Further reading

A Contemporary Struggle, published by Live Art Development Agency
alexandrinahemsley.com
jamilajohnsonsmall.wordpress.com

PART 3

The company you keep

Deer Park

Made In China

Bertrand Lesca and Nasi Voutsas

Neil Callaghan and
Simone Kenyon

Action Hero

Deer Park

National Student Drama Festival

In my first year of university I was cast in a new play called *Like Skinnydipping* by the writer Chris Perkin. It told the story of a group of teenagers growing up in South Yorkshire in the 1980s and then returning years later to confront the traumatic disappearance of one of their friends. It was epic and feverishly ambitious, a dizzying mix of earnest yearning and knowing irony, each new scene written by Chris in an insomniac daze the night before we were due to rehearse it; home-made holocaust tattoos and buckets of vomit, fraught teenage romance, drinking, shouting, crying, Joy Division and Billy Bragg, a sex scene involving a prosthetic hand, a re-enactment of the attack on the twin towers and an act of spectacular self-mutilation using a prop gun and a bucket of fake blood, all taking place on an artificial hill made of real turf. I made a convincing thirteen-year-old in my cheap white shirt and school tie but was otherwise, I would quietly come to realize, not a good enough actor or a convincing enough northerner to do myself or the writing justice.

Nonetheless the show was selected to be part of the National Student Drama Festival that year and so, after a little bit of re-rehearsal, we packed our stuff and headed to Scarborough, sleeping two or three to a room in a tiny holiday flat in the centre of town. In its new home the show seemed much bigger than it had before, more showy and spectacular, but still at its heart as bruised as it had always been.

Perhaps somewhat unfairly for a student drama festival most of the people involved in our show, including Chris, the director Lydia and at least half of the cast, had already graduated from university at least eighteen months previously and so approached the absurdity of the festival with a degree of cool detachment. I, on the other hand, was enchanted. From the very beginning, as the various starry-eyed attendees gathered in the main hall to listen with unnecessary reverence to the opening speeches of the men (and it did seem almost exclusively to be men) who ran the festival, an intoxicating aura of supposed significance hung over everything like holiday

bunting. With nothing but our furious enthusiasm and access to a handful of local auditoriums, the students of the National Student Drama Festival built for ourselves a convincing simulacrum of the theatrical world that we all longed to be a part of. Even some sixteen years later, no one I have ever met has taken theatre as seriously as the people I met at the National Student Drama Festival. There were post-show discussions that stretched on for hours, mornings spent sitting in greasy spoon cafes awaiting the release of each day's festival newspaper, swordfights on Scarborough beach with lurid yellow plastic sabres.

But more than anything else I remember a show by a company called Deer Park.

Dartington

Deer Park came from Dartington College of Arts, though at the time I had no idea what or where this was.

As much as I can understand it, having never been there, Dartington was a kind of art school version of Hogwarts located on a remote country estate near Totnes, with the wide open spaces of Dartmoor to the west and the English Channel to the east. Its remoteness was part of the point, created as it was with the aim of being a kind of self-contained educational experiment with its roots in the bohemian escapism of the Bloomsbury Group and its foundations in the soft, boggy soil of the Devon countryside.

The performance programmes at Dartington specialized in what might in its simplest terms be described as postdramatic theatre. A kind of non-narrative performance that emphasized visuality and movement, in which text, image and action accrete in abstract and fragmentary layers; not exactly scripted but not unscripted either, not exactly theatre but also not *not* theatre. Yet this does not begin to describe the distinctive yet intangible quality of so much of the work I have seen by artists who studied at Dartington.

Perhaps it is a certain kind of flat, affectless demeanour; words of solemn, loaded simplicity spoken into a microphone with the knowing irony of Droopy the dog. Or perhaps it is a way of moving, at once casual and deliberate, ordinary and unreadable, seemingly always waving and drowning at the same time. Perhaps more than anything it was the remoteness, a geographical detachment that has hardened in the work like a fossil hardening inside a rock. So often when I have seen a show by a company from Dartington, I have had the feeling that what is happening in front of us in the theatre is also always at the same time happening elsewhere, on Dartmoor maybe or some windswept headland, for an audience of precisely no one. It is a kind of *danse macabre* that follows its own ineffable logic, forged not at the Dartington College of the mid-2000s or even the Dartington Hall of the 1920s, but that is instead connected to some much older understanding of what performance is and what purpose it serves.

Without knowing any of this, Deer Park still seemed to me to arrive at NSDF like a flock of rare birds alighting through an open window, so far removed were they from the clumsy networking and vaulting ambition of the rest of the festival.

See You Swoon

The show Deer Park were presenting at NSDF was called *See You Swoon*. It took place in a gymnasium on a university campus on the outskirts of the town. I walked there in sunshine with the rest of the *Like Skinnydipping* cast, knowing essentially nothing about what we were about to see. The stage was a bare rectangle of gymnasium floor decorated only with a series of pot plants that were moved at regular intervals throughout the show for no discernible reason. The show had something to do with Stendhal's syndrome, the phenomenon whereby the beauty of a work of art is so overwhelming it causes the viewer to faint. In truth I remember it less as an actual show and more as a series of images floating in oblique relation to one another, which might be due to the many years that have passed since then but equally might be just what the show was actually like.

A young woman in a neat school uniform repeatedly threw herself to the ground. A swoon. Arms flung in the air and her legs crumpling underneath her.

Different members of the cast, all wearing the same school uniforms, came forward at different moments to speak into a single microphone, their various European accents adding to the sense of dislocation.

Only one character was not wearing a school uniform and he was dressed as a cowboy. And this may not be true but I seem to remember that we spent a lot of time afterwards trying to interpret what this meant, what it signified, but when we asked Deer Park themselves why he was dressed as a cowboy they simply told us that they couldn't find a school uniform big enough to fit him.

At one point towards the end of the show I remember there was a video of the sea projected on the bare gymnasium wall, its blue ripples half blending in to the uniformity of the bricks. And perhaps music was playing, and they all stood, a half dozen or so people in school uniforms and a single cowboy, both in and out of this rippling water. Everything was very still and somehow this simple image was, is, one of the most beautiful things I have ever seen.

Though it is hard to remember this being the case, I think at times I was bored. Undoubtedly at times I was confused. Nothing that was happening seemed to fit a legible pattern. It refused easy interpretation. Roughly eight years of English literature and precisely zero years of postdramatic theatre had left me ill-equipped to deal with its opacity and its illusiveness, with its seductive, enchanting remoteness.

At the end each audience member was handed a little brown book, or perhaps we had to pay a little extra for the book, I can't remember. The book was not a programme, more an extension of the show itself, made up of delicate little diagrams and a series of quotations from people like Dostoyevsky printed in neat small letters and arranged carefully on each otherwise empty page. One of these quotations read:

This is more the expression of a longing than an account of what is actually happening

And when I read this something in me lifted.

I had always imagined theatre as a communicative medium, ideas encrypted in words and bodies, waiting to be deciphered by the audience, whose ability to do so more or less defines their enjoyment of what they are watching. I treated the experience of going to the theatre like those acts of close reading I had learned to undertake at school, brow furrowed, nose pressed up close to the page.

Seeing this show and then reading that single line, it felt to me like someone had opened a large window, revealing the page in front of me to be perhaps the least interesting thing in the room. Instead the theatre felt suddenly like a space. A space for uncertainty, for longing and curiosity, a place for images of ineffability to be encountered without needing to be deciphered. All of which is not to say that thinking about theatre suddenly seemed redundant, rather that thinking became something we did together, artist and audience, picking our way delicately through a shared forest of questions and desires.

That one phrase changed the way I look at theatre, and as a consequence the way I make it, for ever. I took the book home with me and put it in a drawer.

Traces remain

As far as I know, Deer Park made one or maybe two more shows after *See You Swoon* and then went their separate ways in 2008. That same year Dartington College of Arts became a part of University College Falmouth, and only two years later the last of its programmes were cleared out of Dartington Hall, packed up in boxes and transported to the main campus in Falmouth.

Yet despite the years that have passed since, there are traces that remain.

The memory of Dartington, the peculiarities of its geography, the idiosyncrasies of its approach, persist in the work of its graduate artists who are still making work today. Artists like Lone Twin, Jo Bannon, Verity Standen, Living Structures, Rachael Clerke, Tom Parkinson, Ivor MacAskill,

Martin O'Brien, Neil Callaghan and Ria Jade Hartley. They carry its influence with them and they in turn influence others who encounter them.

To untangle all the trace elements of Dartington's ineffable remoteness that thread their way through the contemporary performance landscape would be an impossible task. At Forest Fringe, for example, the influence of Dartington was visible in a variety of explicit and implicit ways. In performances by Dartington graduates like Jo Bannon, Tom Parkinson, Verity Standen and Augusto Corrieri, one of the members of Deer Park who I first saw as a nineteen-year-old in that Scarborough gymnasium and then met again almost exactly a decade later. Perhaps most profoundly the presence of Dartington was tangible in the performances of a company called Tinned Fingers, whose delicate, disarmingly clever work was a regular feature of Forest Fringe in its earliest years and undoubtedly helped define the texture and character of the place, to the extent that one member of the company, Ira Brand, is now one of Forest Fringe's co-directors.

Like Deer Park, Tinned Fingers existed for a relatively short amount of time, five or six years perhaps, three or four shows, but the influence of both companies on my own work has been immense.

When success in theatre is so often measured by longevity and the seeming pursuit of perpetual growth, it feels almost radical to celebrate those companies who, out of choice or necessity, refused this trajectory. Companies who existed for a few years and then simply stopped existing, without fanfare or lifetime achievement awards or any kind of great last waltz. Companies who created small, beautiful things of outsize influence, cherished by those that were there much more than other more well-documented work. Companies like These Horses and Mapping 4D, or Present Attempt, or Me and The Machine, or Stoke Newington International Airport, or The Special Guests.

Their traces all remain. As abandoned WordPress sites and Tumblr accounts. As names in web archives and old programmes, in reviews and journal articles and the occasional mention in an academic text somewhere. But these are their least interesting traces.

Other remnants orbit more meaningfully but intangibly. As an idea seen and borrowed. Fragments passed by osmosis from one company to the next, from a gymnasium in Scarborough to a church hall in Edinburgh to a town hall in Battersea to the back room of a pub in Bristol. I remember Christopher Brett Bailey telling me about seeing the Present Attempt show *Life at the Molecular Level* at the Edinburgh Fringe in 2008 and how it had the same effect on him as Deer Park had had on me a few years earlier, exploding his notion of what was even allowed in theatre. This is where these companies will persist most profoundly, in these fleshy memories, illusive and unreliable. In the shape of a body or a movement. In an affectless tone of a voice or a way of framing a stage image just so. In the memory of the way she falls, arms in the air and crumpling to her left. In an expression of a feeling, or even a longing, rather than in the accounts of what actually happened.

The little brown book

In the course of writing this I wanted to check the origin of the phrase I had found back in 2003 in that little brown book from *See You Swoon*, so I did what anyone would do and typed it into Google.

It returned only three links. All three were links to my own website, each a different instance in which I had taken my half-remembered version of this phrase and inserted it into my own writing. Fuzzy traces of Dartington College of Arts floating in foreign waters.

Curious as to what the actual phrase might have been, I went to my drawer to get the book so I could check, but despite some thorough searching the book was nowhere to be found.

(AF)

Further reading

In Place of a Show: What Happens Inside Theatres When Nothing Is Happening, by Augusto Corrieri, published by Methuen Drama

Made In China

1

I moved to London in 2006, arriving into what appeared at the time to be some kind of war. This may have been true or it may have been my imagination. On one side there was playwriting, or 'text-based theatre' as it was frequently called. On the other there was the disparate range of practices that had become known as 'devised theatre'. In most eyes, devised theatre's most important feature was that it was not playwriting and therefore shouldn't have a script. This was often how venues described it and, for a time at least, it seemed the closest thing a lot of people had to a defining principle for it.

As far as I understand it, this seemingly unbreachable division hadn't existed even a few years before, when companies like Improbable, Ridiculusmus, Forced Entertainment and Complicité all devised work that was none the less predominantly text-based. I even had a copy of Methuen's collection of Complicité scripts, designed no differently from similar collections by Mark Ravenhill, Joe Penhall and Sarah Kane. But around the mid-2000s a more adversarial attitude seemed to be taking hold.

Young and loud and undoubtedly very annoying, with a very public platform on the *Guardian* website that neither my knowledge or experience really justified, I found myself frequently in intensely serious arguments with playwrights and playwriting companies in the years that followed. With hindsight, these arguments were nearly always defined by mutual defensiveness and I think a lot of insecurity about our future survival in what was then a brand-new era of austerity. Thinking and writing about it now over a decade later, after all the political turmoil, the revolutions, social transformations, climate horrors and global pandemics of the intervening years, the amount of time I spent worrying about all this seems like a memory from another world. But nevertheless we did worry about it.

At Battersea Arts Centre, where I then worked, producers talked quite openly about not accepting any script-based work. The building was teeming

with graduates from Dartington College of Arts, a lot of people who had subjected themselves to training under various notoriously mean French clowns, and various unclassifiable live artists, avant-garde musicians and alternative comedians. Punchdrunk were about to take over the building with a largely wordless dance-theatre adaptation of Edgar Allan Poe's *The Masque of the Red Death*.

But then, at the same time, there was the TEAM.

2

The first time I saw the TEAM perform was in a small studio theatre at Battersea Arts Centre around this same time, in spring 2007. They were there to present *Particularly in the Heartland*, their Edinburgh Fringe Festival hit from the previous summer. The details are hazy but I remember my heart feeling entirely full. It was a story about Kansas told with the kind of restless exuberance of nothing I had ever seen. I remember characters drawn with all the delicate, beautiful simplicity of a Charles Schulz cartoon, the wild collision of ordinary life and the self-mythologizing grandeur of American history, and perhaps most of all I remember these moments of exquisiteness when the stage shimmered with movement and energy and grace. It was and remains one of my favourite theatrical experiences of all time.

The TEAM describe the things that they make as 'theatre plays', a term which seems designed to emphasize not only the common theatrical meaning of the word play, but also play as a verb. Theatre plays, is playful, is a kind of playing. Play from the old English *plega* meaning brisk movement or the old Dutch *pleien* meaning to dance or leap for joy. To make theatre is to write plays but it is also at the very same time to dance around and leap for joy.

In a show by the TEAM these different understandings of theatre are beautifully synthesized. Their shows pivot from scenes of intimate domesticity to dazzling collective choreography to absurdist cabaret with a lightness and a playfulness that seems to understand such shifts of scale and of texture as the only way to tell the wildly complex, multifaceted stories they are trying to tell. For the most part the stories the TEAM want to tell are stories about America – stories that are as big and small, as comic and tragic, as beautiful and messy and contradictory as that vast, unfathomable place. They seem to recognize that words aren't enough on their own to describe it, that it requires a gestalt theatre of movement, action, dialogue and music; a theatre that combines rich textual detail and ravishing handmade spectacle.

Such a theatre is not easy to make. I once heard the company's artistic director Rachel Chavkin describe their process as one of 'radical inefficiency'. They work for years on each show, writing, researching, moving, devising; it is by all accounts physically exhausting and emotionally draining. Traces of their show *Mission Drift* could be found as far back as a fifteen-minute experiment they did at Forest Fringe in 2008, but the show itself didn't

arrive at the festival as a finished thing until 2011. In between I saw an early full-length work-in-progress at the Almeida which was brilliant in its own right but almost entirely discarded by the time the show was finished. Perhaps for this reason there is a kind of agony etched into each show, even as they are filled with seeming lightness and exuberance.

I don't think any American company, or indeed any current American playwright, has had as much influence on British theatre as the TEAM have. Not least because they seemed to anticipate and even to help bring about the dissolution of this temporary and arbitrary opposition between 'text-based' and 'devised' theatre. And a major part of this was to reintroduce the playscript into the world of independent theatre, opening up space for young artists who weren't playwrights but whose work similarly combined elements of new writing with more abstract, choreographic and musical elements. And for me there were two companies who seemed to immediately embrace this opportunity – one was Little Bulb Theatre and the other was Made In China.

I don't know if Made In China were directly influenced by the TEAM, but I do know that Little Bulb were. Both appeared at the Edinburgh Festival at around the same time, Little Bulb with *Crocosmia* in 2008 and *Sporadical* in 2009 and Made In China with *Stationary Excess* in 2010 and *We Hope That You're Happy (Why Would We Lie?)* in 2011. These shows were all theatre plays in the TEAM's mould, involving extensive use of a written text as one part of a larger assemblage of theatrical elements. But whereas Little Bulb seemed to embrace the most harmonic, joyous and perhaps wistfully melancholic elements of the TEAM's work (not least their love of the music of Sufjan Stevens), Made In China embodied all its most agonizing, prickly and furiously dissonant elements. A theatre that didn't so much synthesize text and performance as set them at war with one another.

3

This is probably already obvious, but nothing about the company Made In China is actually made in China. Tim is from north London and Jess is from Connecticut, by way of New York City. They met at Goldsmiths, Tim on the playwriting course and Jess studying performance. From the beginning Made In China was a company born out of the distance between these two programmes, and an attempt to see what they could make from that distance.

The name Made In China refers to the statement of origin frequently found printed on the label of a cheap T-shirt or the bottom of a novelty mug. It is a mark that denotes mass-produced ubiquity and the excesses of globalized capitalism. As the name of a theatre company it might suggest a kind of kicking against an expectation of theatre as refined, genteel and culturally sophisticated. To claim to be Made In China is a statement of intent; it is, as another adopted New Yorker, Claes Oldenburg, once put it,

to be 'for an art that embroils itself with the everyday crap and still comes out on top'. Made In China swig Budweiser and dance to David Bowie and Kanye West. They talk about facial regimes and social media celebrities. They wear sparkly hot pants while dreaming of Celine dresses.

But I think there is also more to the name than the kind of pop-culture fixation that is now a commonplace part of much contemporary performance. To name yourself Made In China is to draw attention not just to the kind of mass-produced plastic crap that we stereotypically associate with the phrase 'made in China', but also to the process of its manufacture, and perhaps to the ways in which theatre is not quite as different from those processes as it would like to think itself.

Just as it does with so many other elements of our lives, the shadow of the factory shimmers in British theatre's bones. It is there in the workshop, in the R&D that happens there and the 'new material' generated by doing it. It is there in the script and its role as a blueprint, determining the shape and pattern of the final product, and in that blueprint's assembly by a team of labourers, learning and performing a series of circumscribed and endlessly repeatable actions under the watchful guidance of a supervising director. It is there in the way theatre commodifies performance, transforming the unpredictable and the intangible into a quality-controlled product, user-reviewed on a five-point scale.

And whereas most theatre chooses to look demurely away from this reality, Made In China, as their name might imply, are defiantly fixated on it. In their shows the script and its whole attendant theatrical apparatus act upon the bodily autonomy of the live performers with a kind of mercantile sadism. Jess is trapped on an exercise bike, or she is trapped on a raised platform, or she is trapped inside a two-metre-square cube, never able to leave the stage. Ringing bells and booming musical cues interrupt the story to demand that she and her occasional co-performers engage in bouts of repetitive dancing, or other abstracted physical actions: chugging beers, swigging champagne straight from the bottle. There is an effortfulness to all of this that makes explicit the labour of performing, night after night, at the whim of some malevolent authority. In *Gym Party* a voice over a loudspeaker literally instructs the performers what to do and when to do it.

The discord is partly the point. The interruptions, the repetitions, the simmering tension between the performers onstage and the work they are required to do. It is as if the script can't help but draw attention to itself, to the power it has over the bodies onstage. Or, really it would be fairer to say that Jess and Tim repeatedly draw our attention to this power, the cartoonish cruelty of their own shows serving as a way to slyly ask the question: is all theatre not actually like this? Do its better manners make its power over the performers' bodies any less violent?

Meanwhile Jess and her fellow performers smile and make the best of it, peering out into the audience with looks of swallowed despair, breathing deep breaths, carrying on and on and on.

These are shows about the exercising of power, in which the subjugation inherent in theatre is used to stand in for the subjugation we might experience in other more real situations, and in which those other situations in turn inform the way Jess and Tim speak about the theatre. Perhaps the best example of this is *Tonight I'm Gonna Be The New Me*, in which the character of Jess (the performer) performs a script written by her partner Tim (the writer). Jess seems to bristle at the words he has written, narrating some humdrum story of their life together, humiliating Tim by demanding he go and fetch her a beer and fantasizing at length about his death in a far-off country – and yet, of course, all the time it is made clear she is still just following the script he has apparently written, once again doing what he wants her to do. Her interactions with the audience mirror her own situation, telling them the answers they must give to the questions she asks them. This is all a power game, but one she seemingly can't win.

And all of it is made all the more fraught by the knowledge that Jess and Tim are indeed a couple, and that Jess is primarily known as a performer and Tim as a playwright. But who really wrote this script, and who is performing it – Jess or 'Jess'? Perhaps the show is a metaphor for the cruelty and the conflict in their relationship, or perhaps they have reshaped their own lives into a metaphor for the cruelty and conflict in the relationship between a writer and a performer. Either way something crackles, a fury, a resentment, a defiance; an inexpressible, uncontainable truth buried in layers of elaborate artifice.

4

I think for Made In China something was resolved in the doing of this show. Some kind of catharsis. Immediately after it they made a children's show for the Unicorn Theatre that was just as sly and delightfully extreme but without the undercurrent of venom, and after that they made *Super Duper Close Up*, a show still full of anxiety, anger and a ruthless dissection of power in the art world, but with constituent parts that seemed to move with a new fluidity, a frictionless synthesis of music, movement, gesture and a turbulent river of words. It is as if having explored the outer limits of the kind of choreographed conflict that structured their previous shows, they decided to do something very different, finding another equally compelling way of telling the same story.

Perhaps this change also speaks to the fact that theatre in the UK has itself changed so substantially in the decade they have been working. *Super Duper Close Up* was commissioned by the Yard Theatre; it was followed by a festival of dance and live art which in turn was followed by a production of Arthur Miller's *The Crucible*. At Battersea Arts Centre their recent commissions include a beatbox adaptation of Mary Shelley's *Frankenstein*, an immersive noise performance by Christopher Brett Bailey and a new

show by Little Bulb. The last time the TEAM came to London they performed at the Royal Court. Meanwhile about a thousand new theatre companies have seemingly emerged from University of Warwick, whose sophisticated text-based devised work bears not a trace of the arbitrary divisions that once seemed so important to me.

And I think this is at least in part due to the work of Made In China. Just as the TEAM made space for them, they in turn have made space for others. Space forged from conflict and frustration, from power games and a dramaturgy of relentless interruptions, from the gap between devising and playwriting and the gap between the two of them, between Jess and Tim and 'Jess' and 'Tim'.

(AF)

Further reading

Super Duper Close Up, by Jess Latowicki and Made In China, published by Oberon

Bertrand Lesca and Nasi Voutsas

A Greek guy and a French guy walk into a theatre . . .

Since it sounds like the start of a joke, why not play it for laughs. Sweet talk the audience. Hell, why not even share a bag of sweets? That's how Bert and Nasi begin their first show, *Eurohouse*. Early in their second show, *Palmyra*, they float sort-of flippantly, but also sort-of elegantly, on four-wheeled flat trolleys, an absurd skateboard ballet to the alabaster strains of classical music. Crashing just occasionally.

Bert and Nasi, so civilized with each other. The epitome of civilization.

A Greek guy and a French guy walk into a theatre in the summer of the UK EU referendum, a year after the Greek bailout referendum. They are friends, if somewhat unequal friends: Nasi the Greek shoulder-hunched and hangdog, Bert more assured, debonair, suave. I'm nonplussed by the beginning of *Eurohouse*, to be honest, because they're just two white guys goofing about and I'm not sure what I'm getting from this. And then the bullying starts. Whatever Nasi wants to do, Bert says no. Whatever Nasi doesn't want to do, he does anyway, because Bert – well, what would Bert do to him otherwise? Does it matter? He has arrogant self-conviction; all Nasi has is abnegation and anxiety.

In *Eurohouse* Bert and Nasi's national identities are at stake: they are countries sublimated, distilled to an essence. In *Palmyra* their connection to Syria initially seems more tenuous. Bullying makes a common thread, violence psychological and physical. A china plate lies broken on the floor: I thought it might relate to the Greeks' bombastic practice of smashing china when dancing, but it works instead as a metaphor for the thoughtless destruction of everything that is beautiful about human cultural history through the escalated violence of unnecessary war. From one plate to two plates to a whole cardboard box of shattered china. Who exactly is responsible? Nasi seems so defiant at first but it's hard for him to uphold that front when a hammer's being brandished in his face.

There is a sick feeling in my stomach as I watch this fight unfold, and partly it's because the aggression is repulsive, but it's also because I'm finding

it gripping. Even more so in *Eurohouse*, where the force is all mental. Fleetwood Mac's 'Go Your Own Way' plays and Nasi dances and Bert's whole body is taut as a whip demanding that Nasi does it again, and again, and again. I think back to the Greek referendum and shudder. I think back to the UK referendum and I didn't vote to leave the EU, but a part of me really wanted to, because I loathe that structure of dominant power, that masquerade of equality.

A Greek guy and a French guy walk into a theatre . . .
 and I think it's a real question, now, of what it is to inhabit or – depending on the stance, the swagger – wield a white male body in public space. How do you comment on the problems of the patriarchy and capitalist supremacy forged in your image without contributing to those problems?
 Bert and Nasi are attuned to this. They inhabit the symbiosis of aggressor and victim the better to comment on its insidious presence in relationships interpersonal and international. Bert makes intimidation funny, comical, not to slough it off or make excuses for it but to implicate everyone in its orbit. Because pretty much everyone is complicit in oppression somehow. No, you don't want this, you probably didn't even vote for it, but it's all being done in your name. Your power is their disempowerment. Scapegoat if you dare.
 Eurohouse is 'about' the EU crisis and *Palmyra* is 'about' the Syrian civil war but what Bert and Nasi are really about is the problem of entitled masculinity: its uncurbed violence, its tendency to destruction, its refusal to let go its arms. It has and will destroy individual lives, it has and will destroy civilizations. It wields a hammer and it wields words and it is implacable, merciless. There's a scene in *Eurohouse* in which Bert demands that Nasi return the sweets that Nasi has already eaten. That violence of masculinity that wants the very insides of you, that wants to lay claim to everything you own, body and soul.
 And that 'you' includes white men too. Chewed up by the system made in their image, made to bend, crawl, bleed, again, and again, and again.

A [insert nationality here] guy and a [insert nationality here] guy walk into a theatre and . . .

(MC)

Further reading

'Can't we just bottle this up and keep it?': Bertrand Lesca and Nasi Voutsas in
 conversation with Kate Wyver, published at exeuntmagazine.com

A space in which
to rage, yes, argue,
yes, confront,
yes, but also
care, speculate,
listen, think

Neil Callaghan and
Simone Kenyon

April 2008

I am watching Neil Callaghan and Simone Kenyon at Battersea Arts Centre. It is April 2008 and Punchdrunk's *The Masque of the Red Death* has transformed the rest of the building into a labyrinthine universe of velveteen opulence and gothic wonder filled with masked audience members pursuing handsome actors down dimly lit corridors; but in this small black box studio a more ordinary world persists. Neil and Simone stand facing each other at opposite sides of the small room, the only sound that of the Punchdrunk show's doomy soundtrack bleeding through the walls. Nothing much is happening but I am watching with rapt attention, transfixed by a single cotton thread stretching from one side of the room to the other, from Simone to Neil, suspended between them like a tightrope, anchored at one end around Neil's teeth and at the other through the piercing in Simone's ear. As the thread tautens, I can see the slight pull it makes on the soft flesh of Simone's earlobe, a movement so delicate as to be almost unnoticeable, and yet I can't take my eyes off it.

This show is called *To begin where I am. . . Mokado* and my memory of what else happens in it is a little hazy. I remember a longing and a kind of ecstasy. The guileless charm and arch goofiness of a Wes Anderson film. I remember Simone dancing a lightning dance from her primary school, a dance of frantic energy and joy, spinning across the small stage in her home-made lightning costume. I remember at one point Neil not being there, hearing his faraway voice through a phone rigged up to a microphone in the theatre as he ran down the street away from the venue, hammering on his drum like thunder, shouting back descriptions of the distance between us.

Everything is airy and uncontainable, these swirling images moving around and away from one another. Thunder and lightning; parts of a single whole separated by the cruelty of distance. And at the centre of it all this moment with the thread: how it held them together while containing inside

itself the threat, perhaps even the anticipation, of so much pain. Ripped flesh and pulled teeth. The fragility, the precarity of being bound to each other in this way. To my twenty-four-year-old self, this is what love looked like. What it felt like: precarious, uncertain, ecstatic and agonizing. Stood close together, trying to be heard over the sound of somebody else's party.

December 2016

It is eight years and eight months later and I am watching Neil Callaghan and Simone Kenyon again, this time at Somerset House in central London. It is a wintry Saturday night and outside people are ice skating in the building's grand central courtyard. Once again, we are sequestered away in a small room in a hard-to-reach corner of a much larger building, this time as part of a three-day event to celebrate and reflect on ten years of Forest Fringe. Throughout the day there have been talks and conversations but now the chairs have been pushed aside and the fifty or so people in the room are stood in a circle to watch Neil and Simone's *Someone Something Someone*.

We watch as over the course of twenty-five wordless minutes Neil and Simone carefully collapse in on one another, first standing face to face, then leaning gently forwards until gravity and momentum draw their heads together, forehead pressed against forehead, then shoulder against shoulder, supporting each other's weight as they slowly move from standing to lying prone on the floor and back again; this single shared movement constituting the piece in its entirety.

It is a calmer dance than eight years previously. There is no shouting, no banging of drums, no running down the street. It is not a dance of thunder and lightning, of sparks and frantic, fearful energy. It is a dance of earth; of resistance and erosion and compromise. Whereas nearly a decade earlier they had imagined themselves a single body broken apart, here they are two bodies colliding with the gradual insistence of geology. A tectonic shift; disparate forms, moving towards, into, onto, over one another, finding an unsymmetrical equilibrium, a new shape entirely of their own.

This is not a dance of precarity. Instead this is a dance of patience and commitment. A careful balancing act, made up of tiny adjustments of feet or arms, of effortful labour, of heavy breathing and gritted teeth, of months, probably years, of rehearsal. In all these ways the history of these bodies and their relationship to one another are written through the dance like the layers of rock through a mountain. It speaks of time and distance, of duration, of the quiet, everyday work of holding things together, of holding each other together, of learning the weight of one another, which grows both easier and harder over time.

All of which is to say that perhaps this too is a show about love.

(AF)

Further reading

Someone Something Someone, a film by Simone Kenyon and Neil Callaghan at vimeo.com

Action Hero

It's raining outside. I'm on a delayed train from Cambridge to Norwich, observing the landscape of my childhood as it trundles by at a provocatively slow pace. Flat brown farmland and a slate grey sky. The skeletons of half-built greenhouses. Squat ponies huddled together against the rain. A white van lying on its side in a copse of trees. Fenland gothic. The Wild East.

The screen saver on my computer is a picture of the Ozarks in Missouri chosen for me by an algorithm. Men on horseback are crossing a wide shallow river. Autumnal yellows and greens glitter in the sunshine and an ethereal mist floats above the water. The men carry ropes and little packs behind their saddles; a couple of them are wearing cowboy hats. The landscape feels vast but in a very different way to the undulating fenland out of the window. It is rich and golden, widescreen and technicolour, a landscape in search of its own string arrangement. A place we are supposed to dream about while commuting through our more prosaic realities.

In their work as Action Hero, Gemma Paintin and James Stenhouse are always describing landscapes. In their early work these are often American landscapes – canyons, waterfalls, the lovers' lookout on the hill above a small town – and while the characters that populate these landscapes are often intentionally little more than silhouettes, the landscape is always painted in vivid colour. In *A Western* they describe a nameless cowboy moving towards us and we imagine the red rocks of Monument Valley or the verdant peaks of the Sierra Madre. In *Watch Me Fall* Gemma stands on a chair and holds her hands in the air, waving and shouting her thanks for our support as if trying to be heard across the thundering expanse of Niagara Falls. A few seconds later she will be deluged in Coca-Cola, a foaming, chaotic waterfall in miniature.

Such fantasy landscapes sit alongside real places navigated in real time, journeys that unfold at the pace of life itself. A walk from Newcastle to Kielder Forest to the house where James grew up in remote Northumberland or, in *Oh Europa*, a six-month-long journey across Europe recording ordinary people singing love songs, leaving behind them a series of radio beacons at the continent's furthest reaches. Each beacon is represented on

their website by a short video of the surrounding landscape. In Nordkapp the mist rolls slowly across the grey Arctic sea. In Llivia there is still snow on the mountains. At Hadrian's Wall there is nothing but empty blue sky and gently rolling hills.

Perhaps these two very different kinds of landscapes might be thought of as the first of several important dualities that underpin Action Hero's work. They are a means Gemma and James use to draw a line between the vivid unreality of fiction – of cinema, television, even theatre – and the gentle banality of life itself. Between a world we create for ourselves and the world we have no choice but to live in. When I watch them perform, I can see them feeling for the tension in that line and then, with great care and a certain amount of flair, dancing across it. Tightrope walkers suspended over a waterfall.

* * *

It's dark. I'm sitting at the computer in the witching hour of the night, my favourite time to write. Everyone else asleep, slipping into the romantic image I have of myself as a compulsive writer, rather than the blunter truth, that I procrastinate too much and fritter time excessively. Sentiment and cynicism, my favourite of the dualities underpinning Action Hero's work.

What draws me into the landscapes they imagine is a recognition of, or nostalgia for, the landscapes of my childhood and adolescence. Not the immediate scruffy landscape of inner London but the mostly American landscapes received through the television: via the Western films I watched with my dad; the daredevil nonsense – whether *The Dukes of Hazzard*, *The A-Team* or the antics of Evel Knievel – that I watched with my brother; the screwballs and weepies I watched with my mum; and the teen movies I hoarded for myself, drifting from John Hughes to John Waters, waiting for life to begin. To watch Action Hero is to grapple with my cultural upbringing, to look again at the messages I absorbed from it, sift the truly radical from the surreptitiously conservative.

If I close my eyes now I can see that lovers' lookout, there on the hill above a small town, and I can see the rooms I was in when Action Hero conjured it. One time it was in a community centre in Edinburgh, another time in a brightly lit gymnasium in Preston, another time in a converted town hall in London. These were the venues I happened to see *Hoke's Bluff* in, and between the first time and the second something happened to that show, and to me as its audience. Maybe it's that James and Gemma stopped looking at their characters from the distance of imagination and let themselves fall in love, which meant I could too. Soon after that first time, James wrote on hope and cynicism:

In the same way that I feel like cynicism isn't necessarily the most effective way to grow creative ideas, perhaps cynicism isn't the best way to grow political ideas, or alternative ideas, or radical ideas. Perhaps we're really missing a trick when irony is our default or when we shrug our shoulders

and sneer at the sentimental folks peddling these sincere stories because the power of those stories is very real. Terrifyingly real in fact. Perhaps by acknowledging the role sentimentality and hope are playing in our culture instead of dismissing it we can navigate our way towards a better narrative than the cynical dismissal of anything that dares to dream.

But there are dreams sincere and hopeful in character and then there is the Capitalist Dream, one co-opted by the other. The tension between them informs so much of Action Hero's work.

* * *

You sent the last section of this essay to me in an email on 3 March 2019 at 23:21. We've skipped forward now. It's light outside and deceptively calm. If this were a film there might be a caption across the middle of the screen that read 'The next morning' or 'March 17' or 'One year later'. I started by thinking mostly about place but now I would like to think more about time.

Action Hero think very carefully about time. They have made conventional hour-long shows and they have made shows, like *Slap Talk* and *RadiOh Europa*, that are much, much longer. Twelve hours long. Twenty-four hours long. Time stretching out, reaching beyond any frame of representation. Within these wildly varying durations, they play with time in interesting ways – telescoping together different eras and ways of experiencing time through re-enactment, recitation and loving homage. Like you, whenever I watch an Action Hero show I am often in two places at once, existing at once in the comforting forever of childhood and the cruel relentlessness of the present.

Also like you I remember the converted town hall in London where Action Hero summoned that lovers' lookout. That show, *Hoke's Bluff*, is the story of a year in the life of a high-school sports star and his cheerleader girlfriend distilled into ninety breathless minutes, with James and Gemma playing every role, like an episode of *Friday Night Lights* written by Thornton Wilder. Gemma and James in red and yellow school sports uniforms, wrapping their awkward English tongues around languid American words. A big Hollywood story told, as you say, with love and without cynicism.

I think one of the main differences between cinema and live performance is that a film is made of fragments that we are responsible for assembling ourselves through the act of watching, whereas theatre is the opposite of this.

Cinema time is built upon two different kinds of mechanical illusion – the frame rate and the cut. The illusion of time passing at twenty-four photographs per second, and the illusion of a linear world stitched together shot by shot. And because in cinema time is always an illusion, it is also ageless and infinite, like the memory of a perfect childhood summer. Inside a film time can be anything, but the mechanics that sustain that illusion are still shaped by the clock-time of capitalism. As Jonathan Crary states in his book *24/7: Late Capitalism and the Ends of Sleep*: 'There are now very few significant interludes of human existence (with the colossal exception of

sleep) that have not been penetrated and taken over as work time, consumption time, or marketing time.' Cinema is no exception. It is a realm of fantasy that was long ago taken over by the logic (and the managers) of capitalism.

In live performance, on the other hand, there is no easy escape from the passage of time. We are aware it is passing in the same way for everyone in the room. We are all here in the real world, subject to the politics and the economics that circumscribe that world. In live performance, rather than reassembling time, the audience are usually taking real time and imagining it into fragments; stretching it out and separating it up. Building months or even years from a couple of hours or less. Sometimes, as with cinema, this is done in such a way as to disguise the machinery that makes this fantasy possible. Sometimes, as in Action Hero's work, it is done to expose it.

There is a moment in *Hoke's Bluff* when James recreates live onstage one of those training montages that are an essential part of every sports film. With his gangly limbs poking out of his short shorts and vest top he does shuttle runs, he does star jumps, he does press-ups, he does more shuttle runs, he does squats. In the background 'Baba O'Riley' by the Who blares away anthemically, evoking the thousand similar montages it has no doubt soundtracked. In such films these montages pass so smoothly. Months sail by with frictionless ease. Our heroes grow stronger, braver, better. But here in this converted town hall James is only growing sweatier, slower and more tired. The apparatus appears to be failing, and yet at the same time his effort is still transcendent. He keeps carrying on and we are carried along with him. By the end he is lying on the floor and we listen enraptured to the sound of his unsteady breaths rising in the all-too-real air.

There are, as you say, dreams which are sincere and there are capitalist dreams, and often they are one and the same thing. I think what happens in Action Hero's work is that Gemma and James place their bodies on the line to separate one kind of dream from the other. Using their time and their vulnerability to drag sentimental fantasies into the harsh light of twenty-first-century capitalism, while still trying desperately to find some hope in them. To find longing to be good in the myth of self-improvement, the dream of a radical life in the fatalistic spectacle of the daredevil, the desire for communion in clichéd love songs. Even as they tear these stories and themselves apart, they are always looking for something to love in the fragments that remain.

* * *

That search for love starts with love itself. I never forget when watching Action Hero perform that Gemma and James are a couple, living and working together on a shared, mutual endeavour. I grew up with parents who tried and failed and tried again and failed better and finally successfully built their own business, which they worked in side by side, hour after hour, day after day, for years: it's left me with an abiding fascination with other couples who work together, especially as intensively as Gemma and James do.

But Action Hero work together differently from the way in which, say, Sleepwalk Collective or Made In China work together. In both those companies, I see the woman on stage, often sexualized or at least in a knowing (iara Sleepwalk) or troubled (Jess Made In China) relationship with her own sexuality, while their male partner is offstage, in some way running the show – he's written the script or he's composed the music or he's operating the lights or whatever. Even when I've seen Gemma and James do something vaguely akin to this, it was nothing like. In *Wrecking Ball*, the power dynamics between their two characters shift like sand in a storm: even if Gemma's celebrity character seems vacuous and easily dismissed at the beginning, she quickly unsettles and undermines James's supercilious photographer, the question always dancing between them of who is controlling whom. Otherwise they are perfectly balanced: both giddying the crowd as cheerleader and mascot in *Hoke's Bluff*, both skewering each other, giving as good as they get, in the traded insults, vitriol and threat of *Slap Talk*.

I find it really touching that, for most of the time we've been writing this book, Gemma and James have been trekking across Europe in a camper van, inviting the people they meet to record love songs. Years ago now you introduced the writer Rebecca Solnit to me, pointing me towards her book *A Paradise Built in Hell*, in particular the passage honouring 'other loves': loves that can't be described or contained within heteronormativity; social loves, charged by altruism and idealism and a desire for social engagement, often rendered invisible in an era dominated by entertainment and consumerism. What love it takes to leave home and comfort, drive for hours across unfamiliar terrain even after the gearstick is broken, and entice strangers into your oddball virtual community that accepts literally anyone, for simply the price of a song. What they render invisible through this project is borders: the borders of nations, of identity, of politics. Or rather, they shore up fragments of these things in song, against the ruins that would be made of humanity by capitalism and all its vicious dreamers.

We began speaking of tension but what Action Hero have moved towards is a synthesis, criticality and love, pop culture and social altruism, seeking balance in the world outside their relationship to match the balance between them. And this book is like the lovers' lookout where we stand beside them, surveying a landscape that is at once wreckage, nostalgia and constantly unfolding, rain-misted dream.

(AF and MC)

Further reading

Action Plans: Selected Performance Pieces, published by Oberon
'What's Love Got To Do With It?' in *The Twenty-First Century Performance Reader*,
 edited by Teresa Brayshaw, Anna Fenemore and Noel Witts, published by Routledge
actionhero.org.uk

PART 4

Fractures and how to mend them

Dan Canham

Sue MacLaine

Amy Sharrocks

Rachel Mars

Selina Thompson

Dan Canham

I am thinking about his hands. Hands that become waves, not waving but a
wave, an undulating flow, a squiggle, his hands are moving and the rest of him
is almost still, back to us, arms straight up above his head, the sleeves of his
dark grey suit jacket sagging down towards his elbows. Through his back I
can see his chest rising and falling with the exertion of the dance he is now
almost two thirds of the way through. The stage is empty save for a small table
and a chair. On the table is a portable reel-to-reel tape deck spinning slowly.

On the floor of the stage he has traced the outline of another theatre in
white masking tape. He did this carefully and precisely. Every time I watch Dan
Canham's *30 Cecil Street* I am newly surprised by how much of this already-
short piece is taken up with laying this tape, the marking of entranceways and
small flights of stairs, the way the tape always rides up over the table and onto
the back wall as if the footprint of the building it maps is too big for the space
allocated to it. This is an act of re-membering. The first of many.

I have seen *30 Cecil Street* over thirty times. This too is an act of
remembering. I am remembering his hands as he spins and shuffles through
the rooms he has imagined into existence. The stage has darkened now and
the voices on the soundtrack have been briefly replaced by a high-pitched
warble like a singing saw. He has his back to us, head down and arms in the
air. His hands are flat, palms down and pointing in towards each other so
that the fingers of his two hands form a line broken in the middle by only a
couple of centimetres of empty space. Slowly Dan arches his left hand
upwards, bending his fingers back at an unnatural angle, while curling his
other hand into a claw, all the while keeping the tips of his fingers pointing
at one another, no more than a few centimetres apart. The line has become
a squiggle. Slowly Dan reverses the gesture, so that his right hand is now an
arch and his left a claw. The squiggle becomes a slowly curling wave, rising
in one hand and falling in the other.

Everything else is still. The singing saw warbles. Dan's hands dance like
waves, like a puckering candle caught in some imagined breeze.

This gesture has its own history. It was originally part of a larger gesture
that Dan performed in a show by the company DV8, a delicate shimmy as

the hands moved from one position to the next. Dan took this fragment, isolated and extended it, turned it into something else entirely.

Before he made *30 Cecil Street* Dan was on tour with DV8. It was, from his descriptions, a punishing experience, physically and emotionally exhausting. When the tour was over Dan retreated to Limerick in Ireland, arriving in the wake of the Irish banking collapse and the subsequent economic downturn. Limerick was, and remains, one of the most deprived cities in the country, home to Ireland's most disadvantaged electoral division with an unemployment rate of over fifty per cent. And in the centre of this fraying city, at 30 Cecil Street, was Limerick Athenaeum, a former theatre, bingo hall, gig venue, art college and cinema that had been closed to the public for the past fourteen years.

His days suddenly full of nothing, Dan discovered this theatre and became fascinated by it. He interviewed local people about their memories of the building: music, wild parties, dancing, fights, sweat condensing on the walls. He found recordings of people who performed there. He explored its decaying interior, using it to make a dance film with his regular collaborator Will Hanke. In it, Dan moves in fractured spurts in the almost-darkness of a dusty corridor, his body hunching over like an ageing consumptive. Later he stands on stage in his old suit and stares out into the gutted auditorium.

In this dilapidated theatre Dan found a parallel for his own present circumstances. It was a building left bruised by overwork; exhausted from too many nights of too much dancing, now discarded and left to slowly disintegrate in isolation. Dan wraps his body around this building, and the building around his body. His documenting of its history is a hymn to dissolution and disillusionment, each fragmentary image from its glorious past an indictment of the similar way both communities and people can be allowed to fall apart through complacency and a lack of care. This is a wounded dance, angry and forlorn. It coughs and it shudders, now still, now suddenly jolted into life, a Frankenstein's monster hewn from bits of other people's melancholy remembrances. Amid these ruins Dan seems to ask the question of what remains when things become this irreparably broken.

What remains is this gesture, broken off in Dan's body like a bone spur or a bullet fragment. Dan remembers it, transforming it from the detritus of a time best forgotten into something new. Something bright dredged from the darkness, polished and made beautiful again. It seems almost to glow, as if his hands are animated by some external force, some accumulation of electricity they have collected from out of the dusty air.

Dan's hands move faster and faster and the wave becomes a waveform, like the undulating lines on an oscilloscope. He prowls in slow circles, his hands still a curling wave folding and unfolding above his head, a receiver scanning the empty room in search of the ghosts still residing there. And then, out of the murk a voice crystallizes, an old recording of a mournful baritone singing the W.B. Yeats poem 'Down by the Salley Gardens'.

In a field by the river my love and I did stand,
And on my leaning shoulder she placed her snow-white hand.
She bid me take life easy, as the grass grows on the weirs;
But I was young and foolish, and now am full of tears.

The sound is grainy, the melancholy voice as dusted with time and decay as
the theatre itself. As the singing comes into focus the speed of the gesture
gets faster, conducting the voice out of the dark and down into the room
around us.

In these moments the sound is not only a score for the piece, it is also a
text and Dan is not only dancing to it he is also dancing from it, acting out
the actions implied by the soundscape like reading words from a page. At
another moment he strides purposefully through the theatre, his own steps
perfectly synced to the recorded steps playing on the reel-to-reel tape, creaky
floorboards echoing in a room much larger than the one we are actually in,
and when we hear the sound of a forehead slamming into a doorframe
Dan's own body recoils in perfect sympathy. There is an uncanny quality to
these sequences, an explicit reference to the work of the composer John
Moran, but also reminiscent of the unwitting passers-by in John Smith's film
The Girl Chewing Gum. People remade as props, as vessels, machine parts
of a larger pre-destined whole; marionette figures caught in splintering loops
of time.

Perhaps here we might also intuit the influence of Punchdrunk, with
whom Dan worked on several shows, most notably as the titular character
in *Faust* in 2006. Their American gothic rendering of the Faust story within
the labyrinthine sprawl of a warehouse in Wapping has always been my
favourite of their shows, perhaps because it was the first one I ever saw but
also because I believe it is the Punchdrunk show where the form most
artfully fitted to the subject matter – a story of inescapable fate told through
the clockwork repetitions of a company of preternaturally beautifully and
restlessly energetic performers, all of them shadowed by small flocks of
faceless souls relentlessly pursuing them wherever they go. Maxine Doyle's
choreography always has an expressionistic figurativeness that slips easily
between literalism and abstraction; a romantic embrace that erupts into a
sequence of spins and holds, or a card game in which the players slide
elegantly across and around the table. But while it is frequently beautiful it
is also required to shout to make itself heard above the baroque realism of
the company's elaborately realized sets and the ever-expanding volume of
audience members aggressively squeezing round to watch. In *30 Cecil Street*
Dan is hemmed in by nothing more than the simple architectural lines he has
drawn around himself, enabling him to move with greater subtlety and more
precision between moments of uncanny literalism and sublime abstraction.

The effect is to allow his body to fade in and out of the memories conjured
by the voices and sounds on the accompanying audio track. When each
moment arrives Dan shimmers, a spirit medium suddenly gripped by some

haunted figure from the past, hauling it through his body and up into the present. And when the old man sings 'Down by the Salley Gardens' the room is dark but suddenly full of light, I can smell the spilt beer and the jostle and murmur of the crowd, feel the warmth of bodies, the cold breeze from an open window, see the shake of his hands, and the way he lifts his head to send the top notes towards the roof and heaven beyond it.

Like the gesture itself, these ghosts are remembrances reconstituted as something new. Fragments we have shored against our ruin. Dan composes them as an elegy for the dead, for what is gone and can't come back, but also as a possibility of renewal, a hope for redemption. I could watch this show thirty times more and never grow tired of it.

I am remembering now. It is 2011, the last year that we will run Forest Fringe in Edinburgh at its original home on Bristo Place. After a struggle that we knew we could probably never win, the building has been lost to developers and quite by coincidence *30 Cecil Street* is the last show that will ever be performed there in its current incarnation. I watch the show every night, often running the sound or the lights myself, watching Dan's triplicated shadow spiralling against the dirty white wall, beads of sweat twinkling as they fall, listening to the old man singing 'Down by the Salley Gardens'.

2011 was an indelible summer. It was the year of the Arab Spring and the Occupy movement. A year of fracture and fragile hope that less than a decade on seems already to belong to a different era. In Edinburgh we were drawn together in resistance to the loss of the building that had been our home for five years, in which we had built a kind of tentative community and harboured some fragile hopes of our own. An artist called Gary McNair was encouraging people to shred their own money, Sharon Smith and Tom Parkinson used sound and cheap wine to imagine a new way for us to exist together, Bristol-based duo Action Hero dismantled the lazy iconography of heroism and America, on the high street Tania El Khoury was redrawing her relationship to the male gaze and patriarchal control, and each night Dan Canham conjured an old theatre out of the ether for us. We lived together, virtually on top of one another, in an overcrowded flat in Newington and in the evenings together in bars and living rooms we wondered together what might come next.

What came next was that Dan came with us to London to perform *30 Cecil Street* at the Gate, and later to Dublin, and later still to Madrid. I broke up with my girlfriend and moved to Bristol, where Dan and his partner Laura lived. We saw a lot of each other in those years, talked about his next show *Ours Was The Fen Country*, about this strange and overlooked part of the country that we both grew up on the edge of. But things change. I moved back to London. Work with Forest Fringe and on my own projects took me to other places. Dan's own work continued to grow in scale and complexity, to find new spaces in which to live. This is what happens in theatre. People you live and work alongside at intense moments and in intensive ways inevitably move on to other things. The community you have built rearranges itself like the coloured pieces in a kaleidoscope.

As I write this Tania is in Lebanon. Sharon is in Berlin. Gary is writing plays in Glasgow. Action Hero have just been travelling across Europe for six months recording love songs from every corner of the continent. The world has changed irreparably, in ways that even if we had been older and a little less wilfully optimistic, we probably still never could have anticipated.

For now though I am remembering 2011. I am remembering Dan's hands, the shadows they cast on the wall. How in the blissful minutes between shows, when we were cleaning up or moving chairs or sitting together exhausted at the end of the evening, we would share our inexpert impressions of Dan's impossibly elegant gesture. We all do the hands. The gesture becomes a memory, a mnemonic; it is one of the fragments we shore against our own ruin. Against the disappearance of that venue and all the things Forest Fringe meant to us back then, the things it lost along the way. Against our own inevitable growing up and away. Against the slow untwining of our lives from each other.

Those hands, slowly moving backwards and forwards. Hands that become waves, not waving but a wave. A wave hello. A wave goodbye.

(AF)

Further reading

30 Cecil Street, a film by Will Hanke, Dan Canham and Laura Dannequin at vimeo.com

Sue MacLaine

shhhhhhh

[an ongoing struggle with language, with meaning, with the (im)possibility of representation, with the necessity of communicating clearly to you, who are reading, you, who haven't seen, you, who are piecing together a picture of an artist from]

shhhhhhh

[an intensifying struggle with speaking, with writing, with raising my voice, with wanting to be heard, wanting to be seen, wanting to communicate and to be understood, but not wanting to compromise: rejecting concession, rejecting convention, reaching beyond explanation, to a place in which – possibly – nothing makes sense]

shhhhhhh

[nothing makes sense in patriarchy, in capitalism, in white supremacy, the order of those words doesn't make sense, in that it implies a hierarchy, invokes a hierarchy, betrays the ways in which I encounter the world, and so encounter theatre, which represents the world, shapes meaning, but also recreates it, recreates its hierarchies, the hierarchies of patriarchy, of capitalism, of white supremacy, not necessarily in that order]

shhhhhhh

As a prime minister of the United Kingdom said, in the House of Commons, to a female MP five years his senior: Calm down, dear.

Women of a certain age are not meant to speak. Women of any age are not meant to speak. Women are not meant to engage in public life: they are meant to stay at home and cook the meals and wash the dishes so that men can shape the institutions within which public life is performed and the language in which it is enacted and then recorded for posterity. Woman as vessel of male desire: to command, to control. Women who do otherwise

can expect to receive threats of rape, death, bullets in the head, a knife to the heart. Just ask MP Diane Abbott. Just ask MP Jo Cox.

[shhhhhhh]

Sue MacLaine's *Vessel* took as its starting point the practice of the anchoress: a woman who would seal herself away from the world of men to live in solitary contemplation. Her cell was 'a site of intellectual exchange, spiritual progression and growth'. Much like the theatre space, in its ideal state: a vessel for human encounter, connection, transformation. Theatre as (quoting *Vessel* again):

fortified space

contradictory space

counter space

space to congregate for community

congregate for respite

congregate for shelter

Four women sit in a row. Windows high above, silhouettes of plants. The curving wall and floor of the set glows ochre, their soft dresses turquoise, olive, aquamarine. On each lap a book. The older white woman speaks from it first. 'Let's talk about who has the privilege of speaking first – about who is privileged to speak first.' Already *Vessel* is knowing.

One by one the others begin to speak, their voices overlapping, echoing, reinforcing, occluding, musicality attending to meaning, shifting the mode of attention. They speak less in unison than in difference, attending to the structures of the world: to 'patterns and purposeful language that sustains positions of power'. The words are written in the book and also projected on the walls behind them, enclosing them as they speak 'about enclosure and consolidation of holdings to establish absolute right of ownership', attending to the ways in which ownership of language means ownership of personhood and who is excluded from this and how, from that exclusion, that difference, it might be possible to start again.

They ask: is this just about the patriarchy?

[there is the privilege of speaking first and then the privilege of recording the words, of enclosing them in a book, and in that act creating knowledge. Sue MacLaine as a vessel for my voice]

They ask: what commands large-scale attention, what drifts by without so much as a glance?

[the review of *Vessel* that described it as 'wilfully obscure' 'and also pretty hard work'; the review that found it so 'profoundly frustrating' 'that after a while you begin to wonder why *Vessel* is actually a play'; the review that dismissed it as 'desperately tedious virtue-signalling with no passion or indeed content whatsoever']

They ask: can my pleasure be independent of yours?

[shhhhhhh]

Sue MacLaine's *Can I Start Again Please* is one of the most difficult works I've ever watched. Not 'difficult' in the common application of the word to any theatre – like *Vessel* – that refuses to be enclosed by character, plot, narrative conventions, that plays in a different way, with gesture and the language of the body, with tone and the geometries of speech, that finds its pleasure in thought, intellect, the political fusion of what is being said to how it's being communicated, which might not involve speech at all. *Can I Start Again Please* is difficult because of a growing sense of tension that penetrates deeper and deeper until the eventual revelation that the trauma being described begins with an act of sexual assault, a father penetrating his child, aged six, a father commanding silence: 'He said quiet. He said quiet and continued until I was no longer a daughter.'

The work thinks about silence, words, translation, interpretation, how a single word can mean (mean) more than one thing. It is performed by one person speaking English (when I saw it, Sue herself), and another – Deaf – using British Sign Language (alongside Sue, Nadia Nadarajah), the two bodies connected by a single scroll that unfurls between them, but also separated by languages that generate another tension, that of (not) listening and (not) speaking and using words in a wholly different way. British Sign Language shatters English into shards, rearranges its grammar for directness and clarity. In the published text, 'What do I have to say to make you listen to me?' becomes '[WANT+YOU] [LISTEN+ME] [HOW?]'. Or, 'We no longer have the right to remain silent' becomes '[ME+SECRET] (shake head) [MUST+INFORM] (keep still)'.

In *Vessel* – where the use of projected text, or creative captioning, is another invitation to d/Deaf audiences – the four women themselves are the shards: the shards that fly from a shattering not only of grammar but of 'social norms which masquerade as natural or the natural', a shattering that comes with 'knowing exactly what has been hidden buried submerged silenced', a shattering that represents 'a project for liberation' in which 'everything is political'. They take the

shhhhhhh

of shattering, the

shhhhhhh

of shimmering, the

shhhhhhh

of shards, above all the

shhhhhhh

of shouting, shouting, shouting, but with this

shhhhhhh

they are never actually shouting: they speak calmly, with resolution, with authority, directly in challenge to 'who has authority', understanding the connection between authority and command of language, 'language as an essential preliminary to the imaginative exploration of person and of universe', understanding the ways in which it is necessary to start again.

Let's start again.

Language was once mutable, land was once owned in common, and I'm sure it's not coincidence that the first single-language English dictionary ever, Robert Cawdrey's *Table Alphabeticall*, was published in 1604, the same year that (according to the UK Parliament website) the first official act of land enclosure was passed. A reckoning is needed, many overlapping reckonings are needed: with the damage inflicted by a father abusing his daughter; the damage inflicted by a society that refuses to acknowledge the needs of Deaf people; the damage inflicted by a dictionary researched and written by just one man (Samuel Johnson, 1755) that, for instance, equated being a woman with being 'pliant' and the colour black (in Johnson's fourth meaning) with being 'horrible; wicked; atrocious'; the damage inflicted by pale-skinned humans when they chose to describe dark-skinned humans not as brown (Johnson: 'the name of a colour') but black.

Let's start again.

[with clarity, with purpose, with authority, with confidence]

Let's start again.

[without breaking to do the dishes – I've ignored the dishes! – the entire section of *Vessel*, repeated by each of the women, about the dishes, the mundane, 'so much to do before the task can even be started', the task of 'attempting to activate solidarity']

Let's start again.

[with Audre Lorde: 'My silences had not protected me. Your silence will not protect you. But for every real word spoken, for every attempt I had ever made to speak those truths for which I am still seeking, I had made contact with other women while we examined the words to fit a world in which we all believed, bridging our differences.']

Let's start again.

[sh–]

(MC)

Further reading

Can I Start Again Please, published by Oberon
'A provocation: how to keep surviving as an artist', read by Gemma Paintin, on YouTube
An interview with Sue MacLaine by Phil Cleaves, published at essentialdrama.com

A theatrical world as endless and repetitive, as vast and comic and occasionally unbearable as life itself

Amy Sharrocks

It is a June morning in 2009 and we are taking a walk. Sixty-something people dressed in blue, tied together by a light blue ribbon that zigzags back and forth across the muddle of walkers. We have the unsettling air of a genteel cult, an impression heightened by the fact that nobody is speaking.

We are tracing the route of the Walbrook, one of London's buried medieval rivers. To do so the artist Amy Sharrocks has employed an expert dowser, a diviner of water who appears to use two metal poles to guide us along an unseen watery path. We follow this path from Highbury and Islington all the way down to the Thames. Initially at least the journey is as calm as a duck pond. In the otherwise empty residential streets of North London we are free to fill the pavement with our polite smiles and a cat's cradle of ribbon; an azure echo, sloshing our unhurried way through the warmth of a peaceful Friday morning.

Water is a seemingly innocuous subject for art. *Innocuous*, from the Latin meaning not-injurious; transparent, odourless, non-toxic. It is a basic constituent of our bodies, our diets and the world in which we live. It is everywhere, as ordinary a thing as it is possible to imagine. But just as we know this to be true, we also know that water is a fraught subject; *fraught* from the Middle Dutch for a ship's cargo. Politicized and commodified, contaminated and corrupted, unevenly distributed, plumbed, privatized, bottled, carbonated, used to fill several hundred swimming pools in the Greater London area alone. Without water people die, cities crumble, empires fall, species disappear. It is a subject at once profoundly quotidian and at the same time as impossibly vast and complex as the Atlantic Ocean. How could anyone possibly tackle such a subject? It would take years, perhaps a lifetime.

Amy Sharrocks has been making art about water for as long as I have been an artist. In 2007 when I was a new graduate living in a shared house in Tooting she made *SWIM*, a journey across London inspired by John Cheever's short story 'The Swimmer'. In the story an attempt to traverse an ordinary suburban neighbourhood by way of its archipelago of private swimming pools becomes a reflection on the shallow aspirations and brittle desires of middle-class America. Amy's journey-by-swimming-pool was also

a kind of reflection; fifty shivering obsessives in swimming caps and flip-flops scrambling across London in sporadic twenty-five-metre bursts, their slapstick journey holding up a mirror to the city and its inequities; its basement pools and its private gyms, its leisure centres and its lidos.

Then in 2009 Amy created *drift*, which involved one audience member at a time sitting with Amy in a small boat and drifting across a body of water. Here again water becomes a means of reflecting. You shimmer across its surface, allowing your mind to wander, to drift, unmoored and undirected. In 2015 I volunteered to help with a version of the piece that took place overnight in the otherwise empty Stratford Olympic Pool, giving me the opportunity to observe Amy's inflatable dinghy under Zaha Hadid's vast cetacean ceiling as dawn light slowly spilled in through the great glass windows; to wonder at the strangeness of this tiny boat in that spectacle of a building, spinning carefree in its eddying currents of power.

In both pieces water is not just the subject but also the medium, and its presence necessitates a certain instability and an uncharacteristic humility. A giving up of control, allowing ourselves to be directed by water rather than the other way around.

By allowing water to shape her work, Amy enables those works to start to take on some of its characteristics. Water both reflects and absorbs that which it encounters. It resists when it is struck and yields when it is not, freezes when cold and evaporates when hot. Water describes the world around it; in its simplicity and mutability it becomes a kind of story we can tell about that world and our complex relationship to it. Amy's work similarly uses its simplicity and mutability to reflect back to us stories we should already know about ourselves. The simple act of drifting takes on profound but strikingly different meanings for each floating passenger. A swim across London becomes a way of mapping the infinitely complex politics of that city.

Like so many of Amy's other artworks, our walk on that Friday morning in 2009 was disarming in its simplicity. It was, after all, just a walk – a journey from one place to another along familiar streets with little in the way of commentary or spectacle. Yet as Amy herself has made clear, walking in the city is always a political act, and this walk was no exception. To reclaim this river, to mark its loss, to move through these streets recognizing its absence, is an overtly political gesture.

As we walked we formed and reformed ourselves. I found myself sometimes at the back and sometimes at the front, where people were taking it in turns to try their hand at dowsing. I had heard of dowsing rods before this walk but never seen them used. If I'm honest I'd only really understood them as a quaint curiosity, an archaic superstition like crossing your fingers for good luck. And yet here they were, moving with what appeared to be a will of their own, seemingly acknowledging the water we imagined might be flowing beneath the pavement. Someone showed me how to hold the dowsing rod and I tried to listen through it, to feel it drawing me towards the river beneath, but though I did my best I was a hopeless diviner. More

than any water, the real pull I felt in this strange device was towards history, and the memory it carried of an older way of doing things.

Amy's work is often concerned with history in this way, looking to the past to help us find ways of navigating the present. It is there in *drift* in the way the piece asks you to give yourself up to the movement of the water, in doing so embracing an older relationship to the non-human world that has been almost totally eroded by successive waves of technological progress, from the umbrella to the electric light to GPS satellites, centuries of human mastery from which the piece asks us to temporarily release our white-knuckle grip.

In *SWIM* this look to the past took the more tangible form of an old red Routemaster bus on which Amy and her swimmers navigated between pools, its anachronistic presence perhaps a reminder of a time when London was a different kind of city; a river city whose life and geography was organized around the water.

This sense of looking to the past to try and once again orient our cities and our lives around water is also present in Amy's best-known piece, *Museum of Water*. Initiated in 2013, it's an ever-growing collection of publicly donated water, each numbered contribution accompanied by a personal story of its origin or meaning. It is a vast and wondrous collection – seawater, snow, iceberg-fragments, tears, sweat, urine, breath – that describes the unmeasurable extent of our relationship to water; all the ways in which we live by it, through it and with it. I have my own contribution to the museum; a zip-lock food bag containing the melted remains of a block of ice that once sat in my hands during a show I created with my friend Ira in 2015. I remember sitting with Amy on a sunny day in Soho Square, writing out as carefully as I could what it meant to me and why I had chosen to donate it.

The piece is a fitting culmination to all those years devoted to water; swimming across London, floating across swimming pools and ponds, tracing the memories of old rivers. A fine vessel into which to pour over a decade of thinking. And like so much of Amy's work its power lies in its simplicity and all the myriad meanings this allows it to contain.

Museums are nostalgic places, recalling both our own childhoods and the fascination we perhaps once had for collecting and cataloguing, trying to measure the whole world one piece at a time. At the same time, the idea of a museum encourages us to think of water as something valuable and scarce, something that needs protecting. *Museum of Water* is beautiful, it is charming and celebratory, but beneath the surface it is also a warning.

Our walk all those years ago was also for the most part charming and celebratory. And yet, like the river we were retracing, it too contained hidden multitudes and altered its shape and its character in response to the changing city around it.

In the quieter, leafier parts of North London we walked in contemplative, unhurried silence, like pilgrims on the trail, holding on to the notion of this

historic river like some intangible relic. A ghost river, whose presence, despite the dowsing rods and Amy's no-doubt careful research, felt inconceivable amid the gastropubs and the million-pound town houses. As we reached the city, however, the feeling changed. More people appeared on the streets and amid all this busyness our presence, still daisy-chained together by a maze of blue ribbon, felt like less of a curiosity and more of a nuisance. Tutting city workers jostled to get past as we made our way clumsily along narrow pavements. Their demands that we explain ourselves transformed our silence from a kind of meditation into an act of obstinate resistance.

By the high walls and the Doric columns of the Bank of England we reached the entrance to Walbrook, an unassuming semi-pedestrianized passage flanked by Mansion House on one side and London Magistrates Court on the other. This was perhaps the first tangible evidence of the river we had encountered on the entire walk, but here it no longer seemed just hauntingly absent. Instead you could feel it buried under the weight of all this commerce, under the traffic-choked roads and the headquarters of our august financial institutions. In this moment the walk became not only a meditation on this absent river but an act of reclamation. Our troublesome bodies drawing the water back to the surface like a spring, allowing it once again to hinder the progress of the city that had ploughed it into the ground.

We ended, inevitably, at the Thames, walking down some old concrete steps to a pebbly bank and the flowing grey mass beyond it. Churchill once described the river as 'the golden thread of our nation's history' but of course it is much older than that. For a number of years Amy has been running a campaign to create an annual mass swim of the Thames, north to south, landing at Tower Beach beneath the Tower of London. For an hour each year, shipping lanes would close, trade would temporarily cease, and our goosepimpled bodies would slip down into the river. We would swim, tasting the silty water in our mouths as we turn our heads to breathe, our bare legs brushing against slithering eels, crisp packets, old plastic bags, following the splash of a stranger's feet in front of us, feeling the pull of the tide, the currents of history, the water connecting us to past and the future, to the mudflats and the estuary and the wide open sea beyond it.

(AF)

Further reading

museumofwater.co.uk
swimthethames.co.uk

Rachel Mars

Yom Kippur . . . the day of atonement where you apologise for your own sins and those of the whole world. There are twenty-four things you apologize for on repeat throughout the day. Like, we have lied, we have betrayed, we have been violent. And one of them is – latznu – which is translated to mean we have clowned around about matters that we should have treated seriously; we have ridiculed good people; we've made a joke of things and that prevents us from proper repentance because we don't take things seriously enough.

RACHEL MARS, *The Way You Tell Them*

Before there were the seven deadly sins, there was a monk called Evagrius who liked to dress well and fell in love with a married woman. I'm going by Wikipedia here. To get his soul back on track he fled to Jerusalem where, among other things, he drew on existing theological writings to devise a list of eight evil thoughts that could lead a person astray. That list was translated from Greek into Latin by another monk, John Cassian, and two centuries later adopted by Pope Gregory I, gradually morphing into the seven sins we know today. The evil thought that was shed in this lengthy process was acedia: dejection, listlessness, lack of care, something akin to depression.

I first came across acedia in Ann Cvetkovich's book *Depression: A Public Feeling*, which uses Cassian's writing on spiritual crisis as a starting point 'to explore depression as a political category', induced by living in systems of inequality. That capitalism 'denies any possibility of a social causation of mental illness' is a central point in Mark Fisher's 2009 book *Capitalist Realism*, a concise argument against capitalism's insistence that 'not only is [it] the only viable political and economic system, but also that it is now impossible even to imagine a coherent alternative to it'. Integral to this is the way 'neoliberalism has sought to eliminate the very category of value in the ethical sense'.

Rachel Mars takes a clowning delight in joke and ridicule and irreverence. But she also works with a deep sense of morality, contemplating values, ethics, responsibility and meaning. And even though she's Jewish and I'm baffled by religion, I see her work through the prism of the seven deadly sins.

Wrath

Enter the Rage Arena begins with two participants talking about the things that make them angry – the apoplectic kind of angry that surges like a cyclone intent on destruction. Rachel then gives them tools, safety goggles, household objects, and invites them to get smashing. Someone I know let rip to such an extent that they broke their own thumb. I have no idea how I feel about this.

I have no idea how I feel about this because I'm conditioned to accept social systems rather than question them, because what's the point of questioning something so innate to human character it can't be changed? I was born in 1975, Rachel in 1980: we both grew up in 'the period', as Fisher wrote, 'when capitalist realism was fought for and established, when Margaret Thatcher's doctrine that "there is no alternative" . . . became a brutally self-fulfilling prophecy'. The milk we drank as children was curdled by the tenets of capitalism: inequality is inevitable, competition promotes innovation, humans are competitive by instinct, hierarchy hard-wired into us by evolution. But any system of human control is spun like a story, written by an author. Just like the seven deadly sins.

Sometimes to be angry at something you have to be able to see it – or perhaps past it, around it, through it. Thatcherism, capitalist realism, neoliberalism blur and block such sight. And this was the anger in *The Lady's Not for Walking Like an Egyptian*, Rachel's 2013 collaboration with nat tarrab, which raked over the 1980s, rubbing speeches by Thatcher up against the decade's pop hits, gradually illuminating her brutal legacy. Writer Matt Trueman sat in on some of their rehearsals and vividly traced the process by which Rachel came to 'take on a role as the archetypal child of the 80s [who] can never completely understand all the fuss about Thatcherite free-market economics [because] "This is what we are. This is what we do"', while nat – eight years her senior – 'boil[ed] over to the point where it breaks the show'.

When the pair collaborated again in 2017 for *Roller*, they flipped roles: here, Rachel was the tower of rage and nat, initially matching her word for word, pulled back to question their fantasy of violent, retributive revolution. While nat advocated reasoning and dialogue, Rachel wielded a metal pipe and snarled about beating people to pulp. Staged within a roller-derby rink, *Roller* was a spiky contemplation of feminism – in particular white feminism – and how the language of social progress can get tangled up in the language of privilege, offering a shift of power for some in the guise of making society equitable for all.

Envy (and a dash of pride)

[W]e're acted upon by systems that engender envy in us all the time. But to feel the natural reaction to that – we feel that's taboo and shameful

and we punish ourselves for it. We're caught in a cycle. So, fuck it, let's talk about it, let's talk about this and let's talk about it in an entertaining and funny way. It just, for me, decreases the whole power that all those systems have over us – just for a moment – and that's very satisfying.

RACHEL MARS, interviewed by Lindsey Sikes,
Fusebox Festival blog

In 2014, Rachel started a choir called *Sing It! Spirit of Envy* specifically to play with people's perceptions of inequality and how it makes them feel. The crowd-sourced lyrics identified as objects of jealousy everything from 'people who don't have depression' or 'don't need a UK visa' to 'foxes in my garden having sex', occasionally punctuated with the words 'Destiny's Child'. A refrain running through it was this obnoxious line from Boris Johnson: 'Some measure of inequality is essential for the spirit of envy . . . that is, like greed, a valuable spur to economic activity.'

Fisher refutes such thinking in *Capitalist Realism*, quoting from Oliver James to expose the 'Selfish Capitalist toxins' that systemically convince people 'that material affluence is the key to fulfilment'. A culture that measures human value through economic activity isn't one that will be sympathetic when the sense of worthlessness this induces leads to, in Cvetkovich's words, 'a breakdown in functionality'. She draws a line connecting acedia, laziness (sloth) and the 'contemporary depression that . . . is a major problem for neoliberal and market-based conceptions of the self', seeing a political potential in 'negative feelings of failure, mourning, despair, and shame'. Fisher agrees, arguing: 'We must convert widespread mental health problems from medicalized conditions into effective antagonisms.' This is the pool of thinking the *Spirit of Envy* choir skated across, light as a dragonfly. And then the unsettling, fantastically nuanced liturgy of *Our Carnal Hearts* dived to its depths.

Alternating hymnal songs with increasingly violent stories of envy and revenge, *Our Carnal Hearts* felt, the first time I saw it in October 2016, like a conundrum. On the one hand I was dazzled, because the singing (arranged by Sh!t Theatre's Louise Mothersole and performed by four women) was exquisite, but on the other hand discombobulated, because I wasn't certain what moral position was being taken, whether Rachel was speaking truth to power or accepting power – and the envy it attracts – as unassailable truth. But when I saw it again, in August 2017, its ethics felt clearer, the satire gleamed sharper, respect for the inventively malevolent thoughts envy conjures up twisted with ridicule, while 'sorrowfully acknowledg[ing]', as Lyn Gardner noted in her *Guardian* review, 'how the system utilises envy as a spur to profit and turns us all into losers'. What was the difference between the two performances? I'm not sure I could tell you, not even sure whether it lay in the show itself or in me as audience to it. But the second time its reframing of envy as a natural human emotion felt like a kind of grace, akin to the understanding in Judaism that to sin is a part of life, because no human is perfect. Instead what's unnatural is the perversion of envy, whether

by external manipulation, overindulgence or suppression: it morphs into poison either way.

Lust

Fisher's starting point in *Capitalist Realism* is the idea that 'it's easier to imagine the end of the world than the end of capitalism', a reference in part to 'cinematic dystopias' and their obsessive insistence that civilization, humanity itself, would collapse without globalized commerce and a singular hero to uphold the economic status quo. Since its earliest days, film critic Laura Mulvey wrote, Hollywood has 'proclaimed the desirability of capitalism'; already in the 1920s it was co-opting feminism 'in the interests of commodity capitalism' – the commodity being, of course, the female body. In another great aphorism, roughly translated from René Pollesch's play *Love is Colder than Capital*, even if you try to force capitalists to talk about money, 'they always just talk about love'. Love as in care? Or love as in desire?

There's a line of thinking that each of the seven deadly sins is a corruption of love, and *Your Sexts Are Shit: Older Better Letters* spins this idea of corruption in a multitude of directions. It began with Rachel and a few friends reading out erotic correspondence by James Joyce, Frida Kahlo, Georgia O'Keeffe, Gertrude Stein and Eleanor Roosevelt, letters that dripped with longing for their lovers' heat, touch, pulse and, in the case of Joyce, their symphony of farts. But as Rachel continued to work on the show, to the point where I saw it in 2018, it became a more nuanced meditation on love's visibility and shadow, contrasting this voluptuous lyricism from the past not only with the crass blunt prose of contemporary text messaging, but with the melancholy banality of a long-term relationship in which sex talk gives way to quick-jotted notes about taking out the bins and shopping for milk. It's typical of the complexity of Rachel's thinking that any of this material could be considered corruption of a sort.

Rachel's point wasn't that it's hard to hold on to lust, or love for that matter, with time wreaking its ravages and familiarity quietly breeding contempt, but that it's hard to hold on to lust, and love, in a society that has been so callous in dismissing a panoply of human relationships as transgressive or queer. Infidelity, polyamory, disability, even a familial love that phrases itself almost as incest, all are accommodated, taboo and heteronormative hierarchy alike banished in favour of celebrating love's expansiveness and endless imagination.

Gluttony, or greed

The question of moral responsibility has been central to Rachel's work for as long as I've been watching it. In *The Way You Tell Them* (2013), her

dissection of how comedy works and what it's used for, she took a particular interest in the idea of 'decommitting': that thing anyone being racist or homophobic or sexist does – a comedian, for instance, or Nigel Farage – 'when you say a thing that you really believe, and then you panic that you will be judged so you just [step away and do Tommy Cooper hands] only joking, not really.' Writing in the dog days of the 2010s, it's terrifying how many people have given up on the 'only joking' part.

The Way You Tell Them began with a belief that 'when I laugh . . . it is a sign of my moral consent to what I am hearing or seeing', but refused to let this mean that the audience is the 'ethical arbiter' in comedy while the performer is absolved of responsibility. It ended with Rachel playing a soundtrack of baroque farts over a film of a man talking about how he had survived the drug trial for men with AIDS that had killed all other participants, including his partner. In between she poked at taboo and conversed with shame with such consideration I've been a devoted fan ever since.

I trust her: trust her approach, trust her thinking. Which is why I stayed in my seat – writhing and squirming – throughout *Story #1*, her collaboration with Greg Wohead, even though so much of it sprinted past the boundaries I have as audience. I never watch horror because it gives me nightmares and I avoid porn because, far from turning me on, it makes me hate my body, and yet the stories that unfold in *Story #1* revel in the narrative structures of both, taking the lives of its four characters to gory, fluid-squirting, body-dismembering extremes. And all this begins with a full screening – forty-seven whole minutes – of an episode of *Come Dine With Me*: in my eyes an act of violence itself.

Come Dine With Me is an invitation to indulge, and *Story #1* felt like a competition in gorging, Rachel and Greg vying to see who could cram the goriest details into their versions of the four contestants' future lives. But again, they do so with a deeper purpose: as Greg wrote of this work, it's concerned with 'finding the possibilities for radical narrative: I'm not totally sure I can pin down what we might mean by that, but it's something about fucking with realness and not-realness when it comes to stories – finding blurriness and slipperiness in that'.

If 'capitalist realism' sets out to convince people that it is 'impossible even to imagine a coherent alternative', perhaps radical narrative, with its slips and blurs, has the power to shatter that conviction. Because the thing that is really innate to humanity isn't capitalist competition: it's storytelling. Yuval Noah Harari argues as much in his book *Sapiens: A Brief History of Humankind*: 'language', he says, 'evolved as a way of gossiping', and it was this ability to spread and share stories that secured Sapiens' survival. Crucially, what humans could share was fictions – 'As far as we know, only Sapiens can talk about entire kinds of entities that they have never seen, touched or smelled' – and this enabled us 'not merely to imagine things, but to do so collectively. We can weave common myths such as the biblical creation story, the Dreamtime myths of Aboriginal Australians, and the

nationalist myths of modern states.' And these myths gifted Sapiens 'the unprecedented ability to cooperate flexibly in large numbers'.

Language created the religious, cultural, political fictions that shaped human society, but it also holds the fictions of white supremacy and fascism that murdered seventeen members of Rachel's family and drive humans apart. Over the time Greg and Rachel were developing *Story #1*, the UK voted to leave the EU, largely on the basis of fear-mongering around immigration and lies about the NHS, and Donald Trump became President of the United States. 'Now, more than ever, the way events are turned into stories, and the way stories are deemed "true" or "not true" is up for consideration,' Rachel noted in a conversation with Greg.

The politics we're living in have set moral compasses spinning. I think of Rachel stilling the needle, her work seeking to make it point true.

(MC)

Further reading

'Singing, Women and Resistance': Rachel Mars in conversation with Roberta Mock, published at larktheatre.org

Selina Thompson

Three conversations that led to friendship with Selina Thompson

August 2014: I had arranged to meet Selina and Louise Orwin in a café in Edinburgh as part of an experimental project in public art-dialogue that somewhat failed in that no one else turned up. The main thing I remember about this conversation is Selina talking about seeing Byrony Kimmings perform and feeling encouraged to make work from her own body, life and experiences by Bryony doing it.

January 2015: Selina was living in Leeds, me in London, and she suggested we have a Skype conversation, picking up on some of the threads of our Edinburgh chat. The main thing I remember about this conversation is me talking about the concept of 'passing', which I'd first encountered in a novel of that title published in 1929 by Nella Larsen, a brilliant writer of the Harlem Renaissance. My working-class family are all from Cyprus, a former British colony, but I've never been read as second-generation because my accent is cockney and my skin pale. What does it mean, I asked Selina, to appropriate the term 'passing' from people of black heritage? We've been talking about race and class and diasporic intersections ever since.

May 2015: Selina arranged to meet me in London, so she could ask me to be a dramaturg on a new work she was planning called *salt.*, a meditation on the trauma of slavery and its legacies in institutional racism, particularly evident in the deaths of black people at the hands of white police that led to the Black Lives Matter movement. Two other things I remember from this conversation are Selina saying she wanted to be in company and dialogue with older women (there's fifteen years between us; sometimes I feel it, sometimes it dissolves), and me saying that I'd started thinking about the roots of words like democracy, misogyny, xenophobia, not only in the Greek language but in the ancient Greek culture of constructed inequality – a culture we have inherited and consolidated along with the words to describe it.

Six books I have read because of Selina

bell hooks: *All About Love* and *Killing Rage: Ending Racism*

No one wants to see themselves as part of the problem, but the realization in 2016 that I'd had *Killing Rage* unopened on a bookshelf for twenty years was a moment of recognizing the whiteness of my feminism: a feminism that had railed against capitalism and patriarchy but not the 'imperialist white-supremacist capitalist patriarchy' hooks so shrewdly names. *All About Love* – the book that sits in the small of Selina's back in *salt.* – is political in a different way, speaking against the romantic love peddled by capitalism, advocating instead a definition of love as 'a combination of trust, commitment, care, respect, knowledge, and responsibility', essential to all kinds of human relationships.

Audre Lorde: *Sister Outsider*

Another one I read in 2016, prompted by a question in *Race Cards*, a collection of 1,000 acute questions Selina has built up over several years on race and racism: what did Adrienne Rich get out of her friendship with Audre Lorde? The essays are eminently quotable but this line, from 'The Transformation of Silence into Language and Action', makes an especially good mantra: 'Where the words of women are crying to be heard, we must each of us recognize our responsibility to seek those words out, to read them and share them and examine them in their pertinence to our lives.'

Dionne Brand: *A Map to the Door of No Return*

A source text for the reworking of *salt.*, lyrical and painful, meditating on the 'rupture in history' effected by the slave trade. I was just beginning to engage with 'no borders' politics when reading it and particularly connected with this argument: 'Nation-states are configurations of origins as exclusionary power structures which have legitimacy based solely on conquest and acquisition.'

Barbara Applebaum: *Being White, Being Good*

Applebaum is an American academic focused on social justice pedagogy so the likelihood of me stumbling upon this book in 2017 except via Selina was almost zero. It shifts the discourse around whiteness away from 'privilege' to 'complicity' and an invitation to 'do whiteness differently', with vigilance and criticality and the kind of careful listening that is ready to rethink.

adrienne maree brown: *Emergent Strategy*

The one I'm reading as I write, a book of open-hearted wonder and untrammelled hope in the possibility of human adaptation in the face of environmental catastrophe. Selina and I talk a lot about how to make a difference in the world, the ways in which the work that involves might be very small, quite boring, and basically unseen. Like a dandelion spore, says brown, seeding even in inhospitable circumstances, growing a plant that the attentive know contains medicine.

Three concepts introduced to me by Selina

Afro-pessimism and its mirrorball antithesis, afrofuturism

The first was in the background of *salt.*; the online research site Oxford Bibliographies describes it as a way of theorizing 'blackness as an effect of structural violence, as opposed to thinking of blackness as a performance and embodiment of cultural and/or anthropological attributes'. The second is influencing Selina's work post *salt.*, and offers a site of imagining (again from Oxford Bibliographies) 'greater justice and a freer expression of black subjectivity in the future or in alternative places, times, or realities'.

Sortition

The central concept of *Oh God, Not Another One!?*, title and work alike inspired by the explosive reaction of viral video star Brenda from Bristol to the announcement of a snap general election in spring 2017. Has there really been, as Brenda fumed, too much politics in the UK in the 2010s, or just too much defective, self-serving, corroding politics? The principle of sortition looks back to the roots of democracy in ancient Greece: back then, the kind of electoral system we use now would have been dismissed as oligarchy; instead, public leaders were selected, if not totally at random, at least through a lottery. Naturally the ancient Greeks had their own objections to this, arguing for instance that one wouldn't choose a surgeon or builder this way, so why a politician? But if a surgeon and builder are equally subject to the decisions made by political leaders, why shouldn't they contribute to society's decision-making process too?

Restorative justice

Being totally accurate, I'd come across ideas related to restorative justice from other people, but Selina consolidated the thinking and applied it more locally to theatre, especially in the wake of the #metoo conversation that

exploded in autumn 2017. Amid more frivolous gossip about our pets, recipes, TV programmes, astrology, we share what we know about people in positions of power in the theatre/performance industry who have abused the people they've worked with, emotionally, psychologically, intellectually. Some of those people have been ostracized, some haven't, but retributive justice has done nothing to change the industry as a whole. What might genuinely healing, restorative work look like in this field? It's becoming integral to Selina's practice to find out.

Two songs that remind me of Selina

I'm in Selina's flat in Birmingham working my way through a plate of tiny Bounties discarded from a tin of Celebrations. Selina is pottering around, doing laundry, cooking, and 'Umi Says' by Mos Def comes on the playlist she's listening to. It's such a gorgeous incantation, hip-hop as spiritual, freedom dream passing from elder to younger. Sunshine sidles into the room and I think of the first time I met Toni-Dee Paul, as a student in Preston, before she was associate artist and access assistant in Selina's company: how Toni glowed when she talked about Selina as inspiration, as the person who had most encouraged her in making her own work.

'Almeda', by Solange, shares with 'Umi Says' the qualities of incantation and defiance, but with very different mood, a different pulse in the veins. Selina wove its lyrics into her foreword to the published text of *Idol* by Jamal Gerald – another younger artist following Selina's example in making his own work about black representation. *Idol* dances between Orisha worship, pop culture and how different the world would be if Christianity revered a Black Jesus, and I would never have gotten to work on it as dramaturg except that Jamal saw and loved *salt..* So that's another thing I have to thank Selina for.

Four things I've noticed myself saying or thinking that being friends with Selina has helped me address as white complicity

'I have normal hair': I'm ashamed to admit that I barely noticed the linguistic contortion of the phrase 'shampoo for normal hair' until walking to see Selina's show *Dark and Lovely*, about the fraught relationship between black women and their hair, and how it's damaged daily by white supremacy, capitalism and colonial thinking just like mine.

'. . . and it's funny, my best friend at primary school was a black girl called. . .': This didn't feel like a cliché in the moment of expressing it, not long after

meeting Selina, but within the next few months I noticed enough black women sharing stories of a white person saying something similar to them that my heart sank. Powder-puff nostalgia: just one of the many wrongs wreaked on society by a catastrophically segregated education system.

'That can't have happened – can it?' Another problem with the casual and naturalized segregation that happens in British education and housing and workplaces is that lots of white people have no idea what forms racism takes, and so are apt, when faced with descriptions of that racism, to be disbelieving at first. I don't touch black women's hair so can't imagine someone else doing it, let alone uninvited, that sort of thing. But the racism is real. And disbelief is part of the problem.

'. . . but the black audience. . .': I mean, this one ought to be elementary. If there's no 'we' that holds a single audience together, how can I talk about a 'black audience' as though a homogeneous entity?

Something that might not be clear already and might be worth spelling out

Like so many of the artists in this book, Selina doesn't simply make product to present in arts spaces: she makes different ways of thinking, talking, living. She makes values and generosity and space: not just for herself but for people in her orbit. To see her work as a set of performances and installations is to miss the heartbeat of what she does.

I haven't collaborated with Selina officially since *salt.* but our relationship is always a working one at some level: she brings company and project problems to me and I bring freelance relationship questions to her and we ruminate together, helping each other from a place of mutual respect. But it's also a friendship and our support for each other comes from that place too. We are friends and colleagues in an industry that we know isn't good enough, isn't working hard enough to change, to be inclusive, to challenge or dismantle its colonial power structures. An industry full of people who betray their own ideals. Being friends with Selina holds me to account, in particular holds my whiteness to account. I hold myself to account in a way my younger self never thought to.

One of the things I admire most about Selina is how demanding she is. She demands that when she makes work, it pays for well-being – her own, and that of everyone who works with her. She is demanding because it allows her to share, to give opportunities to other black women, to younger artists, to support those with different health needs, different mental or physical needs. She tries always to be attuned to difference, and to the ways in which she experiences privilege, and how that privilege might close her mind. She is

open. Open with strictly defined boundaries. Open because that is what's needed to hear beyond one's own needs, and make change accordingly.

Five resonant questions from an early version of her installation *Race Cards*

What does a decolonized mind feel like?

How do I negotiate your gaze?

If trauma can be passed down genetically, what does that mean for the descendants of immigrants?

Where am I an oppressor in my daily life?

How can I be more like Grace Jones?

Some of the kinds of honesty Selina talks about

In conventional theatre criticism, honesty can be a pretty brutal thing: the knife of the one-star review, the pithy put-down, the scathing description. And in a theatre industry that keeps everyone scared for their livelihoods, in which open criticism is avoided, honesty is too often swallowed. Somewhere between these two poles Selina talks to me of other kinds of honesty, naming some in a text message in September 2019:

strong honestys

kind honestys

constructive honestys

curious honestys

The more I look at these words, the more they feel like a mantra to live by.

(MC)

Further reading

salt., published by Oberon

'Fat Demands', in *Can We All Be Feminists?* edited by June Eric-Udorie, published by Virago

Conversations Across Generations: a Howlround Theatre Commons series, at howlround.com

PART 5

Close encounters

Abigail Conway

Sheila Ghelani

Brian Lobel

Ria Hartley

Stephanie Albert

Abigail Conway

1

Imagine you are sitting at a little wooden desk hidden behind a small screen that separates you from a waiting queue of people, like a voting booth or a confessional. In front of you on the table is a tiny plastic sachet containing a set of instructions and an orange envelope which in turn contains a small purple disk about the size of a communion wafer. The instructions invite you to write on the wafer words that you have never said out loud.

The simple phrasing is deliberately elusive. It doesn't tell you to write a secret, or a confession. Only to write something you have never said. The installation is called *On the tip of your tongue* and already, before you have even really entered, you are thinking about what it means to say something out loud; dredging sounds up from the depths of your chest, wrapping your mouth around them and spitting them out into the world. What power do spoken words have? Promises, betrayals, confessions. All the moments where things said or unsaid had the power to change your life for ever.

You place the inscribed wafer carefully back in the envelope and step into a large, dark room spectacularly filled with candles. They cover every surface, spreading out across the floor in front of you like a flickering yellow carpet. The candles and the darkness remind you of churches, their quality of effortful silence, the way the air gets cooler as you step in from the outside.

A path through the candles leads to the back of the room where an altar of sorts is concealed by a large gauze screen. There you discover two jars, one empty and the other full of little coloured envelopes just like the one you have in your hand; orange, green, purple, blue. A card instructs you to place your envelope in the jar and take one deposited by somebody else. You open the envelope and take out the little wafer, reading the unspoken words someone has written there. As instructed, you whisper those words into the empty jar, summoning them briefly, elusively, into the world; releasing them perhaps, like a prayer, or trapping them, like a secret.

When you have done so you place the little disk in your mouth and it melts into your tongue. You can taste sugar and the person whose words were written there. A kind of subtle transubstantiation. All the beauty and wonder of ancient ceremony, repurposed for a secular ritual, a binding of you to me, their words in your mouth and your words for now left waiting in this jar for someone else to find.

2

Let's imagine now a new kind of art. An art of the encounter, with its own preoccupations and its own peculiar history.

One version of this history begins in Europe in the 1960s. It begins with Valie Export transforming herself into a portable cinema on the streets of Vienna, inviting passers-by to reach in and touch her. It is an encounter of transgressive intimacy; Hollywood's lurid gaze taken to an absurd and uncomfortable extreme.

Another equally plausible version of the same history might begin in New York at around the same time with Vito Acconci following strangers through the streets of the city and documenting where they lead him, or with Allan Kaprow's participatory happenings, a woman wrapped in tinfoil waiting on a street corner, or a group of students building a house out of ice in the middle of the desert.

In each of these instances the terms of art are being rewritten so that the work of art is not something that the audience encounter, on a stage or in a gallery or wherever else. It is the encounter itself which becomes the work of art, with the artist's job no longer being the building of objects or the writing of stories, but rather that of a host, holding open a kind of space, shaping the process whereby we meet each other; managing the details of our interactions.

But such encounters were not invented in Vienna or New York in the second half of the twentieth century. There is another, equally important history of this proposed artform. One that begins not with art-world experiments but rather with a constellation of more everyday human encounters that form a regular part of our ordinary lives and have done for hundreds if not thousands of years; a therapy session, or a haircut, a taxi ride, a blind date, a dance party, participation in a traditional rite of penance.

The word *encounter* comes from the Latin *in kontra*, in and against, and was originally used to mean a meeting of adversaries. Implicit in the word is the idea that the people encountering one another are fundamentally different. To encounter someone is to recognize them as a person separate to you, with a separate experience of the world. An encounter is not easy, nor is it expected. We encounter difficulties. We encounter problems. An encounter is fraught with uncertainty and unpredictability, yet also filled with opportunity. It is a meeting in which we can sit with our differences, be in and against one another, and perhaps attempt to resolve them.

If traditional theatre is structured around the playscript, and dance and performance art begin with the body of the performer, then might the idea of the encounter serve as the foundation for a different, as yet uncodified kind of live performance? A meeting between people in which that meeting is the material of the performance in the same way that canvas and paint are the material of a painting? An art of the encounter that is a distinct discipline separate from other performance disciplines; a universe all of its own?

Perhaps this is a way to think about the kind of otherwise largely unclassifiable work made by artists like Abigail Conway. Work that roams broadly across a range of recognizable disciplines, from theatre to installation to digital art, all of which serve as occasionally apt descriptors of the form or aesthetic of the work while failing to accurately describe its spirit and intent.

Abigail makes encounters. The shapes and conventions of her work are not inherited from theatre or visual art, they are instead borrowed from ceremonies, rituals, workshops and other less codified ways of meeting; games of make-believe, a night spent holding hands in the cinema or dancing with a stranger.

To frame this work as a series of encounters is to try and create a critical frame for it that exists outside of the conventions and expectations of other mediums. It is to pay attention in a different way; to consider, most fundamentally, the ways in which such work invites us to meet one another. To recognize the obvious and deliberate care with which each of these encounters has been constructed – the careful use of light and sound, the delicate precision with which every object we encounter has been laid out, the meticulousness with which each stage of the encounter has been organized and arranged – and to recognize that these details constitute not good design or pleasing attention to detail, but rather the essence of the work itself. The medium is the message, and all this accumulation of careful detail is the language through which that message is conveyed. To think of these works as encounters is my way of trying to pay careful attention to these myriad delicate manipulations of our environment, to better understand the politics and the ideas that are buried within them.

Careful attention is at the heart of all of this. I think if this would-be discipline has a central motif, it is that of care. In the first instance the care with which the artist constructs the encounter, but also the consequent care and consideration that we are invited to have as we navigate through it. This is a way of working shaped not only by artistic training but by the influence of all the other kinds of people that regularly take care of us, be they nurses, teachers, barbers, priests or simply the parents or 'carers' that raised us.

So much of Abigail Conway's work is about taking care, whether we are listening to the unspoken words of strangers, negotiating the terms of a shared dance, delicately dismantling a watch and transforming it into a beautiful ornament, finding our place within a vast miniature city, or simply waiting patiently for a flower to open. Abigail pays attention to nuances and

the peculiarities of where we are meeting and how, and in doing so she creates artworks that encourage such care in others.

3

You are imagining standing in another room now, listening to what sounds like a party bleeding through the wall from the neighbouring room.

You have been asked to choose a song to dance to and you chose 'Drunk in Love' or 'Dancing on My Own', or 'MMMBop', or 'Africa' by Toto. It doesn't really matter. Whatever you chose, when the door to the next room finally opens your song is already playing. This new room is smaller than you expected and dark, glitterball light dancing across the walls, a smoke machine coughing in the corner. The music is very loud and the room is warm with the memory of other people's dancing.

At the other end of the room Abigail Conway is spinning around in a white tank top and skinny black jeans, skipping from one foot to the other, arms in the air, head down. She is a good dancer, but not intimidatingly so. She dances like she really wants to dance, like your song is the song she has been waiting for all day. It is the kind of dancing that makes you want to join in.

As the door closes, you begin an awkward half-skip, half-walk towards the middle of the room, head sort-of nodding, trying to overcome the awkwardness of dancing with a stranger completely sober on a Saturday afternoon. Or perhaps you're not that kind of person. Perhaps the moment the door opened you bounded over to Abigail with all the enthusiasm you could muster and the two of you are now throwing yourselves around like children on a bouncy castle. Or perhaps you don't dance at all. Whatever, this is your song and you can do what you want.

It's all so simple, but at the same time it's not. The music is too loud to talk and it's too dark to really see each other's faces. Nonetheless somewhere in the space created by this song you are trying to meet one another, to be vulnerable, to trust one another, to find common ground through an improvised language of adjustments and reflections. Abigail's body moving with your body, trying to find in your movements whatever it is that you love about this song, and you trying to tell her. It is an attempt at a kind of empathy, across the myriad differences that separate you from each other.

(AF)

Sheila Ghelani

1. The field

John Berger's essay 'Field' is framed by a Russian proverb: 'Life is not a walk across an open field.' It's a description of a set of experiences, events with a particular relation to time, and the 'ideal mode' of this experience requires a field. 'Any field, if perceived in a certain way, may offer it,' he says, but there is also an 'ideal' field, with four characteristics: it is grassy, it is situated on a hillside, the season is not winter, and the field 'is not hedged on all sides', because such a field 'limits the number of possible exits or entrances (except for birds)'.

2. The book

As far as I recall, the first proper conversation I had with Sheila Ghelani concerned not knowing. She had bought a book called *Rambles with Nature Students* by Elizabeth Brightwen, an all-but-forgotten Victorian naturalist, and was beginning to dream her way into a body of work that would share the overall title *Rambles with Nature*. She didn't know yet what it would involve, except that it would 'begin with / follow / explore the hedgerow'. The hedgerow she described as:

> A place to start out from. A place to disappear into. Or a connecting line, simply to follow. Literally, metaphorically, ecologically. An outdoor place. A habitat. Full of species, plants, animals, roots. Hybrids, lineages, power struggles. Fashioned by hand. A woodland relic. An ancient pathway grown wayward and wild. Teeming with myths. Teeming with histories. Barrier. Screen. Symbol of Britain. Of the Enclosure Acts. Of an impossible to remember common land.

Her approach to both hedgerows and rambles took guidance from an observation of Brightwen's: 'If we pass by everything with our mental eyes shut, our physical eyes observe nothing.'

There are different kinds of not knowing. There is a kind that is bullishly proud, closer to ignorance, the deliberate not knowing of the lucky man who scorns those who don't have his advantages and cannot understand why benefits should be available to scroungers and thinks it's wrong that anyone should have anything for free. And then there is the kind that is attentive, receptive, listens carefully and wonders, in the double sense of thinking, but also of marvel. A not knowing that, as Berger says of his ideal field, is an 'openness to events'.

3. The hedgerow

Rambles with Nature officially lasted two years, spring 2013 to summer 2015, and took many forms: walks, conversations, sound pieces, objects, films, texts, a series of encounters and experiences – events – unfolding slowly over time. At the end of the project Sheila created a book documenting some of its elements, and wrote in it of her gradual realization that '*Rambles with Nature* hasn't been about walking at all, but about finding ways in which to create art on my own terms, following my own vision, in tandem with those I'm collaborating with.' Her collaborators might be other artists, other writers, musicians, specialists in other fields (and let's be alert to that quirk of the English language there), community groups, members of the public, each of whom might open up a new angle of perception, a new line of inquiry, a new and unexpected possibility.

In other projects Sheila is more explicitly concerned with care, in the literal sense of nursing: my first encounter with her work was as a participant in *Nurse Knows Best* as part of a one-to-one festival at Battersea Arts Centre, lying down in a hospital bed getting treatment for some self-diagnosed ailment I no longer remember but was most likely a guise for the shyness and anxiety I was feeling at participating in one-to-one work. In *Rambles*, however, that care was less physical, more intellectual: a care for relationships, between people, with our environment; and particularly a care for the hidden. That which might be missed even with mental eyes open.

There is a kind of not knowing that is the inevitable result of so much in human history being covered up and (not-)written out of existence. And much of that is to do with colonialism and race.

4. The camouflage

Another ongoing concern in Sheila's work is hybridity, which has its roots in her mixed Indian/English heritage. As a site of 'much diversity – through its accommodation of species, plants, animals, hybrids, roots, lineages, power

struggles', the hedgerow also seemed to Sheila 'a less obvious way to explore hybridity', to think about diversity 'in a slightly camouflaged way'.

What is camouflaged in the telling of history? Working with artist Sue Palmer, Sheila followed one hedge after another until she reached the Great Hedge of India, a customs barrier 2,504 miles long, raised and guarded by the East India Company in the 1860s, the better to levy murderous salt taxes, on which so much of its profit depended. Sheila and Sue re-enact this journey in their performance *Common Salt*, following in the footsteps of writer Roy Moxham, who went in search of evidence for the hedge-barrier's existence and found only a road, deliberately placed to conceal.

I watched *Common Salt* kind of holding my jaw in position because every turn of the storytelling unveiled a fact that pulled it floorwards. Holding my ribs even tighter to assuage my hurting heart. Sheila and Sue follow the hedgerow to notice the connections between enclosure, land ownership, and ownership in general; between hedges and hedge funds and the inequalities enabled by both; between inequality and exploitation, capitalism and capitalizing on opportunities regardless of the human or environmental cost; between the seemingly intangible and the common, the everyday. More painfully they follow the roots of the hedgerow, back in time to the first Enclosure Act of 1604, and to the royal charter granted in 1600 to the East India Company, to begin trading in 'cotton, silk, salt, saltpetre for gunpowder, tea, opium'. Wealthy merchants and aristocrats could invest in the company in return for shares (and let's be alert to that quirk of the English language that occludes the generosity of sharing). It was 'the first registered trade mark in the world, and the first recorded company logo'. The East India Company was the model. The East India Company was the seed.

Within the show, Sheila and Sue screen a video from YouTube, a delightfully shonky DIY demonstration of how to remove a hedge: how to dig really deep into the ground to ensure that all its roots are lifted. But what equivalent demonstration video exists for how to dig up the roots of colonialism and capitalism, in ways that not only reveal them, and ensure that the violence that result from them might actually end, but that prevent new roots, new shoots, from growing? Among the laments expressed in the show, Sheila reveals that the East India Company has been revived by an Indian businessman, 'capitalising on the legacy'. Everything is going to be forgotten, they mourn. It seems as though people learn nothing.

Although *Rambles with Nature* resulted in a book and *Common Salt*, a tourable show, it would be a misperception to see Sheila as a maker of products. She is the maker of a way of thinking and living in the world: of following instinct and curiosity without knowing where they might lead, of giving attention, connecting, making space for reflection. She has an unassuming quality that makes her easy to overlook, a quiet that is easy to ignore. Like the event that happens in Berger's 'Field', 'not in itself over-dramatic', so absorbing it seems to suspend time, and in doing so opens up being.

5. The field, revisited

Those quiet occurrences, 'not overly dramatic' events, to be observed in Berger's ideal field might be nothing more than 'two horses grazing', 'a dog running' or 'a hawk hovering above'. The first event 'fixes your attention'; each subsequent event draws you further and further 'within the experience', to the point that the field, and the events it contains, 'appears to have the same proportions as your own life'.

Life is not a walk across an open field. But perhaps it is a walk alongside a series of hedgerows, perhaps the hedgerows that construct a maze, always keeping your left hand touching, in the hopes of eventually finding a way out.

(MC)

Further reading

Rambles with Nature, self-published by Sheila Ghelani

'Checklist of care', via sheilaghelani.co.uk, or in *This Book Is Yours: Recipes for Artistic Collaboration*, edited by Sally de Kunst, published by Vexer Verlag

'24 Frames in Commemoration of You', published in *Performance Research (On Repetition)*, Issue 20.5

Brian Lobel

1

The first Brian Lobel show I ever saw was called *Hold My Hand and We're Halfway There*. It is a performance that lasts anywhere from four hours to several days. In that time Brian watches hundreds of song-and-dance numbers from classic musicals on a series of televisions arranged neatly around a replica of his childhood bed. The musicals Brian watches are all VHS videos, each preserved in its original plastic case. It is Brian's own VHS collection, lovingly assembled over many years and now carried with him to wherever he performs the show. When *Hold My Hand. . .* was presented at Forest Fringe in 2009 the videos arrived with Brian in several oversized plastic laundry bags already splitting at the seams under the weight of their contents: 45kg of classic cinema, about the same weight as a small person. In 2013 when Brian presented the show in Bangkok it required him to bring the whole collection from London in two of biggest suitcases I have ever seen. I remember watching him unpack them on the dusty floor of the old cinema lobby where the show was taking place, stacking them in neat piles as curious passers-by watched him from the entranceway.

(When not being used in this performance the videos are all stored on a high shelf running the whole length of Brian's living room. They peer down on him as he eats dinner or entertains guests, like a dress circle full of old Hollywood dignitaries: Ginger Rogers, Gene Kelly, Frank Sinatra, Diana Ross, Yul Brynner, Julie Andrews.)

In the show Brian is always dancing. He watches no film all the way through, instead fast-forwarding or rewinding until he finds a musical number that he can dance along to. Routines are plucked from across his library of movies seemingly at random, each new selection accompanied by the comforting thunk and whirr of the video being sucked into the VCR. He wears a pair of headphones with two giant colourful stars glued on to the earpieces. The headphones are plugged into whichever VCR he happens to be watching at that point, meaning the only thing anyone watching can hear is Brian's fractured rendition of whatever song is playing silently on the TV monitor in front of him.

Hold My Hand. . . is performed in public space – in lobbies and foyers and cafes – and passers-by are invited to join Brian by picking up one of several other sets of headphones he provides for them. A lot of the time, however, Brian is alone, exhaustedly making his way through one routine after another; this is dance as a kind of manual labour, a mechanism of survival rather than an expression of joy. This all changes when someone chooses to join him. In this moment, through this small act of solidarity, the performance is transformed into a miniature celebration; it glows with the warmth of two old friends in a childhood bedroom, stumbling their way giddily through 'Getting To Know You' or 'Remember My Name' or 'Diamonds Are a Girl's Best Friend'.

Whether on his own or surrounded by new friends, it is apparent that what Brian is concerned with in this show is not what these films represent as discrete works of art but rather what they mean to us, and the use we choose to make of them. Cinema here is not something abstract and remote. It is a mountain of moulded plastic and electromagnetic tape. It is something that we keep in our houses and perhaps occasionally carry around with us in laundry bags or oversized suitcases. It is a burden and it is a refuge. It is a place for us, that belongs to us and us alone, and if we hold his hand Brian will take us there.

2

Few artists I know care as much as Brian does about the role popular culture plays in our lives. His work is often explicitly, unselfconsciously about precisely this. It is about classic musicals, Whitney Houston, *Sex and the City*, *Les Misérables* and the Eurovision Song Contest. He uses these points of reference to navigate the space between our lives and his, to find a common language through which we can untangle the complexities of our relationships to each other. In these performances we dance with Brian, we lie on a bed with him, we make mixtapes together, and by doing so we can think together about belonging, identity, community, mortality and care. Brian presents popular culture as a tangible part of the architecture of our everyday lives, as real and as personal as any of the other keepsakes and mementos that sit on our shelves gathering love and dust.

Such tangibility might seem anachronistic in an age of streaming subscriptions and digital rights management, when the cultural stuff we fill our lives with never actually belongs to us any more. It is an era in which it can sometimes feel as though ordinary people like us are no longer the end consumers of culture but instead just another product to be consumed. Our every action logged, our every desire recorded and sold by gargantuan new digital corporations, transforming us into little more than anonymous data points aggregated into an infinite and unknowable system.

When we try to step back and appreciate the true nature of the digital infrastructure we are now inescapably a part of, the experience can be dizzying and filled with dread. Digital art often seems to me to be preoccupied

with this feeling. With attempts to explain the scale of the unknowability of this digital realm and the powerlessness of our place within it. A place where, as James Bridle has stated, 'the resulting sense of helplessness, rather than giving us pause to reconsider our assumptions, seems to be driving us deeper into paranoia and social disintegration.'

3

In *Purge* the audience enter to find Brian sat behind his laptop. He is on Facebook. We can tell this because the computer's desktop is projected across the wall behind him, and open in a window on that desktop is Facebook, its hauntingly familiar white-and-blue layout blown up to a monstrous scale. It fills the room. Music is playing. This is the church of Facebook and we are its congregation. In an acutely literal sense this is a site-specific performance. Brian is typing a message to the audience as a Facebook status update. We watch him typing, the cursor blinking, letters appearing and occasionally deleted again. He is welcoming us to the show, his words as disarmingly informal as any other Facebook status update we might have read that day.

By this point in time we all know what Facebook is: vast and complex, opaque and unfathomably powerful, empowering extremists, undermining our trust in the media, gathering from its 2.5 billion monthly users the largest library of personal data in human history, beyond the oversight of any government or international body, and ruled over by a millennial sun king whose expansionist desires are matched only by his love of charcoal-grey cotton T-shirts.

Purge does not exist in ignorance of this knowledge, but neither is *Purge* an attempt to explicitly confront it. Instead, Brian confronts Facebook at street level, through the multifarious ordinary and unspectacular interactions that make up our everyday experience of it. He does so with empathy and without judgement or shame, as someone who himself both understands the evils of the platform and also recognizes the reasons that we are all drawn to it. In the end I think *Purge* is not a show about Facebook as much as it is a show about friendship, belonging, connectivity and care, and perhaps the way in which our desire for these things is often exploited and left unfulfilled by social media.

Specifically *Purge* tells the story of an earlier project Brian made, also called *Purge*, in which over the course of several days he asked members of the public to decide whether he should keep or delete each of his 1,300 Facebook 'friends', giving himself one minute to make a case for each of them in turn. In the new version of *Purge*, Brian discusses the fallout from this earlier project, how its challenge to the inertia of digital friendship rippled out across his real life in the form of dialogues with friends who were by turns delighted, curious and appalled by Brian's choice to hold their friendship up to the judgement of complete strangers. He discusses the conversations it initiated, the arguments that it caused, and the familiar

frustrations and disappointments of maintaining friendships across the internet.

Throughout Brian sits at the front of the room, smiling warmly, his laptop open on the desk in front of him. He talks to us, asks us to hold up signs. At one stage someone from the audience is invited up to log in to their own Facebook page and write a message to someone they have fallen out of touch with. This is, it turns out, not the church of Facebook at all, but rather another, older kind of gathering, one at which we, facilitated by Brian, can collectively determine the kind of communion we want to have. A gathering at which together we can reimagine the way we use this social network and the space that it takes up in our lives, drawing our own human desire lines through its byzantine coding, asserting from within its oppressive architecture the radical ways in which we desire to love and be loved.

4

At the beginning of perhaps the most well-known chapter of Michel de Certeau's *The Practice of Everyday Life*, he stands on the 110th floor of the World Trade Center gazing down at the vast spectacle of Manhattan laid out beneath him, a 'stage of concrete, steel and glass cut out between two oceans (the Atlantic and the American) by a frigid body of water, the tallest letters in the world composing a gigantic rhetoric of excess in both expenditure and production'.

It was at the time the most iconic view of perhaps the most iconic city in the world; the city against which all others are measured and understood. But for de Certeau, this scopic version of New York, impossibly vast and bleakly excessive, is only 'a theoretical simulacrum'; it is a dark fantasy of the city belonging only to urban planners and cartographers, no more real than their charts and maps. We think we can see the city from up here, but we can't. To truly know the city, we must descend back into the dirty, busy streets. We must concern ourselves with the people that live there, their infinite intersecting movements, the way they make and remake that city as they pass through it, the tactics they use to survive. It is not the abstract concept of the city that is the subject of this chapter, but rather the actions of the ordinary people that inhabit it, and it is to such ordinary people that de Certeau dedicates his book:

> To a common hero, an ubiquitous character, walking in countless thousands on the streets.

Brian's work might bear a similar dedication. He is always in the process of making his own journey down into the cities he inhabits, cities made not only of buildings but also of classic musicals and popular television shows, of video games and pop music, cities made up of the infinite intersecting writings of the internet.

He understands intuitively the ways in which ordinary people – people like him, people like me and you – navigate through all this stuff, the way they make use of it to build an identity for themselves, to find a sense of belonging, to create communities, to create a home. Consequently, he recognizes that all these seemingly trivial things are always more important than they might initially appear. In Brian's work the case is made that the best way to initiate change in any system is not by trying to apprehend the whole of it all at once, but rather through a myriad of tiny gestures, small readjustments to our relationship to that system. Different ways of seeing and participating and of understanding one another. Our route to a better world is through re-evaluating the use we are making of the current one.

5

My very favourite piece of Brian's is a project called *Love Letters and Lehman Brothers*. In it Brian sits at a work desk carefully cutting out individual words and letters from the 2,000-page legal examination into the collapse of Lehman Brothers and delicately gluing them onto a roll of white paper, as if tenderly composing the world's largest ransom note.

The Lehman Brothers examination is big: two dense volumes hardbound in sombre red. Brian uses a scalpel to carefully remove each word, leaving behind only a rectangular hole, an accidental redaction. Over hours, days even, the pieces of this impenetrable legal document are used to recompose emails between Brian and his former partner Grant, one of the people responsible for writing the report. The emails are casual, loving, funny, unremarkable, unbearably intimate. They are the kind of love letters that anyone might hope to have safely stored away somewhere. Brian slowly and patiently pieces them back together, stopping to chat to people as they enter the room to find out what he is doing.

Slowly Brian sets in motion the most unremarkable and quietly beautiful act of transformation in any of his works; an alchemical substitution, of kindness and empathy for selfishness and greed, a story of one kind of collapse replaced with another very different one. It is a hymn to the everyday stuff of ordinary relationships, of sadness and love, of belonging and understanding, the quiet goodness that I hope we all aspire to, and the possibility for such ordinariness to reclaim the world from the greedy and the powerful, one email at a time.

(AF)

Further reading

Purge, published by Oberon

Artists who lack manners in the best possible way

Ria Hartley

You are standing with your legs apart and your hands holding open your jacket to reveal your T-shirt. I am sitting behind you, on a panel with two other women, and in front of you is a white man who has waffled for ten minutes – as white men in panel discussion audiences often do – about live art and criticism and the irrelevance of these things in his eyes, and you are holding open your jacket to reveal your T-shirt, which has two rough-drawn circles on it. One is larger and inside it are written the words: loud white men. The other is smaller and contains the words: opinions that matter. The overlap between them is tiny. You are standing with your legs apart, like Wonder Woman, radiant, and as the audience cheers you for interrupting this man, I think: I love you, Ria Hartley.

*

In 2013, on the day of their thirtieth birthday, Ria Hartley married themself. They wore a white dress, carried a bouquet, declared vows they had written, committing themself to the life they had chosen to lead: life as an artist, as someone who practises 'creativity, criticality, politics, philosophy and life through all of my senses and intelligences'. The quote comes from a speech they gave, early in 2015, to a gathering of Live Art producers, venue directors, makers; I wasn't there, but Ria gave me the printed text to read, which felt at the time like an act of trust, that I wouldn't some day misuse their words. We had only just met, and I was shy, because I had read about their self-marriage and was inarticulate with admiration. In 2015 I was coming up to forty, wriggling inside a heteronormative marriage, and the idea of this commitment to self, expressive not so much of self-love but self-belief and self-respect, astonished me. What would it have taken to feel that at thirty, when I accepted that proposal of marriage? What would it take to feel now?

And of course, it's not just about self: in that speech for Live Art UK Ria further wrote that 'my work desires communication, exchanges, shared experience', and that within it they are 'speaking in solidarity with all those who experience the struggles of inequality, oppression, exploitation,

injustice, otherness and violence'. The self-marriage was, is, a political act, an act of defiance against an 'imperialist, white-supremacist, capitalist patriarchy' that, for centuries, reinforced itself through the structures of marriage. It is a commitment to the 'other loves' celebrated by Rebecca Solnit in *A Paradise Built in Hell*, loves she characterizes as principles, ideas, citizenship, social engagement. And it is a commitment to community in the way described by bell hooks in *All About Love*: 'Many of us seek community solely to escape the fear of being alone. Knowing how to be solitary is central to the art of loving. When we can be alone, we can be with others without using them as a means of escape.'

<div align="center">*</div>

I was trying to write to you personally, directly, but the tone was off-kilter: grave, stilted, distant. I was writing to declare that I love you, but also you unnerve me. Your strength unnerves me, because I don't have it. Your perspicacity unnerves me, because I feel you can see through me. Your anger unnerves me, because I am a product of the imperialist, white-supremacist, capitalist patriarchy you fight against. The dismissive trope of the 'angry black woman', which I introduce so carelessly, identifies me as such.

Maybe what that self-love and self-belief takes, I wrote in that first draft, is an accumulation of traumas, whose toxic effect you are having to clear from your system, slowly, in adversity. An adversity that includes me.

<div align="center">*</div>

Part of the adversity Ria works against is the idea of diversity, which they described to the Live Art UK gathering as 'just another term for "other" or "marginal"', one that renders those othered inferior to 'the imperialist model of what is deemed uniform, normal and correct'. To begin to challenge this, they argued, 'privilege must be acknowledged in everything we do . . . It's risky, and it will be painful and uncomfortable, and many of us will have to change some of the ways we do things and think about things . . . [But] we must find the courage to first acknowledge this and then embrace our responsibilities to ourselves, and to each other.'

This thinking followed me into *Spit Kit*, a short one-to-one Ria performed as part of the Fierce Festival in 2015. It's modelled on both DNA testing (it takes place in a mock-up of a lab, Ria in a white coat, small plastic vials lining the walls, an atmosphere of antiseptic calm) and standard diversity monitoring forms, and invites participants to notice for themselves the interplay of imperialism, supremacy and capitalism within the human body. I left it feeling like I'd broken the work: not because I was resistant to what it was trying to draw out, but because of the arrogance with which I approached it.

Spit Kit takes to their logical extreme the questions so often asked of people of colour: 'Where are you from? But where are you really from?' Ria asked me about family, where I was born, what I knew about my background,

further and further back, most of which is a mystery, obscured by poverty and indifferent bureaucracy. I grew up in London, an island within an island, with parents from another island (Cyprus), once colonized by this island, still claimed by another country, so strategically positioned that for centuries it has formed a bridge – or a thoroughfare – between worlds. I've long enjoyed the possibility that my blood co-mingles that of unknown restless people, and even if it doesn't, London is a city that houses the globe: I'm proud to name Londoner as my national identity, it's the only one that fits. This was what I insisted on within the work, and I knew at the time – albeit subconsciously – that in doing so, I wasn't really listening. That arrogance I mentioned is born of whiteness and an Englishness that, being of Cypriot heritage, I'm quick to disavow. In 2015 I was only just beginning to notice the privilege it is to move through the world as a white woman of indiscernible background – let alone the privilege it has been to call London home, while so much of the country has crumbled with neglect. I look back on my engagement with *Spit Kit* as not only a failure to acknowledge that privilege, but a stubborn refusal to change.

<div align="center">*</div>

I send a first draft of this text to my friend Mary Paterson, a brilliant writer who often supports me as editor, and she responds with a list of incisive questions:

'When you say "I love you Ria Hartley", are you being literal, or is it more like a figure of speech? Is it uncomplicated and sisterly? Or is it about longing? About otherness? How is it complicated? How is it easy? How does this kind of declaration of love impact on someone who is redefining their relationships to love, to subject-hood, to visibility, to desire? Also, how does that love relate to you? Is your declaration of love a kind of declaration of hate for yourself? Is it a displacement of how you feel about yourself? Does it place them in an impossible/idealized relationship to you? Are you making them an icon? Are they teaching you something?'

<div align="center">*</div>

That refusal to change – temporary, I hope – exposed by *Spit Kit* rankled because it was so different to the desire and readiness for change that is expressed throughout your work: for change in 'our health services, our government, our value systems' on the outside; but also for change within yourself. The quote this time comes from the information sheet handed out with *Untouchable*, a work of such stark autobiography I want to sit beside you as I write about it, talk directly to you.

In *Untouchable* you peeled away the bandages of self-protection you had to wrap yourself in to survive a childhood of domestic violence, and stood before your audience exposed. What you revealed wasn't a victim but a volcano: as much as you were hurt, damaged, scarred, you were still seething with deep-buried rage. And just as a volcano offers a fertile soil for

new life, *Untouchable* suggested the abundant possibility in learning to live with your past.

There is so much self-hatred in wanting to be different inside, so much potential for depression, but while it was clear that this had been your experience, something more positive was also going on. At the heart of *Untouchable* is the ritual of Descansos, described by analyst and storyteller Clarissa Pinkola Estés in her book *Women Who Run with the Wolves*: a ritual of (self-)forgiveness, which begins with making a timeline from birth to present of all the 'roads not taken, paths that were cut off, ambushes, betrayals and deaths' that have twisted a life into its individual shape. There were photographs and a short film of you and your mother returning to the homes in which you had experienced violence, leaving there a flower to mark the ritual of mourning, but also of forgiveness: forgiving each other, forgiving yourselves.

That was one act of healing; another was the family therapy process you underwent with your mum and brother. The room you performed in at the Albany looked a little like a counselling room: there were soft chairs and low coffee tables holding pot plants and boxes of tissues; but also mementos, a school report, maybe a soft toy? So it looked like a family sitting room – the kind of neat and calm family sitting room you were never able to experience. Your mum had children with three different men, each of a different background, giving each child a different skin colour: her very own United Colours of Benetton, you joked. Except there was no unity. The men were violent, and then they left, but the violence didn't. This is my abiding memory: you are standing with your legs apart and your hands holding – what? A cricket bat, a rolling pin, a walking stick? Nothing at all? – in a sense it doesn't matter, what matters is the rage that erupts from you as you bring it smashing down, down, down.

Against that violence was the tender care you brought to the room: it set a standard for how work based in trauma could, or should, be shared. Every audience member is greeted as they enter: because of course *Untouchable* is a work of such stark autobiography that when you perform it you want to sit beside us, talk directly to us. You begin by saying that being in the room will be difficult, and it's OK to leave at any point, return at any point, or not return at all if that is what's needed. You tell us that there is a quiet space outside into which we can escape, and an usher both inside the room and outside the door, trained to look after us so we don't have to be alone. At the end it is OK to stay in the space until we've had a chance to gather ourselves together again. And as we leave you are still there, at the door, worn but whole, with a word of goodbye that carries in it the melody of having done more than survived.

*

To write that 'imperialist, white-supremacist, capitalist patriarchy' reinforced itself through the structures of marriage is to imply, among other things, that

women were transformed by marriage into property, owned by fathers until ownership was exchanged to husbands. And this is true. But we are in a time of reckoning, of white women needing to acknowledge the ways in which – even in the name of feminism – they have overlooked the specific experience of women of colour, who were transformed into property not only by patriarchy but imperialism, white supremacism and capitalism, and still live with the consequences of that. A time of reckoning in which it is insufficient to imply and not clarify. In which it is insufficient to talk of change and not live it.

With every 'I love you' comes a question: what next?

<div align="center">*</div>

In my early twenties I had a car accident: I drove recklessly down a winding slope and span a full turn and a quarter, ending up strapped in my seat but dangling sideways to the ground. I wasn't thinking about this as I walked towards *Recall*, another one-to-one piece, this time at the Spill festival in November 2015, in which Ria invites participants to 'return to a memory and change it'. I was thinking about all the stupid embarrassing things I've said in my life that have haunted me: times when I've revealed myself as the ignorant, thoughtless idiot I truly am.

Within a few minutes of *Recall* finishing I wouldn't have been able to tell anyone what the questions were that emptied my mind of everything I had come in with. It works by stealth; a friend later described it as magic, a thing of unexplained mystery, and she was right. Was I asked about snow? I think I remember that, remember telling Ria about moving to a house with a garden after being evicted from the flat I'd lived in since birth, and how the snow in that garden sits in my mind as the first snow I ever saw. The video trailer reminds me that they asked what the last film was that I watched, where my passport is, who I was missing – all questions that would have sliced right into those thoughts about dependency that plague me. How I was feeling when I woke up, what I dreamed about the night before. In the video Ria talks about studying neurology, specifically the workings of memory, and creating a sequence of questions – a flurry of movement across space and time – that would open up the participant's mind. And that's exactly how it felt.

Into that opening sprang an image of the car accident. More questions from Ria and into the opening slipped an image of me, sitting by the side of the road, a few metres from the wreck, writing a note to my then-boyfriend to say that I was staying alive for him. More questions from Ria and through the opening emerged a way to rewrite the memory: rewrite it so that instead of living for a boy, I could live for me. Embracing the courage, and the responsibility, of that.

Essential to this work is the fact that Ria and their participant are concealed from each other: Ria is seen on a television screen via a camera that works only one way. They explained the thinking behind this in the

video trailer: 'The decision for making the audience anonymous is really to give permission, I guess, for openness and concentration and more agency[:] it gives more permission for more agency, for the audience to choose how far they want to go.'

I still don't know how far I want to go. But I spent the bulk of the time after seeing *Recall* in therapy: an attempt at knowing how to be solitary the better to love community that I trace back to my interaction with Ria in that work. Even if I can't totally rewrite the past then at least I can try to reread it, in such a way that might help me better write the future.

For me, but also for you.

*

We wrote to each other a couple of times in 2017, and that July I confessed:

'i think i'm still processing the ways in which *Recall* impacted me. one day i would love to talk to you in more depth about your own relationship with the work, with people like me telling you things like this, with disclosure in the room. lately i've been thinking a lot about a lyric by a swedish singer, jens lekman, which thinks about how those in positions of care also require care themselves – who is the therapist's therapist, for instance? i think about it whenever an artist puts themselves in such a position of opening people up so they spill in some way (that sounds quite negative! whereas for the audience member i'm thinking it's entirely positive, and just worry about what the space is for the artist to process).'

You said then you were 'thinking a lot about transformation, sacredness and emotionality'. Your website is no longer on the internet. A friend, who is much closer to you than me, tells me that you have moved away from performance, towards processes more related to psychotherapy. I hope the performance world continues to learn from you none the less: from your courage, your complications, your commitment, your care.

(MC)

Stephanie Albert

The financial crisis of 2008 built the theatre that I have lived and worked in for my entire professional career. It is a theatre full of perpetually shrinking rooms, in which the economics of the current era seep into the architecture like dry rot. The people who run this theatre are forever closing things down and selling things off, desperately papering over the cracks in the lobby while allowing large chunks of the auditorium to fall into the sea. Most of the work I get to see also takes place in this theatre and that which doesn't feels strange and impenetrable; too dazzling bright for eyes accustomed to something gloomier. Increasingly it seems that all the artists sheltering here are caught somewhere between attempting to come to terms with these circumstances and the shared dream of escaping the theatre entirely.

I had never been to the ICA in London when, in October 2008, they announced they were closing their department of Live Arts and Media. To people who had been around since the department's glory days under Lois Keidan in the distant 1990s, the announcement came as a shock dulled slightly by the years of neglect it had suffered since that time. The closure seemed to herald the coming of a new post-Crash era in which the awkwardly unprofitable and defiantly unglamorous were easy targets for struggling institutions looking to cut their budgets. ICA Director Ekow Eshun's break-up letter was quick and painful, airily declaring of live art that 'in the main, the art form lacks depth and cultural urgency'.

Shallow, irrelevant and definitively barred from the home it hadn't been welcome in for some time: it seemed unlikely that live art could retain the same degree of influence on the wider culture via its remaining network of precarious artist-run projects, occasional festivals and small-scale venues in historic market towns and fading seaside resorts. My arrival into this world was poorly timed to say the least.

It came as both a surprise and a relief therefore to find myself arriving at the ICA for the first time only a few months later for the opening of an ambitious festival of live art programmed at short notice by Tim Etchells and Ant Hampton as part of a remarkable climbdown from the institution

and its contrite director. The festival was called True Riches and it spilled off the pages of the hastily assembled programme and out into every corner of the building, bringing together many of the most exciting live artists working in the first decade of the twenty-first century.

Like someone recovered from a near-death experience and now attempting to live every day as if it is their last, the work I saw on that foggy January night had a maniacal urgency to it and the kind of recklessness that makes you feel almost breathless. Perhaps the most audacious move of all was to make the venue's main theatre, the legendary site of the majority of its performance work up to this point, completely empty of performers and almost entirely inaccessible. I squeezed with about a dozen or so other people into a narrow opening by a fire escape to watch a fan in the ceiling send tiny ripples eddying out across a vast metre-high tank of water that filled the space to its very edges.

Elsewhere Rimini Protokoll had stationed an actual German Shepherd in the lobby to guard against the ingress of any work lacking the appropriate cultural urgency, though on the several occasions I walked by he was simply curled up in a ball in the corner. In the venue's basement you could hear the loud, mechanical grinding of a menacing-looking machine with which Shunt claimed they were crunching big ideas like 'Love' and 'War' down into shit-sized nuggets that could more successfully be hidden 'if god forbid hiding should become necessary'. Meanwhile in the otherwise empty gallery spaces upstairs Rajni Shah offered guided tours of the bare white walls.

I wandered through all of this like an idiot in a dream, dazzled and exhausted, until I came across a small dark room at the back of the building, its entrance covered by a black curtain. A sign read 'Stephanie Albert, please switch your phones off'.

Inside a few people were sitting around on oversized grey bean bags, their eyes closed, listening to something on sets of headphones that dangled from the ceiling. I found an empty space and put the headphones on.

The voice in the headphones was whispering as if she was in a crowded place and trying not to be heard. Her voice was English but otherwise unplaceable, not old or young, perhaps the gentlest suggestion of a Northern accent. She spoke with unhurried concentration, the space around her voice sounding velvety dark. She seemed to be describing a street performer, a human statue painted silver and standing on a box in a busy city-centre square, and the people who interacted with him – careful reports of comings and goings, children tentatively approaching with coins, couples smiling for a photograph, the changing colour of the sky, his occasional readjustments of position. The implication seemed to be that she was speaking to us live but I had no way of telling if this was the case or not.

Everything felt just banal enough to be true. And yet somehow because of her careful, deliberate delivery, or the specificity of each detail, the whole thing appeared woozily uncanny, like something from a painting by Bruegel. *Is this a description of a performance, or a performance in its own right?*

Are you bearing witness to a theatrical act, with all its attendant magic tricks and sleights of hand, or is the absence of theatre the entire point?

Earlier in the same year on the other side of town I watched Forced Entertainment's *Spectacular*, in which a man in a skeleton outfit forlornly described the various elements of his usual show – the lights, the dancers, all the usual theatrical splendour – that were tonight unexpectedly absent. Around the same time Forced Entertainment director Tim Etchells released *A Short Message Spectacle*, a performance of near-infinite scale and strangeness, described via text messages that arrived at regular intervals over the course of several days. A few years later in *The Author*, Tim Crouch would sit among an actual audience at the Royal Court describing a previous show he had written for the same venue that had never actually taken place.

In each case the words spoken hovered in the air like cartoon cigar smoke, forming the hazy outline of fragments from some far larger theatrical spectacle before quickly fading from view. What was going on here?

Perhaps these words and the shows that contained them might be thought of as a kind of anti-spectacle, an act of reclamation in which the pointed simplicity of a person speaking in an otherwise empty space is juxtaposed with the cartoonish excesses of the show they are describing. The extravagant costumes and the grandiose emotions, the pretend deaths, the special effects, the revolving stage, the lights, the projections and the live band. All the theatre money can buy.

One result of this juxtaposition is to reaffirm the potency of language as an apparatus of representation, a material out of which even in moments of scarcity and disappearance we can build almost anything we want. This is an act of pragmatism and of defiance, a critique of material excess and an invocation of the limitless potential of the imagination. It is also I think a statement about the complicity of artist and audience in giving form to imaginary things and allowing them to escape into the real world.

I don't know how long I sat in that small dark room at the back of the ICA. It was probably around an hour. Over time the words became more like texture than descriptions, a kaleidoscope of patterns and colours, a woman in a bright red coat talking on her mobile phone, a baby in a buggy holding a plastic Spiderman toy, the darkening of the night and then the sudden glare of LED streetlights, the slight tremble in the performer's arm, his head tilted inquisitively sideways, one foot placed carefully in front of the other. I could see him there, his eyes fixed, his breathing just about visible under his costume's elaborate layers. And then suddenly it was over, the man got down from his stool and walked away, and seconds later the connection was cut.

Over the following days I became fixated on this performance by an artist I had never previously heard of and her description of a performer I wasn't even sure really existed. I tried to remember any details she had told us that might give away the street performer's identity or location, but the net was just so implausibly wide. I didn't know if she was in London or even in the

UK, if this was a performance that happened that night or years before or whether every detail had been drawn entirely from her imagination.

I googled Stephanie Albert and discovered a fairly cryptic Myspace account containing little more than a picture of a shadow stretching out across bright green grass and the word 'Zobeide' above a series of links to forthcoming performances. The ICA performance was listed and so were three further performances at the Leeds Met Gallery and Studio Theatre, the Greenroom in Manchester and the National Review of Live Art in Glasgow.

The National Review was a live art institution that, like the ICA, I had yet to visit. In my mind I imagined it as some vast and intimidating cultural spectacle on the scale of Paris Fashion Week or the Cannes Film Festival. I committed myself to going in February and finding the piece again in the hope of unlocking its secrets. In the end, however, this plan came to nothing; after the initial rush of excitement at the idea of going all the way to Glasgow to see a performance I'd already seen, the economic reality of living in London made this a less and less enticing prospect as the months wore on. At the time I was living with eight other people on the top floor of an empty office block on Blackhorse Road in north London, living off a postgraduate grant, running events for nothing in my spare time and trying and mainly failing to interest people in the shows I was making or wanting to make. In the evenings we ate candlelit dinners at a banqueting table borrowed from someone's parents or sat on garden chairs on the roof and watched the sun set over the whole of London. Had I had the comfort of knowing everything would work out OK this would have felt incredibly romantic. As it was, London felt less like a playground of infinite possibilities and more like a labyrinth of dead ends, failures and disappointments.

Eighteen months later I had completely forgotten about Stephanie Albert when in July 2010 I attended the last night of the Shunt Lounge. By this point the world felt a bit more solid but no less precarious. The Edinburgh Fringe Festival venue I ran with a friend of mine was, improbably, some kind of success, though it was already facing its own threats of imminent closure. The last night of the Shunt Lounge was an event that seemed less momentous than it should have done because the Lounge had already had at least two last nights before being granted temporary stays of execution by Network Rail on both occasions. It seemed like perhaps this was just the way it would carry on – an endless succession of last nights, a kind of purgatorial costume party at the end of the world. This time, however, would indeed prove to be the last time, as the venue shut permanently to make way for the regeneration of London Bridge station, leaving behind it a hole as vast as the newly built skyscraper rising above it.

Inside that night, the Lounge seemed much as it always did, albeit even fuller, even wilder; like a kind of Weimar cabaret at the end of the 1930s, except instead of Nazis closing in on all sides it was portfolio managers called Simon. There was an experimental jazz trio playing in an alcove filled

with splinters of broken mirror, a woman in a long flowing dress made of iridescent blue-green butterfly wings and what appeared, from peering through a small window, to be a room full of people fisting each other but might have been a clever trick with video projection (but might equally have been a room full of people fisting each other). I didn't know who any of these people were or how they had got here but here they were.

In the midst of this I was handed a photocopied A5 booklet. Handwritten on the front of it was 'Solos by Stephanie Albert' and contained in the booklet were descriptions of a series of twenty untitled 'solos', numbered in Roman numerals. Each was the outline of an ordinary action or sequence of actions described in the same spare, affectless language I remembered from the piece at the ICA, with no indication given as to whether these were performances that were currently being performed, performances that were to be imagined, or whether this was an invitation for me to perform some or all of these actions myself:

Solo I: A woman stands in a narrow doorway, her eyes opening and closing as people brush past her. When she feels her presence has become conspicuous, she leaves.

Solo VII: A man at the bar waits for a drink to be delivered and thinks about the blue of a swimming pool.

Solo XIV: She is hiding behind a closed door.

I read them quickly and then slowly, glancing up to see various things that could be people acting out these performances or could be bits of reality that the text had cunningly drawn its outline around. Maybe this was just a couple of pieces of paper but maybe it wasn't. The uncertainty allowed the piece to feel almost haunted, containing the mirrored solitudes of the people described, the person describing them, and me, stood on my own in the corner of this giant party experiencing what felt like a performance but without the definitive presence of a performer or even any other audience members to guide me. It was a rejection of live performance's pursuit of connectedness and tangibility; an exercise instead in disconnectedness and uncertainty, a study of the kind of loneliness that modern cities can be so cruelly good at.

In this regard perhaps the work seemed to emerge less from the collective tradition of theatre than the dissociations of the performance art of the 1960s, containing within it traces of the urban alienation of Vito Acconci's *Following Piece* or *Seedbed*, the strange opacity of Joseph Beuys' *How to Explain Pictures to a Dead Hare*, and the intimate quietude of some of George Brecht's event scores. More than anything however, I thought about Sophie Calle's *Suite Vénitienne*, a journey through Venice in pursuit of a stranger, a piece made up of elusive fragments and unresolved longings; a series of photographs about seeing and being unseen in a city that is always, in part, invisible.

I thought briefly about trying to track Stephanie down in the crowd, but not knowing what she looked like, or actually anything about her, the task seemed impossible. After an hour or so of wandering through the increasingly debauched Lounge on my own, I put the booklet in my coat pocket and left to cycle home. The night outside was warm and quiet. I cycled over London Bridge and saw the lights of the city reflected in the river. On Bishopsgate the half-built skyscrapers towered over me but with no one else around it felt like the city, temporarily at least, belonged only to me.

I thought I saw Stephanie's work one more time though I can't be sure it was her. Approximately a month after the Arches in Glasgow was forced into closure, a series of neon posters appeared on the streets around Central Station: each one had the title 'Forthcoming Attractions' and a description below it of an event taking place in the empty space once occupied by the venue. A ladder of chairs piled up to the ceiling, used as a means of escape. Two men dressed as ghosts in white bed sheets fighting in a darkened room. Forty days of intermittent rain from a series of artificial clouds hanging from the otherwise unused lighting rig. I can't know it was her, but it seemed right.

At home I searched again on the internet but now all these years later her old Myspace page could not be found. I emailed Tim Etchells to see if he could put us in touch but he told me he didn't know anyone by that name.

(AF)

Further reading

Suite Vénitienne, by Sophie Calle, published by Siglio Press
George Brecht at UbuWeb.com
If on a Winter's Night a Traveller, by Italo Calvino

PART 6

Acts of resistance

Nic Green

Scottee

Leo Skilbeck and Milk Presents

Christopher Brett Bailey

Adrian Howells

Nic Green

1

When I think of Nic Green usually the first image that comes to mind is of a stage flooded with naked women, whooping, bounding, wobbling. I like this, I like the fact that to think of Nic Green is to think in the plural. This scene of abundant flesh is from the first part of her immense work *Trilogy*, and what unleashes it is Nic and co-performer Laura Bradshaw banging on two tables with drumsticks and yelling the most simple and complex of punk revolution slogans:

start your own fucking movement

start your own fucking movement

start your own

start your own

start

'Feminism is a movement in many senses,' writes Sara Ahmed in *Living a Feminist Life*. 'We are moved to become feminists. Perhaps we are moved by something: a sense of injustice, that something is wrong . . . Feminism as a collective movement is made out of how we are moved to become feminists in dialogue with others. A movement requires us to be moved.'

The movement of flesh, a movement of minds. Women who performed naked in that section of *Trilogy* describe the experience as 'a political awakening': writer Amber Massie-Blomfield was one of them and, in a gorgeous essay published online to honour the tenth anniversary of seeing the show then volunteering to perform in it herself, credits it as the moment that the word feminism became 'part of my vocabulary'.

That moment happened for me in the early 1990s reading about riot grrrl in the pages of music weeklies *Melody Maker* and *NME*. News stories led me to gigs, which led me to zines, which led me to a politics and self-articulation that have guided my understanding of and interactions with the world ever since. Riot grrrl was an extraordinary way for a teenager to become a feminist because it was febrile, scruffy, not at all academic; inspired by punk it advocated doing it yourself, joining in, not just consuming but making; picking up the consciousness-raising baton from the 1970s wave of feminists, its mother's generation, it emphasized that the personal is political and the political is personal, and so encouraged women, young women, girls, to tell their truths, take up space and be heard.

In the 2000s it troubled me that girls younger than me might have encountered feminism first through the Spice Girls, one of whom declared Margaret Thatcher, architect of so much social division and economic inequality, 'the pioneer of our ideology – Girl Power'. I wanted something else to happen in pop culture – where language is lighter, and so easier to move through – to open up that door into, ideally, a more resistant and recalcitrant feminism. Meeting Nic to interview her about *Trilogy* then watching the show at Battersea Arts Centre at the very beginning of 2010 was a moment of thinking: here it is, here is what I've been searching for.

2

In Ahmed's 'Killjoy Survival Kit' – offered as succour to anyone trying to live a feminist life – is a section on bodies: 'bodies that prance, bodies that dance; ... bodies that have to wiggle about to create space'. Those naked bodies bounding and wobbling in the first part of *Trilogy* make space, by the end of the third part, for any woman in the audience to come to the stage, naked as well, and expand its vision of emboldened women. I wonder how differently I might be writing about *Trilogy* now – how differently I might have moved within feminism in the 2010s – if at any point I'd accepted that invitation.

In January 2010 I had a baby not yet a year old and another child approaching her third birthday and the rehearsal schedule for *Trilogy* felt impossible. I mentioned this to Nic at the start of the interview and she said: 'Next time we write the Arts Council application I'm going to budget for a crèche, because it does prevent so many women.' Becoming a parent had done much to unsettle my feminism, or rather expose its limitations: I felt abandoned in the pit of gender normativity, and while I knew how feminism might help me access society despite my children, I wanted a different way of being in the world with them. Nic rephrased this problem with the question: 'Is equality the basis of feminism? Equal to what, to who?'

This sliver of conversation hints at the ways in which inequality is at once a structural issue and an interpersonal one: Nic could have budgeted for

a crèche, but ideally there would already be one in place at all the venues she toured to. It also acknowledges the problem inherent in an idea of equality in a world skewed by multiple systems of domination. Feminism – at least, white feminism – hasn't been free of this skew: in the periphery of my dazzle-eyed vision in the riot grrrl era, I was aware that there were black women who felt it prioritized white experience, Muslim women who found its antipathy to hijab naive at best, at worst itself racist. I was attentive enough to absorb the concept of intersectionality before the word became common currency, but not enough to recognize white-centricity, in myself or others.

Back in 2010, *Trilogy* attracted much the same criticism. One blogger wrote that it appropriated the experiences of women in non-Western cultures without fully engaging with them, for instance by using an image of a woman being stoned, with 'very little consideration of ethnic specificity'. In the *Guardian*, Nosheen Iqbal found that it prioritized body image over women's 'social, academic or historic achievements', adding: 'Where is the work that gives voice to women who are oppressed by race and/or class, and which goes beyond the dominant priorities of white and middle-class women?'

Nic has since acknowledged that 'Systemically the way the piece sat in its various sectors – feminism, art, theatre – was limited.' It wasn't sufficiently 'in dialogue with others'. I think it's worth noting that Nic finished making *Trilogy* more than two years before Flavia Dzodan published the 2011 blog whose blazing title, 'MY FEMINISM WILL BE INTERSECTIONAL OR IT WILL BE BULLSHIT!' galvanized the feminist discussion that – to my mind at least – defines the fourth wave. It's also worth noting that Nic finished it a year before Instagram was launched: the app that has done so much to expose the ways in which the cultural objectification of women's bodies remains virulent, and internalized. There's a fun, cheeky, demoralizing segment in *Trilogy* in which Nic and Laura screen a video of themselves tampering with men's magazines: an action that would be almost impossible today, because how do you do that across the internet?

'A significant step for a feminist movement is to recognize what has not ended,' writes Ahmed. 'So much feminist and antiracist work is the work of trying to convince others that sexism and racism have not ended; that sexism and racism are fundamental to the injustices of late capitalism; that they matter.' In its whiteness, in not looking beyond the bodies of cis women, *Trilogy* was absolutely of its time. But in its insistence that women's bodies are still policed, still sexualized and trivialized and punished by misogyny, it mattered, and it still matters.

3

On the eve of the 2015 general election, three women wearing dark blue suits, their hands and a broad rectangle around their mouths painted gold, stood on the stage of a not-for-profit venue that, a few months later, would

have its nightclub licence revoked, disrupting the delicate balance of its finances and forcing it to close. I wasn't there because the venue, the Arches, was in Glasgow; by the time I saw *Cock and Bull*, performed by Nic and Laura with Rosana Cade, the country was less than a month from the 2016 referendum that would plunge the UK into the political turmoil still roiling as I write this three years later.

Cock and Bull is excoriating. Its text is constructed from common phrases repeated during the 2014 Tory party conference; phrases that the trio repeat as well, deconstruct and cut and paste and splice and layer, layer, layer, revealing through this the distorted morality embedded within them. John Berger calls such language 'ethicides – agents that kill ethics and therefore any notion of history or justice'. When David Cameron – son of a stockbroker, educated at Eton, supported in his political ambitions by his godfather – talked of 'hard-working people', did he mean the kind of hard work Nic and Laura and Rosana put into making this show: composing its text like an electronic symphony, every beat of it placed with infinitesimal precision; throwing every muscle of their bodies into its shattering? No, no he didn't. But then he didn't mean anything by those words, except to condone meanness.

The suit – this is from Berger also – 'was the first ruling-class costume to idealise purely sedentary power. The power of the administrator and conference table. Essentially the suit was made for the gestures of talking and calculating abstractly.' The three women occupy this stage with just three wooden chairs; gradually their abstract, calculating talk becomes a frenzied, libidinous dance of simulated fucking, disrespectful and violent, pushing at the chairs, destabilizing them, because this too is the effect of Tory language on society, on community, on human relations, disrespectful and violent and destabilizing. Gold smears their shirts, their naked flesh when the suits are removed, and the women hold each other, sweaty limbs mingling, a simple solution, but the one that is needed. Love. Care.

Words like love can sound so wishy-washy namby-pamby when rattling around in the hollow ice-cold core of right-wing politics, but in her book *Emergent Strategy: Shaping Change, Changing Worlds*, activist and healer adrienne maree brown gently suggests that love might be the only way to 'imagine liberation from constant oppression'. Like Nic – who told me when I first met her about the ways in which climate and environmental activism is central to her being – brown works from a sense of connection with the universe and all its elements, land and water, creatures big but especially small. In looking at the ways in which 'small, collaborative species' adapt to changes in their environment, finding ways 'to proliferate, survive, grow', brown points in particular to 'the way mushrooms can take substances we think of as toxic, and process them as food'. This is the extraordinary feat of *Cock and Bull*.

4

There's so much of Nic's work I haven't seen, for two reasons: a lot of it happens in Scotland (easily reached from London, but I still do all my work around a school run and other daily demands of growing children); and a lot of it is based in community (I'm one of many people who don't practise what they preach when it comes to giving attention to community performance). Nic has a child now too, and is trying to find for herself a different way of being in the world – particularly a performance world infected by Cameron's capitalist vision of 'hard-working people' – with a small person for whom hard work means something quite different: constantly learning, experimenting, living through play.

Around the time she was pregnant she made *Turn*, inviting women in Glasgow to tell stories of turning points in their lives, bringing to light a different narrative to the masculine one usually associated with the docks along the Clyde. More recently she's made *Like Flying*, working in schools to think about the benefits of art and creative expression to teenagers (but really, to everybody). I think of Nic and I think in the plural and I think of mycelium, first encountered in a blog post by Asher Wolf, who – like brown – believes in 'the supremacy of mycelial networks, matrixes of mushrooms and fungi that care for the biodiversity of the environments they exist in . . . nurturing not only themselves and their species but also the complexity of all the environments they touch'. I imagine that network stretching from Nic in Scotland to me in London, connecting us always, in care, in hope.

(MC)

Scottee

The first time I met Scottee, early in 2012, I thought: this person is going to change the world. I was interviewing them for the *Guardian* about their beauty pageant meets talent show for fat people, *Burger Queen*, soon to be renamed *Hamburger Queen* because a certain global fast-food chain pulled rank ('note how terrified the authorities and elites are': Rebecca Solnit, *Hope in the Dark*). We talked about fat liberation politics, how important it is to have a GP who pays attention to the individual body rather than a socially sanctioned generalized idea of acceptable weight, the diet industry and how fucking damaging diets are mentally and physically, taking inspiration from women and identifying as female while living in an assigned male body, light entertainment, being nice, and how important it had been to make the Royal Vauxhall Tavern stage accessible to wheelchairs so that Nina Neon, the previous year's winner, could take part. We also talked about making work with, or rather making space for, non-professional participants as artists:

> It's all non-professionals and it made me so excited that people have these fantastic ideas in their head and can show off. We had a performer last year called Bea, she comes from Brixton, very shy, she's never sung live, and I bullied and I bullied, I said please please come and do it. I thought she was gonna do some straight opera – she came and did an operatic version of Jessie J dressed in the most amazing African prints that she'd got from Brixton Market. Moments like that just make you amazed, because I'm not creating it, I'm just facilitating it, going: come on, here's the space, do it and then I'll put structure in for you to support you. There's a bit of theory behind it from a theatre practitioner called Augusto Boal, he made work where he got people from lower social status who often were illiterate or couldn't write down or stand up for their politics, and got them to perform it – because we can all play act or all play with each other. So we call it a beauty pageant slash talent show, it actually becomes people going: oh hang on, I can do this, and there's a confidence there that you install.

At time of writing I've had Boal's book *Theatre of the Oppressed* on the shelf for maybe fifteen years and still haven't read it. What is theory for me is practice for Scottee. And that's true in a whole lot of ways.

<p style="text-align:center">*</p>

Scottee is a do-er: if not an activist (they admitted to having 'a love/hate relationship with the term' on their blog), certainly someone who takes action. Within a few months of moving to Westcliff-on-Sea in 2016 they had set up regular community meetings for the artists who live locally to share and plot together, collaborated with the local LGBTQ+ community on dinners and public art works, and – a typical move, this one – responded to the snootiness of the local theatre in Southend deeming their work too 'community' for their programme by setting up Live Art Living Room, a series of performance nights in, you guessed it, their own living room. Concurrently they've been working in Peterborough, deemed in 2015 'one of the UK's worst locations for online homophobia': what began as a residency with Metal is growing into a projected four or five years of work including supporting locals to set up their own Pride event, trying out a temporary queer eco-commune and hosting a queer summit. And those are just the places I know about: there's also the work in Wales, in St Helens, in Ireland, and with the Irish diaspora, that's more or less invisible to the London eye.

It's geographically disparate work but what connects it are the two c words: community and conversation. Scottee does the slow, patient work of community building, community galvanizing, community transforming, that starts and grows through conversation. While I've been writing this, Scottee has been working in Leeds on *Would Like To Meet*, inviting people on a particular street in Bramley to talk about the neighbours they wish they could talk to (and why they aren't already talking to their neighbours), from which they made a series of estate agent placards advertising the conversation both wanted and offered. No one who lives on that street is going to live on it in quite the same way afterwards. And what is art for if not that.

<p style="text-align:center">*</p>

The second time I remember meeting Scottee was at their New Year's Eve night *Camp* at the end of 2013. They'd invited my all-sizes all-amateur dance group, the Actionettes, to perform, and we were truly fucking grateful that we'd been scheduled before bearded drag dancers Legs and Coq because a) they could do far more complicated high-kick moves than us while b) wearing heels at least four inches taller than any of ours. Another time, Scottee and I sat on my sofa and I told them about my tiny domestic climate actions – things like never using the oven unless it's full (no roast potatoes without high-speed cake) – and they said I'm basically queer and I blushed with diffident pride.

<p style="text-align:center">*</p>

There are two other c words that come to mind when I think about Scottee's work: class, and cunt. Class because so much of it addresses their working-class upbringing, and the ways in which entrenched social inequality gets internalized. Cunt because, as a maker of performance, they're not afraid to seem like one: 'I call myself a loudmouth and trouble-maker,' they told academic Steve Greer in 2016, 'and that's because I am.' Their stage work can be abrasive, belligerent, challenging, difficult – never egregiously so, always because unequal systems create ugly behaviour, ugly behaviour has both perpetrators and victims, and the Venn diagram of those two has a discomforting overlap. Scottee's work is morally complicated, because life is complicated, because their life has been complicated. Some of the story of that life, the shattered innocence of it, unfolds in *The Worst of Scottee*, which they perform themself, partly in a sequence of outlandish cabaret turns but mostly in the kind of photo booth people would take selfies in before the arrival of the smartphone, confessing one bad deed after another to peel back layer after layer of attendant guilt and trauma. Some more of the story of that life, the desire and danger of it, unfolds in *Bravado*, which they don't perform, providing instead instructions for a member of the audience to step on stage and read the text from an autocue. There's a question here about theatre and voyeurism: why should Scottee reinhabit the experience of being beaten up, rejected, assaulted for anyone's entertainment? But also, this isn't a singular story: the violence of their life has been invisible (except where sensationalized in the wider culture) because it is normalized – that's what's so toxic about patriarchal masculinity. Disrupting the expectation around the identities of storyteller, performer and audience unsettles that notion of normality, grinding the lens through which the violence is visible.

This tactic of displacement is used to devastating effect in *Putting Words in Your Mouth*, a text built from interviews with gay white men, constructed and directed by Scottee and performed by people of colour (Jamal Gerald, Travis Alabanza and Lasana Shabazz, all makers in their own right). Devastating because the performers, who lip-sync to recorded text throughout, have to mould their mouths into words that are increasingly overt in their suspicion of black and Asian communities, increasingly bold in their racism. Devastating because, if white performers were saying those words, the creeping insidious racism might slip by white audiences almost unnoticed. That can't happen when the effect of the words on the performers is right there in front of you, in muscles tensed and cheeks clenched with queasiness, the moments of physically recoiling and soothing each other. The night I saw it, Lasana Shabazz at one point exploded, screaming at these invisible, disembodied, pervasive voices to fuck off. Devastating because even if Lasana did get the opportunity to shout fuck off into the speakers' actual faces, it would just be taken as more reason to be wary of black people.

I found *Putting Words in Your Mouth* hard to watch, because it seemed to create yet more space for power – white-supremacist power – to speak its

mind. But the show is murkier, more nuanced than that. It makes clear from the beginning the trauma the white speakers have experienced as gay men subject to homophobia, their marginalization as working-class people, their sense of powerlessness arising from both of these things. Performed in traditionally masculine spaces – working men's clubs, boxing rings – *Bravado* is similarly murky, not least for the ways in which Scottee rejects masculinity but secretly desires it. You don't see Scottee's performance work to get answers: you see it to be startled by how the questions might be reframed or reassembled.

<p style="text-align:center">*</p>

In 2017 Scottee and I had our trickiest interaction to date. In a moment of misguided hubris, I'd decided to take part in their online workshop *Notepad Warrior*, a set of 'assignments aimed at getting you making work with clout'. By week two, the only thing I was clouting was myself, each activity a conduit for doubt, weakness and self-pity. To begin, Scottee invited participants to make a list of everything that fucks us off, but stipulated that it should be 'things that directly affect you'. I live an exceptionally cushioned (heteronormative, middle-class, affluent) life and everything I thought of, I crossed off, fearful it would be deemed an appropriation, too indirect.

I write about this not to criticize Scottee – the course got me thinking if not doing – or clout myself even more (well, OK, maybe a bit that one), but because it's a typical dilemma in a suffocating conundrum of what it means to be qualified to speak. I'm a cis-het married woman who aligns with queer makers: is that supporting a marginalized community or claiming its cool without living its pain? I'm a middle-aged woman of average flab and sag, told I had puppy fat throughout adolescence and into my twenties: but if I get involved in fat politics, do I dismantle societal fear of fat, or actually reinforce it? I have white skin and an immigrant background, a working-class (not council-estate) childhood but a middle-class education and adolescence: where might I usefully complicate discussion and where take up space that working-class people would better occupy?

See what I mean about reframing and reassembling the questions?

<p style="text-align:center">*</p>

So that thing I said before about Scottee not being afraid to be or act or seem like a cunt: urgh, uncomfortable, but also it reaches an apotheosis in *Fat Blokes*. Like *Hamburger Queen*, *Fat Blokes* is a work that makes space for people who aren't professional performers to express themselves creatively, politically, confidently and publicly; it's funny rereading that 2012 interview because six years on I can see Fat Blokes' roots in it: 'television programmes [focus on] fat people being broken or unhappy and I understand that exists but there is a contingent of fat people who are really happy and have fulfilled lives, so I wanted to make something which was a comment on that, that fat people aren't broken necessarily and there isn't something that needs to be

fixed.' The show begins with one of the four people, Joe, performing an eroticized dance, aggressively interrupted by Scottee the moment they spot someone in the audience laugh. We're talking seconds, maybe a minute. They want to know what's so fucking funny. They want to know what's so fucking funny about a fat body being sexy. They want to know what's so fucking funny about a fat body being. They go on to tell us how these attitudes are going to be transformed by the end of the show: we're going to admire these fat bodies, love them, desire them. Their tone is a cocktail of promise and threat, spiked with an olive on a skewer.

The audience, particularly the audience who weren't laughing and weren't thinking of laughing, are under attack, and sure, no one asked for this – but then, none of those five people on stage has ever asked for the abuse that's been hurled at them on the street by other people confident in their belief that being fat is wrong, shameful and contemptible. None of them asked to be bullied at school, or told to diet, or hit in the head by a champagne glass that broke, slicing through to the skull. Each of the four non-professional performers is given a chance to tell their story and the details are heartbreaking – but also spiced with joy, from Asad talking about falling in love with his fat husband to Gez deciding to love himself. Lea Anderson's choreography is also delightful, its shapes and patterns simple enough for amateur dancers to look sharp and snappy doing it, given pep by plenty of kick-ball changes and heat by the growing sensuality between them.

At one point when watching I started to wonder why, in a show called *Fat Blokes*, the soundtrack was entirely by women (and, as far as I'm aware, cis women): some of them fat themselves, like Mama Cass and Beth Ditto, a lot of them from the riot grrrl era, many of them furious, rebellious, femme-empowering. And then Scottee started to talk about the misogyny enmeshed in a lot of anti-fatness, the disgust of the fat bloke who has tits and thus is emasculated. To embrace fatness is to reject this misogyny, is to embrace the feminine: and sure, Scottee doesn't identify as cis male – which is why I've used they pronouns throughout this – but three of the fat blokes on stage do. I already thought *Fat Blokes* was astonishing, but it was that rejection of misogyny that claimed my heart.

And this is the thing about the word cunt. Its power as an insult lies in the fact that it's a word for female genitalia; its vitriol is swollen by misogyny. Scottee isn't afraid to seem a cunt in the same way they're not afraid to be fat, queer or working-class. And that fearlessness is an amazing thing to witness.

*

The next time I heard from Scottee after pulling out of *Notepad Warrior*, it was June 2017, and they emailed me unexpectedly a photo of a book called *How to Change the World* by John-Paul Flintoff, with the note: 'Found your solution to all your questions'. A precious gift from one who does to one who merely thinks about doing.

This is my favourite line in that 2012 interview: 'instead of like moaning about it' – whatever it is – 'let's make something really positive out of it as the antidote'. Sometimes when I look at Scottee's face I see that positivity, radiant.

(MC)

Further reading

Scottee: I Made It, edited by Jen Harvie, published by Live Art Development
 Agency
The Oberon Book of Queer Monologues, edited by Scottee, published by Oberon
Bravado, published by Oberon

Precarious, uncertain, ecstatic, stood close together, trying to be heard over the sound of somebody else's party

Leo Skilbeck and Milk Presents

i want to write this in a starburst, in a rush of glitter, not rainbow that's too ~~common, jewel bright, clouds of colour billowing, i want to break it up~~ ~~break it open make something different make somethi~~

no, let's do this properly

Sometimes it's more about the promise, you know? Sitting in a church hall late at night at the Edinburgh Festival, wondering if it might be better to go to bed, but then feeling such warm affinity as three young people talk about queerness, not presenting anything so very surprising, but speaking with such open-heartedness that I think: I want to give attention to these people. There is promise here. There is a promise here.

I think we're at the cusp of something really revolutionary and I hope to be a part of and contribute to that.

~~a rush of glitter, cannon-fired, writing as a shot fired, or no, that's not the wish.~~ ~~it's about deconstruction, disruption: the wish to deconstruct the linear~~ ~~(including mine), to disrupt authority (including mine), wanting also to connect~~

but if i don't do it properly, doesn't it just look like i'm taking the work less seriously?

Sometimes it's more about what you noticed, even if you then forgot. You know? Noticing at the time – the time being 2014, the show being *Self Service* by Milk Presents – that all three performers are wearing exactly the same outfit, regardless of gender. Blonde wig, black eyebrows, black lacy crop top, spangly gold leggings, spiked black heels. Adam Robertson's face dusted with stubble, otherwise difference elided. Leo Skilbeck still using their previous name. Noticing, forgetting, noticing, forgetting. 2014: the same year Emma Frankland and I talked at length at Forest Fringe about coming out, being trans, passing, make-up as a trope of femininity – those conversations weren't happening to such an extent in theatre back then. We're living a moment in history. Not living: making. Not history: the future. This is the promise. Here.

I was at a point in my life where I was questioning a lot of things, and just found myself looking back in history to make sense of stuff. And there aren't many people who are really that well known. A lot of queer history has either been rewritten or written out.

A question to which I don't want an answer: is it Milk Presents like the verb, presenting something? Or Milk Presents like the noun, a set of gifts? Meaning turning on syllabic stress. Gender turning on . . . what? Gender as a collision of what you (think you) know (or assume) and what you are yet to discover. Gender as a question, answers billowing, presented as gifts. Gifts in the plural, a needed plurality, an old-new set of possibility.

(. . . named after my family's milk round business. People always think it's Harvey Milk. And I'm like, no, it's a milk round in Yorkshire.)

Sometimes it's about seeing through a different lens, a kaleidoscope perhaps: what you know reconfigured, change change change. That's how Leo's production at the Young Vic of two short Chekhov farces, *The Proposal* and *The Bear*, worked. *The Proposal* had the three performers – George Ikediashi, Kamari Romeo and Rebecca Root – performing against their own gender, that against-ness complicated by their trans-ness: Kamari in bouffant petticoats, Rebecca in a penguin tux, George disrupting the neatness further because he lives as self and extra self (using the stage name Le Gateau Chocolat), both buttoned up in hunting tweeds. *The Bear* shed the institutionalized drag, replacing it with club- and cabaret-wear, the three performers taking turns to play the widow, the landowner and the footman, woman, man, woman, man, turning the kaleidoscope click click click until everything on stage was a wild, raucous blur.

Or, as Leo once put it (all the quotes so far have been theirs, by the way):

The drag that most interests me is not one gender performing another, it's a space where you can completely explode every assumption around gender and ask some new questions about it in one go.

double but: what does proper mean anyway? it's not taking it less seriously to refuse to do things the way they're always done/usually done/done when there's status attached/done in search of intellectual status. this is about breaking down shaking up, about refusing resisting rejecting. 'We invite you to blur fixed lines, to manoeuvre, to spread out, to kickback, backtrack and change,' Milk Presents write in the About section of their website. 'Queerness is big and complex and messy and it's yours, if you want it to be.'

click

click

click

a shot fired

at the cusp of revolution

With *Bullish*, a play they both wrote and directed, Leo honed this thinking again. (And I've been interested, reading interviews with them, to learn of Leo's anxieties at one time of not being a 'proper' writer, or that they couldn't be a writer and also a 'proper' director. That open-heartedness again, and connection or kinship with those working through a problem out loud, living it and making from it.) *Bullish*: a deconstructed, disrupted retelling of the Minotaur myth, the half-bull beast transformed into a character called Asterion, played fluidly, fluently, by four people of different gender. Sitting in a theatre mesmerized by these bodies just being: not male, not female, not fixed, not defined, not categorized, but also – crucially – not negative. Being in the positive, positively queer. The promise unfolding, a present lifted from its wrapping, gleaming, glittering, such joy.

> Ultimately we want to enable people to queer their world. That would be the thing I want to do. And whether that's as an (inverted commas) 'straight' person or 'cis' person – what that would be, to pick up your queer goggles and put them on and see the world in that way.

And I know there are people who feel the slur makes queer a word that can't be reclaimed, know there are people who feel queer isn't a word that can be claimed by 'straight' people without its radicalism being co-opted or damaged or neutralized, know that Harvey Milk said, in his most famous speech, 'there is a major difference – and it remains a vital difference – between a friend and a gay person', a major difference, that is, between a straight person with their queer goggles on and someone actually queer occupying public space and telling stories for themselves. Harvey Milk fought (and was assassinated) for visibility: 'For invisible, we remain in limbo – a myth.' But what he was speaking towards – what Milk Presents speak towards – is the dialogue that comes with visibility. In the same speech, known as the Hope Speech, in June 1978, Harvey Milk said: 'Unless you have dialogue, unless you open the walls of dialogue, you can never reach to change people's opinion . . . Once you have dialogue starting, you know you can break down prejudice.'

Leo knows this, Milk Presents know this. They dissolve not only the fixities of gender but the categorizations of theatre, mixing cocktails of cabaret and 'straight' play (ha!), working with children, working in subsidized theatres, all to spread the dialogue as far as possible.

because sometimes, deconstructing and disrupting but also doing it properly, is the best way to make/live change. you know?

(MC)

Christopher Brett Bailey

I want to think for a minute about being overwhelmed. The etymology of the word says something about the excess of it: to *whelm* is itself to overturn, cover or engulf. Before I saw *This Is How We Die* I was contacted by two friends who saw it separately, on consecutive nights, and messaged me immediately afterwards saying I would love it, that I would 'fall apart, in all the best ways'. That level of anticipation is too much for me: sitting through the bulk of *This Is How We Die* the first time, what I really felt was underwhelmed (a modern coinage, from the 1950s, facetious reversal of its Middle English root), uncertain how there could be so much fuss about a guy sitting at a desk telling a story, albeit an often very funny, macabre story.

And then I was overwhelmed by the music, and fell apart, and fell in love. The music in *This Is How We Die* surges in waves from the dark; in its optimum setting (I've seen it a few times now, and know this isn't always what it gets), Sherry Coenen's lighting shrouds the musicians at the back of the stage, so that the sound seems to come from nowhere, from a black hole in the universe, from ghosts barely glimpsed, electric interference. The music sucked me back in time to the lostness and anxiety of dragged-out adolescence; it seeped through my skin to my veins to my lungs as though this was my core now, music as marrow. And having been overwhelmed by it once, I went back two nights later – partly to see if I could see the wave coming, partly to feel its impact again.

All of Chris's work that I've seen has that feeling of waiting in it for me: waiting for the impact, to be overturned, engulfed. He works deliberately with exaggeration – not whelm but overwhelm – whether with language, with sound, with comedy, with theatrical effect. And I wonder how I withstand it, and how I succumb.

* * *

I too am thinking about being overwhelmed. By sound, yes, but also by other things.

By the battery of lights pointing directly at the audience at the end of *This Is How We Die* that build in intensity with the music until we find ourselves

completely lost in them. Or by the avalanches of haze in Chris's second show, *Kissing the Shotgun Goodnight*, that fall from the back of the stage, filling the room with dread and sadness and the coppery tang of death.

Such uncomfortable intrusions into the safety of the auditorium might sound like deliberate acts of provocation, but in the moment of experiencing them they have never felt like that, instead seeming more like an attempt by Chris to reach his skinny arms out into the crowd and hold us close. An act of communication, maybe even communion.

In theatre, a separation between the auditorium and the stage can often appear foundational, maybe even sacred, the basis upon which our disbelief is suspended and another world is conjured in the space in front of us. Chris is a skilled theatre maker and as good as anyone in conjuring imagined worlds onstage. But then there is always this other part to his shows as well, emerging from another tradition, a tradition in which the separation between the audience and the performer is something to be transgressed, even eliminated entirely. This is the tradition of bands like My Bloody Valentine, Swans, Boredoms and Lightning Bolt. Music that is often described as intimidating and aggressive but that in practice uses music not to repel us but to draw us in; as if with enough volume and intensity you can melt away the separation between artist and audience, allowing the weight of the sound to hold us all in its tight embrace and go falling through the darkness together. I'm reminded of Tim Etchells' description of the Fall's Mark E. Smith jumping from the stage of the Ajanta cinema in Derby out into the half-empty auditorium.

> He's off, he's over, gone into the emptiness down there . . . out into the no-man's land/wasteground that he's somehow made his own now, barely tethered by the microphone lead and in some ways never to return.

In his shows Chris is making the same leap, albeit more metaphorically; hurtling outwards into the no-man's land between us, barely tethered by his microphone lead. Turning the volume on his darkness up high enough that it might engulf us all.

If that sounds intense maybe that's because it is often quite intense, and aggressive, and violent and loud. But there is also longing there, and love. A desire to squeeze everyone into his handcart so that we might go caterwauling through hell together.

<div align="center">* * *</div>

And now I'm torn: think about emptiness, or think about community? They seem like opposites, but just at this moment they feel entwined. In common with a lot of musicians – Angel Olsen, Courtney Barnett and Anna Meredith are three that spring immediately to mind, but really this is true of multitudes – Chris performs within a community, a music-band of regular collaborators, all billed under his own solo name. (Of the three shows I've seen, only one of his co-performers shares the billing: Tomas Jefanovas for

Rated X.) It's funny to mention Angel and Courtney and Anna in relation to this, because solo artist billing is one of the ways in which the romantic (masculine) trope of the lone genius perpetuates itself. I wonder if that gesture of community sounds more hollow, empties out, when the name everyone is gathered around belongs to a straight white guy.

I want to subvert the idea of the lone male genius: and yet clearly there is a singularity about Chris. I can't think of anyone else working in quite the way that he does. The torrents of prose, the intensity of decibels, this way he has of performing at once taut and teetering at the edge of control. I think of him in *Shotgun*, swinging the microphone on its lead in Catherine-wheel circles, and remember swooning at Father John Misty the night he performed at Village Underground for pulling much the same moves. I remember also the thing Kathleen Hanna reports Kathy Acker telling her, in the opening scenes of *The Punk Singer*: if you want people to listen to you, don't do spoken word, start a band.

In that he wouldn't want to aggrandize himself so much, I'm not sure Chris does want people to listen to him; in that he bludgeons ears with the kind of noise that rattles windows and shakes foundations, I'm not sure he wants people who come to his shows ever to hear anyone else. He wields noise as a weapon against language, overwhelming words with cacophony – but he does it because he has much to say about the violence of the world we live in, and about the masculinity that's shaped it. His own texts are shot through with that violence – using racist or homophobic epithets, for instance, or inhabiting a lizard-cool masculinity – and I know he knows that it's a dicey business, deploying such attitudes to disrupt them.

I wonder what it means to invite people to go caterwauling through hell in a theatre. Because there is no emptiness or even half-emptiness at the edge of the stage there: instead there are sets of social relationships and political conditions, prescribed by the architecture sometimes, reinscribed by the work itself. That some people will be dazzled by his lizard cool and some will be repelled by it, and by those epithets, is not simply a question of taste; the responses themselves emerge from those social relationships and political conditions, and it's an ongoing question what community is possible between them. Sometimes I feel like I'm seeing Chris in the wrong kind of venue: that it makes no sense to sit politely in rows that request a narrative no less linear; that the sleaze of his storytelling demands a venue more used to holding gigs, a place where the noise and light and fog are a means of escape. Ideally I want to see him in the rooms I recall from adolescence, with walls encrusted in sweat and floor sticky with stale beer, rooms stained by nicotine and abandonment and now mostly gentrified out of existence. But I know what I'm longing for there is a release from the necessity of thinking about my place in all this – an invitation to go caterwauling, yes, but with ecstasy, into surrender, unburdened of responsibility or complicity.

* * *

I'm thinking now about the rooms in which I have seen Chris's work, the majority of them arranged in exactly the way you describe; rooms in which there is no easy means of escape. You're totally right to say that in these polite theatres Chris's thrashing around, literal and figurative, often sits uncomfortably, even awkwardly. Yet I think what makes Chris's work so interesting is this very awkwardness, the sharp edges, the shivers of discomfort; experiences built out of oppositions without hope of resolution.

There is, most obviously, the opposition between speech and noise; between words and the impossibility of words. This conflict finds its most paradoxical expression in the final sentence of *This Is How We Die* as the violins begin to dance and Chris pronounces language dead, acknowledging the declarative power of words and employing them to destroy themselves, like a diamond that can be cut only by its own dust.

Then there is the opposition between life and death; between in the first instance the spectre of suicide, the blackness eating away at the edges of Chris's shows like sepsis, and the joyous fixation on fucking and dicks and masturbation and deep-throating microphones and jism, jism, jism, jism, jism. And often walking down the middle of this valley of death and sex, this palace of depravity, is Chris himself, a goofy and unflappably decent narrator stuck somehow in the wrong story, like journeying through Dante's Inferno in the company of Bart Simpson.

Chris embraces such contradictions. There is no attempt to resolve the problem of a language so ruinous it demands its own death, or to find moral resolution for a narrator who can politely fuck the neck-hole of God's decapitated head because it seemed like the right thing to do at the time. Instead such fault lines create a space of uncertainty in which possibility can fester like dirt under a scab.

All of which perhaps makes sense of our decision to write about Chris in the way we have. An alternating sequence of unresolved positions. Attempts at finding the right words to explain contradictory feelings. Offering up to each other thoughts in a language that we are both always on the verge of wanting to pronounce dead, even as we know we can't.

(MC and AF)

Further reading

This Is How We Die and *Suicide Notes*, published by Oberon
Sax Offender at christopherbrettbailey.bandcamp.com

Adrian Howells

Dear Adrian,
I remember when you kissed my feet
in a small room in St Stephen's Church
the smell of the soapy water
and the silence
which felt uncomfortable at first
for someone who had filled their life
with such noise.

> When people talk about your work
> they quote your famous line:
> 'it's all allowed'
> which is
> such a tingly promiscuous little phrase
> what you really allowed for me though
> was quietness.

(AF)

PART 7

Other lives
are possible

Hunt and Darton

Rajni Shah

Bryony Kimmings

Emma Frankland

Figs in Wigs

Hunt and Darton

1

If theatre is a kind of play, it is a play that appears to be perpetually in denial of its own essential play-ness.

At its worst, professional theatre, like professional sport, can appear to be an object lesson in the consequences of treating play like it is important – so in thrall to its own manufactured traditions, so constrained by a kind of stale tastefulness, so concerned with its accidental status as literature and its value as a competitive product in a busy cultural marketplace that it has for the most part become terrified of its own ridiculousness, like some prim Victorian arriviste mortified by their own secret past.

But for all its manners and its pretensions, its Haworth Tompkins-designed bars and restaurants, its seemingly unwavering faith in the power of psychological realism, theatre is still play. It is dressing up in someone else's clothes, running around shouting in a silly hat and glasses, it is pretending to be a cowboy or a lawyer or the king of Scotland, it is blood capsules and stage deaths and crocodile tears. Theatre is just pretend and pretending is, among other things, a bit silly, and no amount of multi-media spectacle or earnest method acting will allow it to fully escape this wonderful fact.

Pantomime is the one part of proper theatre that seems to understand this and perhaps that's why it continues to be the most popular part by some distance. And then there are companies like Forced Entertainment, Sh!t Theatre and Figs in Wigs, and artists like Lucy McCormick and Bryony Kimmings, all of whom recognize that theatre's inescapable silliness is not the opposite of seriousness and who are therefore not so afraid of it. Their shows are propelled by an exuberant delight in the absurdity of dressing up and pretending: made-up songs and stupid dances, costumes of vivid colour and questionable taste, childlike not because of their innocence but because of their knowingness, because they recognize an innate absurdity to all of this that adults too frequently try to suppress or deny. They are artists who lack manners in the best possible way; stretching an idea until

it distorts, becoming in the process wilder and stranger, more absurd and unpredictable.

2

Jenny Hunt and Holly Darton love to play. For as long as I have known them, their work has embodied exactly this raggedy joy in the absurdity of dressing up and pretending. Do an image search for 'hunt and darton' and what you will find is a seemingly infinite series of portraits of two women in matching patterned outfits. Sometimes they are wearing pineapple crowns as headpieces. In others they are wearing matching radio antennae. In a couple they are wearing flat caps adapted to look like tiny golfing greens.

When I first met them Hunt and Darton made stage shows in which they dressed in these identical outfits and deadpanned their way through little sequences of everyday actions that became increasingly absurd the more they were repeated. Perhaps my favourite was a sequence where each of them in turn would clench a fist and growl a 'yes' under their breath, like a tennis player after a winning point, slowly allowing these yesses to build into a surreal frenzy. Like all their work the beauty of this was its simplicity. The rules of the game were immediately obvious, and so even just by watching we could feel like we were all playing along together.

It reminded me of the games I used to play with my brother on long car journeys, repeating a word or a phrase again and again in increasingly absurd voices; taking something normal and playing with it until it fell apart completely. This is what children do, borrowing pieces of the adult world in an effort to understand them better. And of course, in doing so they often end up breaking them. It is perhaps why children's play is so often insulated from everyday grown-up reality, secured in playrooms and playschools and playgrounds; not to protect children from reality but to protect reality from children, and their effortless ability to undermine the supposed truths that grown-ups rely upon.

In the 1988 Penny Marshall film *Big*, Tom Hanks plays a thirteen-year-old boy called Josh Baskin who has his wish to be big granted by a mysterious fairground machine and wakes up the next morning to find he has grown overnight into a thirty-something man.

But Josh is not a thirty-something man, he is a child pretending to be a man and consequently the film is among other things a story about what happens when children surreptitiously infiltrate the adult world. Josh's version of adulthood is a performance that in its ridiculousness highlights the lack of imagination with which adults approach the choices the world gives them. Why wear a plain black tuxedo when you could wear a shiny white one with shimmering gold trim? Why have a tasteful minimalist apartment when you could fill it with trampolines, vending machines and a

giant inflatable dinosaur? When the world gives us so many opportunities to play, why do we so often refuse to take them?

3

In 2012 Hunt and Darton opened the first *Hunt and Darton Café* in an empty shop unit in Cambridge. It served Battenberg cake and finger sandwiches. Hunt and Darton wore matching outfits covered in broccoli patterns with stems of broccoli for headpieces. Guest waiters would perform dances or cabaret numbers or pieces of silent durational performance art. Members of the public who visited regularly were given little badges with the word 'Loyal' written on them. Hunt and Darton themselves would serve a buffet of miniature performances to be consumed at your table.

Since then the café has reappeared in dozens of other spaces, from the Edinburgh Fringe to Tate Modern's Turbine Hall to a converted slaughterhouse in Shanghai.

In one sense the café was a legitimate small business, and yet at the same time Hunt and Darton were always only pretending to be café proprietors. They would claim that because they were artists the café must be art and this enabled them to take the silliness that had always defined their theatre shows and sneak it, Josh Baskin-like, into the adult world. In the café they had the time and space to fully explore their childlike fascination with banality and routine, turning them over and over, playing at being adults in a real adult space with real adult customers.

There are a number of antecedents for the *Hunt and Darton Café*, but perhaps the most well known is Claes Oldenburg's *The Store*, a store-front space that Oldenburg created on New York's Lower East Side in 1961. *The Store* was both an art installation and a functioning store, albeit one filled not with useful items but with replicas made out of chicken wire and plaster and painted in vivid primary colours.

But the differences between *The Store* and the *Hunt and Darton Café* are as informative as their similarities. While Oldenburg delighted in the way that he and *The Store* appeared to disappear into the everyday life of its neighbourhood, he was also aware of the extent to which what he was doing was separated from the ordinary people around him. Oldenburg understood that *The Store* held nothing for them, that its ironized everyday objects would be bought exclusively by the wealthy art-world cognoscenti who would travel down from their galleries on the Upper East Side. For the ordinary people of the neighbourhood Oldenburg's store was opaque and intimidating, its goods useless and expensive, the rules of its game frustratingly opaque. As Oldenburg describes it, he would sit behind his desk at the rear of the space watching local neighbourhood kids peer round the door, not daring to come in.

In sharp contrast, the *Hunt and Darton Café* is always an invitation for everyone to come and play. Perhaps this was because on the most basic level, Hunt and Darton ensured that the café served the needs of the local people who might use it. Its relationship to the neighbourhood around it was not aesthetic or ironic – it was a genuine community resource. People could buy tea and cakes and a sandwich, they could sit for a while out of the rain or take a break from shopping, put a novelty record on the café's ageing record player. And from there Hunt and Darton would gently encourage people to participate in the games the café was playing to whatever extent they wanted, which might mean simply buying a novelty cake or one of their weird sandwich creations, or it might mean ordering off their menu of performances, or it might mean spending your whole day there participating in whatever timetable of ridiculous activities Hunt and Darton had created; it might mean becoming a loyal customer, receiving a special pin badge with the world 'Loyal' written on it and wearing it with pride on every new visit. The game was simple and the rules were clear, in some instances so clear that they were literally written on a mosaic of cardboard signs Blu-Tacked to the wall of the café, saying things like 'you look good in our café', 'do it yourself' and 'yes, it's real'.

In the café I have seen Hunt and Darton being wheeled around on a drinks trolley by giddy six-year-olds. I have seen a prestigious Chinese theatre critic lie on a table pretending to smoke a piece of ham like a cigar while friends and strangers threw pieces of salad at him. I have also seen an elderly man contentedly sit in the corner drinking his tea for an hour.

I suppose one way of describing all of this would be to call it 'socially engaged practice'. The impact that the café has made in communities across the UK and beyond has been as significant as any other piece of community-based performance that I can think of. And Holly and Jenny are able to talk eloquently about the serious socio-political aims that are an implicit part of the *Hunt and Darton Café* and the other projects they have created since. These projects are deeply invested in exploring changing ideas of community and of what it means to be local in Britain in the twenty-first century. Through them we can participate in a kind of resistance to the weaponization of nostalgic nationalism, a resistance that reimagines localness, and perhaps even Britishness itself, as fluid, plural and inclusive.

The café is a performance that temporarily occupies a place without ever needing to take it over, without eliminating or obscuring the people and things that were there already. It is a performance of rigorous silliness that doesn't attempt to sell us its Britishness but instead invites us to participate in it, whoever we may be, turning totems of national identity like the Sunday roast or a Victoria sponge into props in a game anyone is invited to play.

It is a game of ordinary people pretending to be ordinary people, led by two women with broccoli on their heads serving Battenburg cake and polo mints to bemused pensioners and delighted children. A game in which the polite conventions of an ordinary café become as absurd as the unspoken

rules about what suit to wear or how to decorate our houses. A game through which, unconstrained by decorum, we can imagine another way of being together.

(AF)

Further reading

Store Days: Documents from The Store (1961) and *Ray Gun Theater* (1962), by Claes Oldenburg

Rajni Shah

Dear Rajni

This is so much how we communicate since you left the UK. Via letter, handwritten, my untidy scrawl on orderly sheets of paper; your neater script on flotsam scraps, sometimes accompanied by tiny drawings, revisions squashed in the margins. We enjoy this taking time for each other, being slow, being truthful. It is friendship, but it is also typical of the work we are trying to do in the world.

How to write about you, your work, its influence on my work, thinking, life? I was struggling to find the words. And so I thought to write you a letter.

Dear Rajni who is glorious

This is how I knew you before I knew you.

You are standing on a huge stage, statuesque in a column-like dress, surrounded by an octopus tangle of wires, and you are singing. Several people have already decided to leave in the interval, their mutters impatient and laced with distrust. I was bored before the interval but now I'm becoming enraptured. Your voice is a silken thread binding me to you and to the strangers on the stage (most of whom are locals who live in the area) and to the bodies in the seats beside me and the people on the streets outside right now but also to everyone you met, months before this moment, when you and your company stood in the nearby market and invited passers-by to write letters to other strangers. Dear stranger, each letter might begin.

You are singing and I can't distinguish all the words but later I look them up and they pulse with kindness:

when our hands are shaking,
when we're not sure what we're holding
there's a mound of reassurance
in just being in this place

When I wrote about you in April 2011, a week after seeing this work, *Glorious,* I said that it had reminded me of the opening lines from William Blake's poem 'Auguries of Innocence':

> To see a world in a grain of sand
> And a heaven in a wild flower,
> Hold infinity in the palm of your hand
> And eternity in an hour.

I quoted this and I wrote:

I am holding a daffodil as gently as I can. As Glorious *ends, everyone in the room is invited on stage, to take our daffodil, and to understand our place in this work: as central as yours, as central as that of anyone who contributed to it. I am holding a daffodil as I write this (not literally) and I am thinking about heaven, not as distant impossible promise, but as a question of utopian possibility. People in a room together. What might we do?*

> Dear murmur (you sang)
> Hold them gently
> Hold the weight of knowing people
> Hold the weight of staying true
> Place your body in this landscape
> Know your body in this place

Dear Rajni who listens

In the years after *Glorious* you stepped away from that kind of live performance: large-scale, supported but perhaps also shaped by an institution, somewhat compromised by its interaction with capitalism. Instead you did a PhD: still a place of compromise, given the complex and elite language of academic texts, but you approached this work in a spirit of resistance. In a chapter titled 'Influences', you describe the dominant structures of knowledge, thought and expression expected of most academic writing, and detail your refusal. For instance, you warn that your use of quotation is eclectic, looking less to other academic texts than to:

'people I have encountered in a range of different ways: those I might call peers, teachers, friends, or family, as well as theorists, academics, artists, strangers who have become companions, and passers-by who have become performers. All of these thinkers write or speak from their own experience. This is their expertise.'

[I love how we are reclaiming the word expertise. Here's something I said in an interview for the website *Essential Drama*: 'The conversation about theatre should be an open one and the only expertise that you need to bring

to theatre to be able to understand it is expertise in being a human being, in being alive, that's it.' The word is like a snowball that grows bigger – feels more expansive – each time we pass it between us.]

You speak not only in the language of theory but of the body, naming Sara Ahmed as a particular inspiration: she too writes 'from her own embodied experiences as a woman of colour', with a sense that theory is more effective – has a greater affect – 'the closer it gets to the skin'.

Before I knew you, you might have been described as a dancer. In that sense, your work has always been from the body. But the PhD took you somewhere else: towards a practice of stillness, of listening. What interests you is a particular kind of listening: not the listening that is just waiting for its turn to speak, the not-really-listening of formulating a response before the speaker has even finished; instead a listening that wants to understand something complicated, and is willing to be changed by what it is hearing.

Theatre, you write, might be the perfect place in which to practise this listening.

Dear Rajni who digs deep

Silence, you suggest, has a language of its own. Your writing is a sifting of soil, loosened as you dig below dominant structures, to the place where we might start building new social foundations. You work with a sense of radicalism: of roots. Your roots (in India, in systems of hierarchy and colonialism, in performance), the roots of words, the roots of belief systems.

We share a love of etymology and I marvel as you sift the words 'empathy' and 'compassion' of all their Latin parts, building from these clods of language a compelling argument for the difference between these seemingly interchangeable terms. Empathy, I glean, 'involves accommodating the object or person with whom one is empathising': extending kindness to those seen as weaker, marginalized, victims in some way, but from a place of dominance. Whereas compassion 'involves not accommodating but being with': a side-by-side relationship, less hierarchy, more co-existence.

How does this relate to theatre? Because in my seat in a theatre auditorium, I am still, I am listening, and I am with. I think about the people who walked out on *Glorious*, how they refused to be with not only you, but all the strange and wonderful general public also performing that work. Sometimes my relationship with theatre is one of constantly unfolding existential crisis: why am I here? What difference does it make? Your writing helps me find new meaning.

Dear Rajni who let go

From your conversation with performance maker Demi Nandhra, published on the website *HowlRound* in September 2019:

'I loved having a career and being part of a scene. And, in a way, I talked about what it means to be subjected to racism and sexism and all of those stereotypes. I was working with those things directly, especially as somebody who works with their own body. But in another way I just wasn't. It was too painful to acknowledge the reality of working within a sector that was still very racist but had this veneer of niceness.'

Since leaving the UK your body is no longer present in the performance scene, but your mind, your thinking, are. Later in autumn 2019 you took part in a discussion event in London, via a set of recordings from your current home in Australia, organized by Independent Dance. The event was called Anti-Racist Contemporary Dance and at one point you asked whether resistance too easily becomes fight, passion, paranoia – that is, a mirror image of the things it's resisting. At another point you were asked what contemporary dance is in your terms, and replied that it wasn't a term that related to you: rather, it referred to a kind of 'colonization of the body', a set of rules and power dynamics that enforce hierarchy and exclude. You spoke of making space and time for inarticulacy, for the thoughts that don't fit. You asked: what does it mean to look inside, at the very forces (patriarchy, white supremacy) that shape our individual selves?

Dear Rajni who is present at every conversation I facilitate, defying geography, defying distance

In one of the chapters of your PhD you talk about a festival I co-curated in 2014 with producer Jake Orr, called *Talking/Making/Taking Part*. It was designed around a simple-but-complex question: what different kinds of conversation might be possible in a theatre space? One of the formats for conversation it explored was the Long Table, designed by Lois Weaver of Split Britches, which looks easy to host from the outside – there are no designated speakers, anyone can come to the table and be part of the discussion – but is incredibly difficult to get right. Jake and I didn't get it right: hierarchy dominated the room. And so, since then, whenever I facilitate a conversation, I start with you, either invoking your name or holding you in my heart as I open the room. I don't follow your practice exactly but, like Lois Weaver's Long Table Etiquette, the framing devices you use are a constant resource and inspiration.

Here's how you describe some of those devices, each one designed to shift the invisible hierarchies that govern and structure conversations:

No questions.

Silence and speaking are equally valid.

Anything is welcome.

Challenge your usual behaviours, so that those who are usually heard might find this a place in which to practise listening, and those who are

usually unable to come to voice might find enough time and space to be able to speak.

This, too, is not easy. At the beginning of 2020, you wrote in your blog about the challenges you've experienced in the listening work you've focused on through and since finishing the PhD:

'My goal is not to reorient spaces that usually centre whiteness. My goal is to do the listening work that becomes possible having performed this reorientation. But it is hard not to get stuck reeling at the apparent enormity of the first task. The reorientation is such a surprise for some that they seem to experience a strong sense of vertigo. In response to this sensation, they hold on tight. And it is hard, if not impossible, to hold on tight and listen.'

Dear Rajni of the golden thread

I watch a short video of you on Facebook, working with another artist, Kris Grey. It records the closing minutes of a much longer performance, in which the two of you have been spinning lengths of golden thread into rope. In a text message you whisper that these threads are imbued with purpose: they bind trauma, resilience, shame, integrity. In the recording, a cello melts and your voice becomes sound and the rope begins to burn, a fizzing, chemical flame.

On Twitter you slowly spin another thread, made up of scattered thoughts, published under the tag #freewriting:

27 November 2019: I look for those who are brave enough to be kind. How strange that this feels like resistance.

24 December 2019: Not a pushing kind of resistance, but a gathering of compassions, alert and soft and dull and radiant.

29 December 2019: This is the work. This unrooting-listening-arriving, always trying to land, trying to speak, trying to feel.

Around this time you post me a letter. Inside is a slim loop of thread. I place it over my finger, holding it, holding you.

Dear Rajni to whom I tell almost everything

More than with anyone else in this book, I feel so much responsibility writing this. To you, for you; to shared ideals, to quietness, to honesty; to the lack of critical engagement with your work, to story-making, to song; to dismantling dominance, to listening, to the fullness of attention; to all that I've learned from you and tried because of you and articulated through you; to friendship, to companionship, to love.

When I was still struggling with this writing, all frayed edge and fret, I secretly turned to a set of tarot cards and whispered to them: tell me something about Rajni. In return they gave me the Ace of Cups, a card depicting a body of undefined gender leaping into a cup, whose waters overflow into a lake beside a pair of swans. The image reminds me of how you love trampolining, and swimming in the ocean; in the Anti-Racist Contemporary Dance discussion you named these things, alongside meditation, writing letters and mentoring, as self-care practices, which are also practices of generosity. Self-care that overflows in abundance. I notice the whiteness of the swans, their faces turned from the vaulting figure, mouths in the falling water, drinking in wisdom.

Dear Rajni who inspires courage

Like in this email you sent me in February 2014:
'Let's not be afraid of jumping ship. Because the ship was wrong and we didn't believe in where it was heading. Let's be brave and sing the song we both know we really can, and were born to. Because really, as I sometimes so vividly remember, life is short and so worth living in the way that both frightens and illuminates us.'
This is my song, to and of and for you.

(MC)

Further reading

Experiments in Listening, published by Rowman and Littlefield
Dear Stranger, I love you: the ethics of community in Rajni Shah Projects'
 Glorious, published by Live Art Development Agency and Lancaster University
'How I Call Myself', in *Vanishing Points*, edited by Salome Wagaine, published by
 Live Art Development Agency and Diverse Actions

And this book is where we stand beside them, surveying a landscape that is at once wreckage, nostalgia and constantly unfolding, rain-misted dream

Bryony Kimmings

Bryony Kimmings is standing on an otherwise empty stage. She is wearing a thousand costumes and singing a song about her life. It is a song about heartbreak and hope, childhood and adulthood, about drugs and alcohol and depression and London and Cambridge. It is a very long song, about ten years long with around twenty-five different choruses and more verses than I can remember. Bryony is telling us a story of quiet ordinariness and unspectacular sadness. Bryony looks at us and pulls a face, her mouth opening and arching downwards at the sides, her eyes rolling up into her head like some ancient Greek mask come vividly to life; a cartoon tragedian singing songs about the everyday kinds of pain that the tragedians generally chose not to concern themselves with.

In some ways Bryony's work is a story of perpetual change. It is a story told in seven or eight hour-long chapters about a woman and all the things that have happened in her life up to this point. It is a story about a girl from a council estate in Cambridgeshire who moves to London to become an artist, she struggles with sex and alcohol and with what it means to be a young working-class woman in a city of near-infinite risks and temptations, she tries to grow up, to become a better role model for her niece, she falls in love, she has a child of her own, she leaves London, and then at the moment when it seems everything has worked itself out it all falls apart in the most horrible and painful of ways. Somehow though she manages quite heroically to put most of the pieces of her life back together. She manages to rise again.

This story that Bryony is telling is, I suppose, a kind of Odyssey, about leaving home and getting lost and trying to find your way home again. And like another famously ordinary retelling of the *Odyssey*, it is full of dirty jokes and the kind of tiny details that normally get left out of such epic stories; the piss and the shit, the booze and the vomit, the longings, the sex, the whole days spent hiding under the covers or just walking around on the streets of a busy, occasionally bewildering city.

And yet, despite its multiple chapters, with different titles and different themes, each made twelve or eighteen months apart over the course of a decade, there is a lot in the telling of this story that stays pretty much the

same across its entire ten-year running time. There are people, like designer David Curtis-Ring, musician Tom Parkinson and photographer Christa Holka, who have remained faithful collaborators throughout, working on most if not all the parts of Bryony's story, giving the whole thing from the very beginning a sense of glossy coherence, a singular world created in the first moments of the first show and which Bryony has lived in ever since. In this strange place personal stories and private grief from the all-too-real world are alchemically transformed into a vividly technicolour theatrical language of outlandish costumes and archly-chosen props. And while the scale of this world has continued expanding and the audience has slowly swelled from around thirty or forty people to around five hundred or so at last count, at the centre of it all has always been Bryony, enchanting and absurd, a pound-shop Homer, turning her life, piece by piece, into a spectacular myth of her own invention.

I have seen at least one version of every piece Bryony has made since I saw her first solo show *Sex Idiot* in a small and very crowded room at the Edinburgh Festival in 2010. I have seen some of those pieces a number of times or in a number of incarnations, but despite or perhaps because of this when I try and picture these shows the images are a disordered mess: a jumble of costumes, a medley of melodies, a carnival of cartoon faces, stories that seem real and others that seem, well, not so real, all watched over by Bryony, thanking you for coming, affecting the same feigned flippancy as a stand-up comedian, a posture immediately and knowingly undermined by the scale and complexity of the show she has prepared for us.

'Hiya, I'm Bryony Kimmings'

I remember the matador costume, and the clown outfit, a big bunch of flowers and a giant doll's house. I remember the safari hat, and the one where she was dressed as a knight, I think. In my mind it is one fantastical phantasmagoria – an elusive parade of images and ideas, each somehow inseparable from the last.

Certainly part of this confusion is caused by the degree to which Bryony has ensured an incredible amount of continuity across these shows, in their look, their feel, their aims and their form, as if from the very beginning she had a clear idea of the work she wanted to make and the eventual scale she hoped to be making it at. But I think another reason for this sense of her shows blurring into one another is that a certain slipperiness of image and meaning has always been integral to what Bryony is doing.

Like all myths, Bryony's shows are full of things that are constantly becoming other things. A science experiment that turns into a rave. A confession that turns into a pop song. Props that are first one thing and then another. A bouquet of flowers that transforms into a weapon. A hospital ward that becomes a monster's lair. A bowl full of pubic hair that becomes a moustache. A beautiful doll's house that becomes a monstrous Sisyphean burden. And always at the centre of all of this confusion is Bryony herself, cycling through a spectacular and seemingly infinite parade of costume

changes: bird hunter, shaman, bride, scientist, drunk clown, tropical princess, big-game hunter, 1960s housewife, palaeontologist, pop star, until by the end of the decade Bryony has become a literal Phoenix, that most famous mythological manifestation of transformation and rebirth.

In *Mythologies*, Roland Barthes describes the process of contemporary myth-making as a series of appropriations. Stories and images are emptied of the meaning that they once had and are instead used to sell us a new story about the way the world is. I think of Bryony's shows as a similar if perhaps more benign form of mythologizing, in which a constellation of ordinary objects and common ideas are co-opted to create a distinct new mythic universe, one with its own rules and its own logic. In this universe, Bryony makes ordinary pain seem extraordinary. She turns her interior life inside out, spilling it across the stage as a colourful collage of images, symbols and actions.

And this is what only becomes more radical and more thrilling about Bryony's work the larger the stage she presents it on. What she is doing is not simply telling us the story of her life. She is creating for us a mythological framework, enabling theatre to be a place where we can come to think about the private problems of our lonely, fragmented lives – the heartbreaks, the depressions, the fears we know but can't articulate. Like the medieval religious artists who transformed abstract ideas into a symbolic visual language anyone could understand and explore, Bryony turns feelings – guilt, shame, love, anger and so many different kinds of sadness – into tangible things we can look at and hold on to; things we can hold up to the light and examine.

(AF)

Further reading

Credible Likeable Superstar Role Model and *I'm a Phoenix, Bitch*, published by Oberon

Emma Frankland

When I think about the people who have helped me understand gender differently and more deeply, Emma Frankland is top of the list. In August 2014 we began a series of conversations that I think of as a single extended dialogue, turning over the question of what it means to be a woman, to be seen as a woman, in a society that demeans women and reserves a special hatred for trans women. That dialogue began at Forest Fringe, through Emma's performance piece *Doodle*. It's a work designed to galvanize discussion but also harness it: Emma stands beside a huge white board with a stack of coloured pens, talking to people then translating the kernel of each conversation into an image or phrase on the board. 'Is our destiny fixed at birth?' is written on one side of the *Doodle* image in Emma's collection of performance texts *None of Us Is Yet a Robot*. On the other: 'We imprison each other with language.'

What I mostly remember of that *Doodle* conversation was how careful it was: not in terms of caution but the opposite, a conversation full of care for each other, in which we felt we could be honest and robust because we were also being kind, speaking and listening with interest and respect. We'd known each other for about three years by this point, mostly because of working together under the aegis of Chris Goode and Company, but there are also ways in which I didn't know Emma at all, because in a sense she'd been in hiding. That not-knowing led to what I now recognize, in retrospect, as a position of obnoxious entitlement that I held through this *Doodle* conversation, which centred my experience 'as woman' rather than hers.

I remember, for instance, talking about make-up and 'feminine' appearance: if trans women are read as women by wearing lipstick and removing their facial hair, I asked, how does that challenge or dismantle patriarchal expectations around femininity, which tells me that the coarse black hairs that insist on sprouting from my chin are not acceptable? Which might be translated as: what are trans women doing to make the lives of cis women better? When really I should have been turning that question around.

Later in 2014 I was programming a weekend festival in London with my friend Jake Orr, and we asked Emma to perform *Doodle* again across both

days, talking with people on the first day about gender and sexuality, but on the second about performance and politics. We also asked a brilliant community theatre specialist, Lily Einhorn, to do some engagement work for us, and there was one group in particular that she brought along who would have left within the first couple of hours were it not for Emma connecting with them. She brings the same care, curiosity and receptiveness to every *Doodle* conversation, whether with friends or with strangers.

<p style="text-align:center">*</p>

Doodle is unusual in my experience of Emma's work: mostly what I've seen by her might more happily be categorized as theatre. She has a style that is rough-hewn, energetic, messy, compassionate, but with a shimmer of danger. I've seen her hack through a copy of *Don Quixote* with a chainsaw, wield glinting wings constructed of knives, and judder a pneumatic drill though the floor of a theatre. These actions could be read as violent, but I see in them a solicitude, for the people who are subjected to the real violence of the world. Her gusto comes from a spirit of retaliation, from exposing and challenging not only dominant structures but the ways in which others – whether social oddballs committed to solo protest outside Parliament or trans women of the past – have resisted or undermined or survived those structures.

She has a hands-on practice, making work by trial and error, through exercises, provocations, invitations, research, patchwork writing, and actions that draw energy or inspiration from fundamental and elemental symbolism: fire, water, earth, air. Watching her grow into her visibility as a woman, I'd say she takes the same approach to gender: feeling her way forward, experimenting, questioning, challenging every aspect of what a woman is expected to be.

Partly that flexibility was forced on her: in her performance *Rituals for Change*, she briefly charts her journey through different hormone replacement treatments, the shocking impact of one pill after another on her body, the unexpected pain of rare and surprising side-effects until the right treatment for her was found. But I'm also talking about an approach to the task of making: not making a product (a performance, femininity – whatever the fuck that means), but making a process of living and being. A process of flux, digression, provisionality, improvisation. A process necessarily collaborative.

<p style="text-align:center">*</p>

In 2018, Emma and I had another *Doodle*-adjacent conversation, as part of the work she was doing putting together her book *None of Us Is Yet a Robot*, a collection of her performance texts since 2012, during which she said the following:

> I think about the duty of care as an artist, and part of that for me is just being honest and being seen – and this thing that comes out of *Rituals for*

Change, about the radical act is to allow ourselves to be seen while at the same time allowing ourselves to heal. I do think that's not the job of every trans person, or every person who's othered, I don't think that should come with the territory: but I kind of like that it's the job of the artist, of the performance artist. Part of what we do is that we put ourselves in front of people. It's so simplistic but part of the reason of that is to allow people to have a dialogue or to change or to see. I feel like I've been the first trans person a lot of people have met, for a lot of people! And actually have had a lot of conversations – what did you say before about the way that we talked? – there was care in it. I don't tolerate views that I disagree with but I'm quite able to have that conversation calmly and with care and I've done that with a lot of people over the past few years. I do feel like that's part of the job and I like that the work can speak in both directions.

That work of conversation has been much harder since 2014, for two key cultural-political reasons. That was also the year in which Laverne Cox appeared on the cover of *Time* magazine alongside the headline 'The Transgender Tipping Point'. And then, in 2017, MP Justine Greening announced that there would be a consultation towards reform of the Gender Recognition Act. The intention was to change the medicalized and punitive bureaucracy around transition, but instead the consultation released a virulent transphobia, across social media but also in the street, most distressingly among cis women. It's made Emma necessarily, depressingly, more wary of the dialogue, more wary of the potential always present that she's going to be attacked. Or, as she put it in that 2018 conversation:

I feel like today, people are seeing me and they have a context for what they're seeing and perhaps already a formed idea of whether or not they like that. Part of *Doodle* as an art piece was about being visible and also the offer of being able to answer questions – it's so funny because so much of what I do now is about Not a Debate, I'm not having a debate! – but to make a distinction: it's never not wanting to have a respectful informed conversation that will change hearts and minds and learning on both sides and meeting in the middle. It's just I'm not debating people who are abusive and want to say you should not exist.

*

Towards the end of her book, Emma wonders what trans performance might look like – given this surge of transphobia – when it 'strays beyond autobiography'. I hope at least some of it looks like *Republica*, a show Emma directed, more sultry, grimy and passionately queer than anything I've seen by her before. It's performed by her long-term collaborators Juan Carlos Otero and Keir Cooper (with whom she also made *Don Quijote*), and Otero's flamenco partner Lola Rueda, and pays wild, fierce homage to

the Second Socialist Republic of Spain, destroyed by the advent of Franco and fascism. It opens with Otero, dressed as a Catholic priest, stripping down to bondage gear and ushering in the raucous song of revolution, underscored by Cooper's febrile guitar. The sweat and stamp of flamenco becomes the language through which the possibility of socialism is debated; the cumulative effect is less didactic than impressionistic. In a sense *Republica* picked up where *Don Quijote* – not an adaptation of the book but a celebration of the potentiality in transgressing conservative normativity – left off, but *Don Quijote* felt more brawny and direct, *Republica* more sinuous, seductive, elusive, provocative, words I want to sum up with just the one: feminine.

Emma's work expands definitions of words like feminine, encouraging language to transition alongside her – or, perhaps, to return to an era or landscape where language was more supple, the fluidity of gender more appreciated. This is her gift not only to other trans and non-binary and genderqueer people but to cis-het people like me, always straining at the restrictiveness of social models of femininity, exacerbated by the sentimentality that shrouds motherhood. Emma is a father, to a child a little younger than mine, but she's also spiritual mother to a multitude of others: people who, whether because of the work she makes or the conversations she initiates, have been supported to see themselves and society anew.

(MC)

Further reading

None of Us Is Yet a Robot, published by Oberon
Extraordinary Acts, a zine edited by Emma and available from Etsy
'Trans Women on Stage: Erasure, Resurgence and #notadebate', in *The Palgrave Handbook of the History of Women on Stage*, edited by Jan Sewell and Clare Smout, published by Palgrave Macmillan

Figs in Wigs

1

How to describe the joy of watching people dancing in unison? The compelling and uncanny feeling of watching these bodies shaping and shaped by each other, as if the gaps between them are just holes in a larger structure, in some giant, multi-limbed, multi-hearted organism. Anthropologists talk about synchronous activities leading to a sense of 'collective effervescence'; that giddy lightness we feel when we're all moving together in time – doing the macarena maybe or the YMCA – and trace it back to some originary need to bond the members of a family or a tribe to one another, to reinforce the sense of unity that would have once been essential for survival.

In 2009 I was helping run a secret hospital-themed bar hidden in a temporary wall in one of the outer fields at the Glastonbury Festival. The bar could fit, at most, about thirty people, squeezed in shoulder to sweaty shoulder, DJs playing on a tiny sound system, mud covering the white linoleum floor. I remember one night everyone quite by accident started dancing in time, a sea of heads bobbing up and down in perfect unison: one strange, ecstatic family in our tiny crap bar lost in our collective effervescence, in our own temporary utopia.

When I first met Figs in Wigs they seemed to me to be a kind of physical manifestation of the trippy, collective euphoria of a big music festival very late at night; their legendary dance numbers an absurd gift bestowed upon those people stupid enough to still be awake. Indeed, before I had seen any of their shows I knew them mainly as a dance troupe, appearing whenever the evening got weird enough on the cabaret stage at Latitude Festival or a Duckie night at the Royal Vauxhall Tavern. Matching patterned costumes, deadpan stares, dayglow bum bags and their glittery painted-on monobrows; five women dancing in unison.

Watching Figs in Wigs dance was like listening to some strange alien language, a bizarre semaphore of hops and claps and strange hand-gestures

that existed at the exact midpoint between Yvonne Rainer's *Trio A* and 'Saturday Night' by Whigfield. Dances that seem to be made of pixels rather than steps. And like any act of synchronous dancing there was a satisfaction to be had in watching five people moving together in unison, but with Figs there was always something else: something thrilling about how audaciously they constructed their own way of dancing, their own way of being onstage together.

2

Figs in Wigs are not really a dance troupe. There is dance (sort of) in some of their shows, but there is also acting (sort of), comedy (sort of), celebrity impersonation (sort of), and in one of them they formed one of the world's most unpolished electro-punk bands (sort of). All of which is to say that doing synchronized dance routines doesn't define who or what Figs in Wigs are, but I think it does help to explain what makes them so brilliant.

In a Figs in Wigs show the same surreal internal logic that structures their dances is extended outwards into every facet of the show. It is present in their unified and yet bewildering aesthetic choices – matching costumes, matching make-up, matching wigs. It is in their jokes, their relentless punning, the way they speak to each other, the affectless demeanour with which they approach the increasingly absurd situations their shows create, like five brightly coloured cartoon characters refusing to acknowledge that there is anything strange about the fact they have somehow ended up in the real world.

It is there even in the structuring of the shows themselves, which seem to follow a totally unreadable, arrhythmical logic entirely of their own devising. The journey through a Figs show is like a story told by a seven-year-old, full of false starts, extended diversions and endless repetitions. Meticulously setting up rules and conceits only to totally abandon them. Scenes of unpredictable length crashing delightedly into one another like the Figs themselves endlessly careering across the stage. Yet none of this feels careless or accidental. It is all part of the strange, unified world that Figs are perpetually in the process of constructing for themselves.

All of this, all these facets of Figs' singular, unified onstage presence amount in performance to an expanded version of the feeling you get watching them dance together in unison. It is thrilling in its strangeness, illuminated from within by a kind of collective effervescence that means that even when what's happening feels shambolic or indecipherable it has a logic you want to try and understand. It belongs to a world you want to be a part of.

And this is the thing that is so special about Figs in Wigs. At a time when the financial constraints necessitated by a decade of austerity have seen an explosion in theatre work made by duos and solo artists, and in work that

in form and process echoes the traditional writer–director relationship of mainstream theatre, I genuinely can't think of a theatre company of as many as five members who have managed to continue to make work over the course of nearly a decade in the same uncompromisingly collaborative way that Figs in Wigs do, without a director or a writer or really any significant outside influence at all. In doing so they have been able to create something unique – a delirious theatrical universe without precedent, a world unto themselves.

In this world the Figs are able to take all the most ordinary and miserable parts of reality and transform them into something ridiculous and strange. In *Show Off* they are able to take the insecurity and self-absorption of social media and everything bad any critic has ever said about them and transform it into a riot of metatheatre and absurdist self-ridicule. In *Often Onstage* they trace endless patterns across the stage in their too-vivid green business suits. They speak empty motivational aphorisms from game show cards. They dance to the empty muzak of soul-destroying aspirational advertisements. In *Little Wimmin* they take the dour task of faithfully adapting the novel *Little Women* and turn it into a dizzying parade of surrealist props: an ice fountain in the shape of a penis, a person disguised as a Christmas tree and a giant margarita cocktail complete with five oversized straws.

In each case their work is an act of appropriation. It is the transformation of the reality that surrounds them into a world they might want to live in. A place of delirious strangeness and colour, of sophisticated theory and incredibly childish jokes, of care and unity and endless, flocking patterns of movement.

3

If you have ever walked in a protest, you have probably been told that it won't change anything. That the message isn't clear, or is unrealistic.

I think this misses an important point. Often the marching itself is the point. We march together, as a reaffirmation of community, as an act of collective solidarity. It is the creation of a new space we can all live in together, even if only temporarily. And the people on the march will carry the memory of that space with them when they leave. They will carry it together into the things they do in their ordinary lives. It will illuminate their future actions, changing those actions for the better.

Figs in Wigs shows don't appear to make much sense. Like protests they are noisy and colourful, occasionally disordered and frequently lacking in any clear 'message'. And like protests, to critique them based on a perceived failure to communicate anything would be a misunderstanding of what is taking place. Each Figs in Wigs show is a reaffirmation of the beguiling universe they are creating for themselves.

I think in presenting these shows to us, the audience, Figs are not asking that we decode their strangeness, or even hoping that we find it funny. Instead they are hoping that the world they have created might extend temporarily outwards to include the rest of us. That we can slip into the same odd rhythm. That we can harbour in the shelter of their strangeness from all the awfulness of the contemporary world – its competitiveness, its narcissism, its grim economic reality.

On theatre stages and in cabaret bars, in five matching versions of an infinity of costumes, they continue to act with the absolute conviction that they can live inside the world they have created for themselves, and that perhaps we can too. And that in itself is a defiantly, gloriously radical act.

(AF)

Further reading

Cilla Black Bean Sauce, a film by Figs in Wigs at vimeo.com
'Power in Numbers', by Rachel Porter, published at exeuntmagazine.com

PART 8

Ways of remembering

Jemima Yong

Deborah Pearson

Greg Wohead

Forced Entertainment

Tim Crouch and Andy Smith

Jemima Yong

The photograph was taken towards the end of the show. You can see the heat of the room in the way their skin glows under the lights. They are wearing nothing but thin white shorts and they stand in a tight embrace, at least two bodies, maybe three; an indistinct knot of arms and heads, as tough as a mat of hair, and yet at the same time so obviously soft. We can see where their pink bodies are gently pressed into one another, and how their hands rest delicately on arms or shoulders or hang in the empty air, fingers splayed. Around them the rest of the room is pitch black, which only emphasizes how bright they are, like a warning light or a distress signal; a beacon to guide us through the darkness.

The photograph is of Nic Green's show *Cock and Bull*. It doesn't tell us much about the show: it is not clear what's happening, we can't even see the faces of the performers or be sure how many of them there are. The photograph doesn't so much illustrate the performance as echo it, the indistinctness of these bodies a reflection of the way in which the performers themselves move and interact on stage, occasionally together, occasionally apart, words passed between and through them, like an incantation or a spell. The photograph presents these three figures as a single entity, a multi-limbed monster, strange and unknowable, but also euphoric. This is a story about hope in the dark; about the ecstatic, powerful softness of these bodies as a kind of resistance.

Photography has become an intrinsic part of almost every piece of contemporary performance art. There are a number of reasons why it has taken on such significance, not least among them the influence of visual art institutions like MoMA and Tate who are deeply invested in the idea that photography is an authentic means of documenting live performance, going so far as to claim it almost as an act of transubstantiation in which the photograph literally becomes the artwork, enabling it be to integrated neatly into their permanent collections and sold in certificated editions in the gallery shop.

As such the photograph has come to play a role similar to that of the published playscript in theatre, as both a crucial component of the live performance and the means by which that performance can persist into the future. Indeed, often when artists have sought to re-enact old pieces of performance art, such as in Marina Abramović's 2005 re-enactment of Joseph Beuys' *How to Explain Pictures to a Dead Hare*, they have treated photographs of that work like an actual script: a source text from which a new version can be faithfully adapted.

All of this necessarily imbues the photograph and the photographer with a lot of power to shape the way we think about and understand live performance.

Naturally there is a tension in this relocation from one medium to another. Away from the ambiguities and the intimacies of the live, compressed into two dimensions and framed by the directing eye of the camera, the performance becomes something else entirely. A photographer of performance is like a translator who is asked to turn a novel into a four-line poem. The choices they make in doing so will necessarily be a reflection of their values as artists.

When it comes to this fraught act of translation, I think that by and large what photographers value most are the performers themselves. This is especially the case in the kind of performance art in which the performer is also the artist who created the work. By employing the conventions of portraiture, the photographer can locate the performance in the body of the performer, transforming them almost into an icon, representative of the larger whole; their living body captured in the photograph standing in for the liveness of the performance itself. Such an approach has produced a remarkable and incredibly influential body of photographic work emerging out of live art over the last fifty years.

However, there are inevitably things that get lost along the way.

In the bottom left corner of Jemima Yong's picture of *Cock and Bull*, half hidden in the otherwise blackness, you can see a dimly lit row of audience members. Their faces are serious and concentrated, their eyes focused on the illuminated bodies in front of them; one of them is resting his chin on his hand. Such figures are a regular feature of Jemima's performance photography. You could even argue that it is one of the most striking features of her work. In 2013 Jemima published an entire book of photographs of audience members taken at various performances, from a few people scattered across the empty space of a south London warehouse to a vast auditorium filled with innumerable smiling faces. 'What do we watch,' Jemima asks in the text accompanying the collection, 'and does the presence of a spectator turn any live event into performance?'

The picture of *Cock and Bull* is taken from a series that she made as artist-in-residence at Forest Fringe in 2016. In nearly every image from the series the audience are included, at the edges sometimes but also right in the middle, watching, smiling, looking at the action on the other side of the

photograph. Their presence, the collection contends, is an essential part of the event.

It's important, I think, Jemima's choice to include the audience in this way. It speaks to her priorities as a translator of performance. I love Jemima's photographs because I think what she is trying to capture first and foremost is the experience of the audience and the way in which it is their act of witnessing that makes the live event. Jemima often uses wider shots than is conventional for stage photography, acknowledging the performance space in all its imperfections: the lights, the scratched floor, the mess collecting at the sides of the stage, the crossed legs of the audience, the backs of their heads, their concentrated faces. She is particularly good at capturing movement, or the feeling of movement, of conveying the sense that the performance carries on beyond the edges of the frame, in space and in time.

In all this Jemima seems to recognize photography as a part of any contemporary performance while also acknowledging its limitations as a means of truly capturing what the performance really is, or really was. Perhaps it is because she herself is a performer but she seems determined to use the significant role photography plays in the world of contemporary performance to honour the act of gathering that remains at the centre of it; to document this brief moment we spend together, in all its uncertainty and its imperfections. Her photographs are less a record of the artists' intentions and more a document of what it felt like to be there.

In the same collection that the *Cock and Bull* photograph is taken from, there is picture Jemima took of Action Hero performing their daredevil stunt show *Watch Me Fall* in the main space at Forest Fringe. In it Gemma is launching herself into the picture from the right-hand edge of the frame, she is wearing a blue dress covered in white stars and her face is tense with the effort of movement, one leg drawn back behind her. Jim meanwhile lies on the floor in the centre of the picture, his helmeted head strikingly caught in a beam of light. His eyes are closed and his face is calm, arms held above him, fists clenched, like a parachutist awaiting the jump, bracing himself for the kick he knows is about to arrive. And though it is yet to happen you can feel the impact of that kick, and the risk, the energy, the violence, not just of this moment but of the performance itself. This ballet of swaggering Americana, this handmade spectacle of violence and love.

Meanwhile in the background of the photograph are a row of audience members. One has her hands over her mouth, another has hers in her pockets. Another is documenting the moment on her mobile phone.

(AF)

Further reading

Forest Fringe Fragments Exhibition, at jemimayong.format.com

Deborah Pearson

1

In the photograph I am in the foreground and Deborah is in the background. We are both sitting on a bench in a park on the Île Saint-Louis in the centre of Paris. I think the year is 2006 so we are both twenty-two years old, or perhaps Deborah has already turned twenty-three. The late-afternoon sun is falling golden-white over the park with all the softness of a memory. Deborah is wearing a wide-brimmed hat that flops at the edges and we are both smirking. We had just eaten ice creams.

At the time this photograph was taken, Deborah and I had known each other for around a year and a half. We were in Paris to see the Wooster Group's *Hamlet* – an entirely serious and at the same time fantastically ridiculous attempt at re-enacting a filmed recording of Richard Burton playing Hamlet from 1964.

It should be said that it is not a particularly good photograph. I took it on the kind of small digital camera people used to have before they had smartphones. We look young and too pleased with ourselves because in truth we probably were. I'm aware in fact that this whole memory (the sunshine, the ice creams, the hat, Paris) is really too much. But it is ours, and the further away we get from it the happier and sadder it becomes.

2

In the second half of his last book *Camera Lucida* Roland Barthes sits in the house where his mother had lived, the house where she recently died, and searches through a collection of old photographs of her, taking them out one by one and placing them under a lamp. With each photograph he places under the lamp his mother gets a little younger and he travels a little further back in time, in search he says of 'the truth of the face I had loved' but never finding it – always finding her in these photographs to be almost the person

he remembers. 'The almost: love's dreadful regime, but also the dream's disappointing status.'

Eventually, however, he comes across one photograph that is different:

> The photograph was very old. The corners were blunted from having been pasted into an album, the sepia print had faded, and the picture just managed to show two children standing together at the end of a little wooden bridge in a glassed-in conservatory, what was called a Winter Garden in those days. My mother was five at the time (1898), her brother seven.

Despite its ordinariness, its seeming insignificance, something important is captured in this photograph, or we might say something in Barthes himself is captured by it. In it he is able to rediscover his mother: 'the distinctness of her face, the naive attitude of her hands, the place she had docilely taken without either showing or hiding herself'. There is truth in this photograph, a truth that speaks of her, and her death, and his sadness: that speaks of loss. Barthes quotes Godard's assertion that there is no such thing as a 'just image', that it is always 'just an image', but his heart won't allow this.

> [M]y grief wanted a just image, an image which would be both justice and accuracy – justesse: just an image, but a just image. Such, for me, was the Winter Garden Photograph.

3

Before she was a performance artist Deborah was a playwright. She was part of the Royal Court Young Writers programme in London and the Young Playwrights Unit at the Tarragon theatre in Toronto. She wrote smart, elegant plays full of quiet, youthful sadness. They borrowed stories and memories from her own life liberally and guilelessly, like you might borrow clothes from a roommate. These plays were often preoccupied with the past and how we live with it in the present; as loss, as longing and nostalgia.

There was, for example, a lightly fictionalized musical about her grandfather, who was a famous Hungarian film star, and he and her grandmother's escape from Communist Hungary to Canada in the 1950s. There was also a play that I directed and that together we called *Your Ex-Lover is Dead*, in which a writer meets his former lover to get her to read a book he's written about their relationship as a way of winning her back. Throughout their dinner together his one-sided memories physically intrude upon their conversation, pushing her further and further away until eventually she walks out, leaving him and his book behind. As I remember it, the play was as funny and disarmingly smart as Deborah herself, a one-act screwball comedy concealing under a veneer of superficial kookiness some

complicated questions about things lost or ruined and art's faltering and occasionally problematic attempts to reclaim them.

But despite their qualities, with hindsight these plays were an unsatisfactory receptacle for the intimate truth that Deborah was trying to speak about. They were stitched together from painful but unspectacular feelings – broken hearts, unfulfilled promise, the slow falling apart of families, the everyday losses we collect as we get older – the kind of stories that sit inside all of us, whose value as a story comes not from its content but from its importance to us and us alone. 'I cannot reproduce the Winter Garden Photograph,' Barthes says. 'It exists only for me. For you it would be nothing but an indifferent picture, one of the thousand manifestations of the "ordinary".'

Deborah tried to overcome the specificity of her stories, what Barthes might have called their banality, by playing ever more elaborately with the apparatus of theatre; stretching those stories to fit over unexpected forms (the screwball comedy, the Broadway musical), or deconstructing them through elaborate layers of metatextuality. But the quasi-fictions upon which these plays were built were perhaps not firm enough foundations; they lacked a truth, a justesse, at the heart of it all. And perhaps they lacked Deborah herself.

4

In 2008 Deborah and I ran Forest Fringe together for the first time. We moved chairs and cleaned floors. We argued and celebrated, we took tickets and tidied cables, we did things we had only the vaguest idea how to do, and in the middle of it all Deborah made a show. It was called *Music's Been Ruined by Dating* and was partly inspired, I think, by a small interactive piece that the performer Lucy Ellinson had made earlier in the festival, and partly by the experience of intimate performance she herself had accumulated running an advice booth on Brick Lane each Sunday for the previous year.

Music's Been Ruined by Dating was a piece for four audience members at a time, each of whom was given a compilation CD named for one of Deborah's four significant past romantic relationships and containing all the music that she strongly associated with that relationship and consequently now found too painful to listen to. Deborah would ask each person in turn to choose a song from their CD and as they all listened together Deborah would describe the memory she associated with that song, addressing each audience member directly, as if they were the former partner her story described. All this took place in a small den that Deborah would make out of blankets, scattered with photographs and mementos from her house.

Here, all the playfulness of form and the intimacy of content that typified those earlier plays was reconfigured, reorganized around her presence as a performer or, perhaps more accurately, around a past that her presence as a performer confirmed as true. And in this delicate tension between the truth

of the story and the artfulness of its telling emerged, quite unexpectedly, a blueprint for a trilogy of works Deborah would go on to make over the next decade, in which a series of elegant experiments in theatrical form were built upon her physical presence, and the realities, both ordinary and extraordinary, that her presence imbued with meaning.

In *Like You Were Before* (2010) Deborah used camcorder footage recorded on her last day in Toronto before moving to the UK as a means of attempting to understand the distance between the person in the video and the person on the stage in front of you. In *The Future Show* (2014) she quite deliberately shifted from looking backwards to looking forward, writing a new future for herself each time the piece was performed, beginning with the applause that she imagined would end the show and finishing years later with her death. For *History History History* (2016), the final part in this informal trilogy of works about time, Deborah returned to the story about her grandfather that she'd first tried to tell nearly a decade previously, this time, however, reorganizing her telling of it around her own relationship to the material traces of that story that still remain: old pictures, slides, timelines, audio recordings and, at the centre of it all, one of her grandfather's original feature films, which plays out in its entirety across the length of the show.

If Deborah described these pieces as a trilogy about time, they are also a trilogy about loss: about big losses and small; lost loves, lost friendships, lost songs, lost cities, lost days, lost years. In them she speaks of nostalgia and the memory of what it was like to be young, of the quiet unspectacular loss that comes from settling into a life and sacrificing all the other possible lives you won't live, and of the feeling of dislocation from a language and a culture that could have been yours under different circumstances, had history not intervened.

The locations that Deborah chose for these pieces often resonated with this sense of loss and disappearance. The first version of *Like You Were Before* in Edinburgh took place in an independent video store at a moment when such stores were becoming relics of another time (and in fact the store in which it took place closed less than a year later). *History History History* was intended for cinemas, themselves also beginning to feel like anachronisms in the age of Netflix, Amazon and the rest.

Most remarkably, though, in these three pieces Deborah finds a way to speak about the specificity of her own loss, a loss that while occasionally remarkable is also frequently private and unspectacular; the kind of loss that accumulates slowly and invisibly in our muscles like sediment, that shapes us in ways that only we can understand.

5

Each of these pieces has been described as 'autobiographical' and it is true that they are, though perhaps not in the way that this term is usually used to

refer to performance. Conventionally, an autobiography is a history of someone's life, and as such its meaning is derived from the linear unfolding of the events in that life; a story that is usually worth telling either because the individual whose life is being told is remarkable, or because of the remarkability of the situations in which they have found themselves.

I would argue that in none of Deborah's work is this the case. In Deborah's work the meaning is not derived from the linear unfolding of a true story, even in those instances, such as *The Future Show*, where superficially the story appears to play out in a linear way. Instead Deborah's pieces function more like Barthes' Winter Garden photograph, in which the meaning is derived from the relationship between the true event being described and the artificiality of the apparatus used to capture it; between Godard's 'just an image' and Barthes' 'just image'.

In this light it is interesting that in so many of Deborah's shows the true story that is being told is represented by some real, tangible document, whether that be the video in *Like You Were Before*, the film in *History History History* or, in *The Future Show*, Deborah's binder of imagined futures; endless reams of neatly printed A4 describing all the details of her life to come like some vast diary-in-reverse. In each case the 'drama' of the piece revolves around the ways in which these documents are re-enacted or re-performed, their banal reality probed and pulled in pursuit of something more profoundly true.

And in these three pieces at least, the way that truth is reached is through Deborah herself, sat in front of us, playing out (or perhaps playing with) her relationship to these objects and these stories, to this real sadness and this real loss. It is in her paradoxical presence, rehearsed, enacted and yet irreducibly real, that the gap between the factual reality of these stories and the particular meaning that they have for her finds its resolution.

6

[It is interesting to note that having found this place for herself in her work Deborah has now moved on again, leaving behind her role as a performer and central storyteller in her work in order to explore ways in which she might enable other people to explore similarly illusive, subjective kinds of truth.]

7

There is one final photograph to describe, and it appears about halfway through *History History History*, projected onto the screen behind Deborah on a scale that dwarfs her. It is a black and white image, an archival remnant of the 1956 Hungarian revolution, showing a vast crowd of thousands of

people taking to the streets to protest against the Communist government. They stand, an ocean of tiny monochrome faces, all staring into the camera. Deborah picks up a blank placard, an echo of the placards we imagine must have been present during this protest, and as she holds it up to the projected image it magnifies particular faces, pulling them out of this anonymous ocean of history and suspending them in front of us, just for a moment. One by one Deborah picks out these faces in the crowd, like Barthes scanning through the old photographs of his mother and holding them under the light.

We watch her, as she studies each face in turn, searching for someone or something familiar, for connection, for not just an image but a just image, for a truth beyond history.

(AF)

Further reading

The Future Show, published by Oberon
'We are all on this merry go round made of time together': interview with Deborah Pearson by Catherine Love, published at exeuntmagazine.com

Greg Wohead

The desk sits in a high place: the peak of a hill, the rooftop or upper storey of a building. A place that is not too populated and has an unencumbered view. On the desk are an apple and that day's newspaper holding a message written to me from the past: a message relating to time, and how difficult it is to appreciate the present as it's happening, even to experience the present as it's happening. I'm sitting at the desk wearing headphones, and the voice in my ears invites me to look down on the street below. Down there I see a man wearing a cerulean blue T-shirt, the blue of the Mediterranean at the height of summer, raise his arm to wave at me. We are several minutes' walk apart, and yet the intimacy is such that we might be looking directly into each other's eyes.

Now, years later, I try to recall this event, reconstruct it from uncertain memory, using other people's writing as prompts. But what interests me is less that unique experience of my own than the repeated experience of the man: raising his arm at exactly the right moment at regular intervals over the course of an afternoon or evening, trusting that in the repetition, something monumental is happening.

*

Every December since 2015 Greg Wohead has written a round-up of his favourite performances of the year. I love it: he travels a lot so his lists always transport me somewhere unexpected. The 2016 edition, however, started with a sentence that discombobulated me so much I wrote a really bad poem in reply. 'Looking back I can see repetition as a way of wearing away at something,' he said. 'I can see plurality and contradiction prioritized over singularity and neatness. Complexity over simplification. Space held for mystery. Dog whistles. Strangeness.' It's an exquisitely constructed paragraph encapsulating much that I'm also looking for in performance. But in the moment of reading, approaching another school holiday, with two children aged under ten, and my life a litany of tedious repetitions, laundry cycles and dishes to wash and twice-daily school runs and exhortations to brush teeth properly, I felt as though the something being worn away by repetition was me.

*

Greg had been making solo work for about three years before I got around to watching him for the first time, in summer 2014. In an interview on the website *Run Riot* he talks about perceptions of that earlier work, how it was described as 'nostalgic, lovely or charming', and how he saw in the fact that 'people considered my onstage persona charming and were able to trust me' the potential to manipulate an audience, 'to use those strengths to take the audience somewhere very different'. Where he took us in *The Ted Bundy Project* made my skin crawl and stomach churn like I was going to vomit. The something worn away by repetition in this performance is the surface sheen of human civilization, the gossamer fabric of social niceties. The simplification Greg rejects is that Ted Bundy, serial killer and rapist, is a monster; the complexity he presents instead is a reckoning with the monstrous in human nature, which seeks out stories of murder and rape, splashing about in their gore. As an audience member I could try and distance myself from this: I don't watch horror movies, I don't read real-crime stories, I don't play video games that involve killing people. But I've voluntarily come to see a show called *The Ted Bundy Project*. Who exactly am I trying to kid?

Space held for mystery. Dog whistles. Strangeness. Thanks to the derelictions of journalism in the face of rising far-right and fascist ideology, 'dog whistles' carries a negative connotation, but I think Greg means something else by it: the coded message, subtle but obvious enough to anyone tuned in to its frequency. With every repeated act in *The Ted Bundy Project*, Greg aligns himself more and more with the horror of Bundy's personality, the potential for violence, questioning whether it makes a difference if that violence is enacted physically or only in the mind. But even as that accrues, the repetitions of Bundy's movements and words enact something else: a deeply responsible, compassionate reflection on feminist thought and female experience. Rather than attempt to distance himself from a world in which women are rendered vulnerable by rape culture – a world in which the words 'rape culture' are an actual accepted definition – Greg acknowledges his part in that culture, recognizing that such acknowledgements are the first necessary step towards wider social change. Plurality and contradiction prioritized over singularity and neatness.

*

In truth I only remember this because I wrote about *The Ted Bundy Project* soon after seeing it. I watch too much performance to hold on to a lot of it. I remember Gillie Kleiman looking furious when she was the guest performer in Greg's 2015 show *Celebration, Florida*, a blissful resistance in her body to everything being asked of it, and I remember Greg's text talking about being in a hotel room, about missing people, about what it is to ask people to stand in for you, or be you, or be someone else for you, and already I

think: am I making this up? Who Gillie's partner was in the performance I saw, what the substance was of the text, the details of the choreography, the elements repeated, because inevitably, I'm sure of this, elements were repeated, I have no idea.

Sometimes I wonder – and asking this again is another repetition – why I see so much performance. I wonder what it means to leave the house night after night to return to the same small rooms, often recognizing the same people in the audience. What it means to see at once the ways in which a performance is unique and is just like the performance I saw last week, and last month, and last year. What it means to swap one repetition – the nightly climb of the stairs to the children's bedrooms to kiss them goodnight – with the repetition of sitting in the dark, watching, listening, watching, listening, watching, listening, watching, listening, watching, listening, watching, listening, watching, listening, watching, listening, watching, listening, watching, listening, watching, listening, watching, being attentive, listening, watching, listening, watching, listening, watching, listening, watching, listening, watching, listening, watching, listening, watching, listening, watching, listening, watching, listening, watching, listening, watching, listening, watching, bearing witness, listening, watching, listening, watching, listening, watching, listening, watching, listening, watching, listening, watching, listening, watching, listening, watching, listening, watching, listening, watching, listening, watching, listening, watching, listening, watching, listening, watching, listening, watching, listening, watching, listening, watching, listening, watching, listening, watching, being attentive, bearing witness, listening, watching, listening, watching, listening, watching, listening, watching, listening, watching, listening, watching, listening, watching, listening, watching, listening, watching, listening, watching, listening, watching, listening, watching, listening, watching, listening, sometimes feeling totally electrified and present – like in that moment sitting high on a hill in Edinburgh, catching sight of Greg in his blue T-shirt on the street below, holding our bodies in that moment, long enough to understand that this was the present, this was living – only for the electricity to fade, and with it memory.

A few weeks before writing this I interviewed the theatre director Ellen McDougall about form and structure in plays/performance texts, and she began to talk about the use of repetition, how revealing it can be to look at something again and again: 'because we can just be asking an audience to look again at something that might seem familiar but perhaps if we look at it more closely or differently or again it will reveal something else. That in itself is a kind of resistance to the idea of a linear narrative.'

In the moment she said it, I understood exactly why I go to the theatre, and keep going, and keep going. I understood again a message that bears repeating, because I need to keep being reminded of it, that the way in which I attend performance 'in itself is a kind of resistance'.

*

Sometimes it feels like a trap, a catch-22: life, or theatre? The treadmill of university, job, marriage, kids, or the treadmill of one performance after another after another? The answer, of course, is both. Sometimes the loop is a prison, sometimes it's a prism. Maybe it depends on the angle of looking.

Comeback Special thinks about the prison, the prism, the point of view. It's a re-enactment of sorts, of an intimate live performance recorded by Elvis Presley in 1968: the singer's attempt to reinvent himself after a stint in the army and years of duff movies had seemingly erased from cultural view the rock 'n' roll heartthrob who sent teen girls dizzy with desire. Greg describes watching the film of it obsessively, but quickly turns the audience's attention away from himself to Elvis, making us look in increasingly fine and focused detail at his demeanour, his performance, his interaction with his fans. Much of the show is dedicated to directing the audience in a single, granular moment of re-enactment, Greg as Elvis, the rest of us cast as his bandmates and the enraptured women who surround them.

As all this was happening, I thought about three things. One: I thought about the ways in which Elvis relied on his fans to be the person he was, to hold together the person he was. As a performer he was a construct, a vision, a dream, and the *Comeback Special* was his attempt to reconstruct that dream. And that led me to think about the ways in which all of us are social constructions, the sum of our relationships with our parents, our families, our friends, our work colleagues, our lovers, our enemies. There is no me without you. Two: I thought about the ways in which masculinity is a social construction, that relies upon repetition for its reification. What it means to be a man, to be manly, to be masculine: none of these things are absolute, all of them are created and as such can be deconstructed and remade anew. Three: I thought about how Elvis was thirty-three when he filmed his *Comeback Special*, and that Greg was about the same age. I thought about what it might mean for one performer to turn to another to look for clues in how this man chose to reinvent himself – and then thought about myself, turning to Greg, to look for clues for how I might reinvent myself. Each of us wearing away at something in this linear narrative that is life.

A year after Greg made *Comeback Special,* he collaborated with another performer, Rebecca Atkinson-Lord, on a show called *Snowballing,* a pretty explicit discussion of their sex lives. In a blog post to promote the show, Greg wrote about exploring 'alternative relationship set ups – open relationships, polyamory, what options and models there might be when you don't take the dominant standard of monogamy/marriage/kids as a given and how destabilizing and also full of wild potential making up your own model can be'. In retrospect, I feel like I could see all of that latent in *Comeback Special.* The possibility of changing your life completely, redefining yourself, starting again. The longing for difference, to be different.

Greg found that wild potential in himself. I'm still searching for mine.

<center>*</center>

The desk sits in a high place: the peak of a hill, the rooftop or upper storey of a building. A place that is scarcely populated and has an unencumbered view. On the desk are an apple, and that day's newspaper, with a message written to me from the past: a message relating to time, and how difficult it is to appreciate the present as it's happening, even to experience the present as it's happening. The message was written by Greg Wohead; this is his one-to-one show *Hurtling*.

I'm sitting at the desk wearing headphones but in my mind I'm in the car I was driving nearly two decades before, losing control, somersaulting through the air. Memory crashes into the present moment, making it hard to concentrate on the voice speaking to me through headphones, telling me about their own car accident, the tree still marked with a scar.

The voice in my ears invites me to look down on the street below. Down there I see a man, Greg, wearing a cerulean blue T-shirt, the blue of the Mediterranean at the height of summer, raise his arm to wave at me. We are several minutes' walk apart, and yet the intimacy is such that we might be looking directly into each other's eyes.

Now, years later, I try to recall this event, reconstruct it from uncertain memory, using other people's writing as prompts. But what interests me is less that unique experience of my own than the repeated experience of the man, of Greg: raising his arm at exactly the right moment at regular intervals over the course of an afternoon or evening, trusting that in the repetition, something monumental is happening. Trusting in the act of performance to change a life, for a moment, or even for ever.

<center>(MC)</center>

Further reading

The '10 performances that did it for me' series and the *Comeback Special* programme note, both published at gregwohead.com

These memories
are incidental.
What I remember
is the leap

Forced Entertainment

1. I have seen some Forced Entertainment shows

Between 2007 and 2013 I saw every show that the theatre company Forced Entertainment made. In studio theatres and town halls and even via live-stream, I watched everything that I could. I have seen more shows by Forced Entertainment than I have the shows of any other single company.

2. All the Forced Entertainment shows I haven't seen

Jessica in the Room of Lights (1984)

Jessica in the Room of Lights was first performed in Sheffield on 14 December 1984. I was living in Stockport at the time, only about an hour away. I was 352 days old. In the show disparate elements combine in ways that are new and unexpected. Tape recorders crackle, John Avery's soundscapes fizz and hum and bare lightbulbs illuminate the room with an abrasive lack of theatricality. All of this is happening in a faded pre-digital monochrome; a show assembled from shaky snapshots and blurred impressions. My hair is black but it won't stay that way.

200% and Bloody Thirsty (1987)

In the photograph three performers lie semi-naked on a bed surrounded by mountains of discarded clothes, as if some orgy of metamorphosis has just reached its sweaty conclusion, a feverish scramble through a rogues' gallery of hastily-sketched but achingly familiar characters. The three performers look young and somewhat intimidating, sharing the trace of menace implicit

in their company's name. In the background a red neon sign reads 200% AND BLOODY THIRSTY, which I think makes sense because if I had come up with a title that good I too would suspend it above the stage in large illuminated letters.

Emanuelle Enchanted (1992)

More costumes and more characters, their descriptions now drawn on hand-painted cardboard signs. These characters are, by turns, familiar and strange, comic and heartbreakingly sad, conjuring in their multitude a restless and dizzyingly expansive version of the world; a portrait of a time and a place that is less like the bounded world of the theatre and more like the experience of too many bloodshot hours spent skipping aimlessly through late-night television in insomniac darkness. These characters are what I associate most closely with these early unexperienced years of Forced Entertainment and the thing I have stolen most flagrantly and unintentionally from them, populating an early show of mine about disaster movies with an uncannily similar collage of imagined people, each with their name neatly printed on an accompanying white index card. A man walking a dog. Poor Sharon. A horny priest. Geronimo. A sexist van driver. A woman picking gum out of her hair. A man trying to extricate himself from a torrid affair. Kevin (looking for his keys). The world's last Neil Diamond fan. A woman who can barely remember her own name. An aspiring artist caught accidentally in an obvious act of plagiarism.

Club of No Regrets (1993)

It is the summer of 1993, my family and I are at Universal Studios in Florida and it is the most enchanting place I have ever been. The air is thick and popcorn-sweet. I am losing myself in sentimental Hollywood glamour: a vast New York skyline painted in steel greys, a carbon-fibre Amity Island shark hanging jaws-first from a wooden gibbet, Marilyn Monroe and the Blues Brothers smiling and waving and signing autographs; even the cobbles of a San Francisco street amaze me. It is like slipping temporarily into a world I don't belong to, and yet of course at the same time it isn't. It is deliberately unreal, and that is part of its allure; the appealing flatness of that New York skyline, the way the cobbles abruptly end, replaced by regulation theme-park asphalt. It thrills me in the same way as a half-finished painting or learning how a magic trick is done. Even now it is hard to know whether I am more in love with the impossibly romantic make-believe America cinema imagines, or the fantasy-making apparatus that produces it.

Speak Bitterness (1994)

The stage is a long desk, long enough for seven or eight people to be sat behind it as if arranged for a press conference, and along the top of the desk

are hundreds of sheets of paper. So much paper, so many words, as there so often are in Forced Entertainment's work. No end and no beginning, just seemingly infinite variations on simple linguistic constructions: a litany of confessions, a long list of questions, thousands of 'in the futures' or 'once upon a times'. I'm reminded of Allan Kaprow writing about the legacy of Jackson Pollock, of how his painting refused to acknowledge the presence or meaning of an edge, instead seeming to extend outwards in all directions well beyond the limits of the visible canvas. The four sides of the painting are thus an abrupt leaving-off of the activity which our imaginations continue outward indefinitely, as though refusing to accept the artificiality of 'ending'. More than once I have been in a Forced Entertainment show that I believed might never end, any semblance of a satisfying dramatic arc bulldozed aside by a kind of relentless televisual logic; a theatrical world as endless and repetitive, as vast and comic and occasionally unbearable as life itself.

Nights in This City (1995)

We are driving through a city at night. It might be Sheffield in 1995, but it might also be London in 2010. This could be a Forced Entertainment show or an idea of one, either way it is not clear who is driving, or where you are going. Outside the streets unfold like some interminable sentence, a never-ending story made of glass lobbies, shuttered off-licences and late-night takeaways, but from in here it all appears too quiet and too peaceful to be entirely real. This quality of theme-park estrangement is heightened by the voices in your ear, deadpan, inscrutable, describing a place that seems at once wildly imaginary and tediously real; they sound drunk, or maybe just confused, yelling into the amber-lit drizzle of the disinterested city, asking for something it cannot give them. You pass the occasional person out on the street, some of whom seem to turn slowly to meet your gaze as you drift by. They all look uncannily perfect, like they are moving in quotation marks. The city shivers, as if even exposure to these trace amounts of unreality can cause it to unmake and remake itself. It is still not clear whose show this is, what city you're in or even what year it is. But isn't that the definition of liveness, asks Tim, when guides twitch nervously or appear to be lost? Where safe passage back to the everyday is no longer assured?

Showtime (1996)

The word 'deadpan' first appeared in print in the *New York Times* in 1928, used to refer to Buster Keaton, although the newspaper's casual deployment of the term would seem to imply it was already common parlance by this point. Maybe you already know this but *pan* used to be theatrical slang for your face and hence a dead pan was a face seemingly without life or feeling – expressionless, impassive. It is, quite literally, a face haunted by death. A face with the skull

already showing through, like the hapless skeletons that have appeared in Forced Entertainment's work on more than one occasion. It is a reminder (as if we needed one) of how humour always glimmers with death, or perhaps death glimmers with laughter. A shirtless man, holding tinned spaghetti innards to his abdomen, slowly expiring over the course of about an hour.

Pleasure (1997)

I am closing my eyes and listening to Forced Entertainment in my head, that unmistakable shared cadence; deadpan, opaque, themselves and not themselves, at once invested in the words they are saying and the stories they are telling, but also always aware of the disposability of those words, and their artifice; always ready in a moment to demolish and discard the fictions they have patiently constructed, like a cat suddenly breaking in half the mouse it has spent the last hour playing with. The pleasure of creation and the pleasure of destruction. Storytelling for the nuclear age.

Dirty Work (1998)

What is it exactly that I'm doing here? Is it a game? A practical exercise? A too-cute conceit for measuring the influence on my own work and that of my contemporaries of a company who have existed for almost exactly as long as I have? Is it a list? Is it a way of admitting my fear that I have nothing to say about Forced Entertainment that other people haven't already said more eloquently elsewhere? Is this all too clever for its own good? Will it get repetitive? Will it wear painfully thin long before I reach *Real Magic*? Will it get repetitive? How many more Forced Entertainment shows will I have to admit to stealing from? Will I decide to include the story about the job interview? Will you stick with it? Will it get repetitive? Will you make it as far as this part? And this part? And this one? And this one? And this one?

Disco Relax (1999)

I was sixteen on the eve of the new millennium. While Tony and Cherie, the Royal Family and various other invited guests gathered under the pristine white canopy of the newly completed Millennium Dome and the crowds massed in the cold to witness a river of fire erupting along the Thames, I was standing outside the Histon Village Shoppe with a girl called Katie Joel, trying to persuade an older boy we didn't know to buy us a small bottle of vodka that we would take with us to Joanna Quincey's house party. I drank it in urgent swigs, straight from the bottle, swallowing hard and holding the metallic burn deep in my throat to stop it rising back up again. I hoped Katie and I might kiss at midnight but we didn't. Instead we all watched the celebrations in London on television from Jo's parents' front room. The

grandeur and the glamour of that distant party did not belong to us and never would. We had party poppers and tinsel, soft furnishings and no-brand vodka. We were the people on the other side of the television. We still are.

First Night (2001)

It would be easy to identify all the ways in which Forced Entertainment have influenced the work of the artists who have come after them – the flat affectless delivery, the relentless making and unmaking of the mechanics of theatre, the childlike play of dressing up and pretending, a vernacular and a kind of narrative logic drawn as much if not more from television and film than it is from theatre, a belief that humour and silliness are not the opposite of seriousness. But to what extent are the similarities between Forced Entertainment's work and our own a result of direct influence, and to what extent is it the case that they were the theatre company that first, or perhaps most visibly, reflected the changed cultural landscape that we grew up in; a world of *Only Fools and Horses* and Christmas pantomimes, of Universal Studios and *Pat Sharp's Fun House*. And as that cultural landscape changes again in the internet age, will the place they and their work occupy change accordingly?

Bloody Mess (2004)

This is the one, isn't it? The One. The Culmination. The Apotheosis. The show that all their other shows were building up to, against which everything else is to be measured. The one with the blood and the smoke and the lights. The one with all the performers, all of them, not just Claire and Richard and Terry and so forth but guests as well, Wendy Houston, Belinda Carlisle, Lionel Blair, Pauline Quirke, Prince Michael of Kent, Edd the Duck, and there they all are, running around and shouting, sweating their way in and out of costumes in great rolling banks of mist and light and at first nothing seems to make sense at all, there is too much of everything, it is all too incredible, too disparate, too messy, but then suddenly somehow it all comes together so magnificently, a low rumble of thunder but you can't be sure if it's coming from the theatre PA system or somewhere outside in the grey dawning of a still-new century and then it's raining confetti and actual rain and by the end everything really is a fucking mess but you know you can say I was there I was there I was there.

Exquisite Pain (2005)

Forced Entertainment have never been invited to perform at the National Theatre. Perhaps it is presumptuous to assume any company has ever earned the right for their work to be presented at the National Theatre. After all,

Sarah Kane, arguably the only other artist of their generation to be as internationally recognized and acclaimed, has had her work presented there just once, posthumously, in the building's smallest theatre. Perhaps this speaks of nothing but the various shades of conservatism of the four Cambridge-educated knights of the realm and one RADA-trained former actor who have presided over the National Theatre in the period that Forced Entertainment have existed. But I think it also speaks damningly of the ideology of the NT, the way in which it quantifies value and measures success, and the influence this has on the wider theatre culture in this country. I remember once sitting in a massive conference room listening to then-culture-secretary Jeremy Hunt praise 'our actors who start off at the National and go on to star in the West End or in Hollywood'. It rang with a bitter truth. This is, in the end, what the NT (and many other smaller theatres in London and beyond) are most proud of: their association with or proximity to success in the West End and in film and television. They want to be part of the world on the glossy side of the television screen.

The World in Pictures (2006)

I actually had a ticket to this show, at the Riverside Studios in Hammersmith. It was part of my MA Text and Performance course, run by Alan Read, newly appointed as King's College's first professor of theatre. He led us with the mischievous fervour of a disreputable uncle left mistakenly in charge of all the children. He told us about his plan to reintroduce maypoles to central London, he took us to Paris to see the Wooster Group, he gave all his lessons in an empty anatomy theatre that King's College refused to give him permission to use, and demanded we operate during our parallel lessons at RADA as spies given an unprecedented glimpse inside the apparatus of establishment theatre. But for reasons that I do not remember I did not go to Hammersmith to see *The World in Pictures*. I remember only the argument about it that we had the following day when a fellow classmate complained that it was incredibly boring and Alan, like Archimedes leaping from his bath, exclaimed: 'But let's think for a minute about the value of boredom!'

The Last Adventures (2013)

Cardboard clouds floating across the stage. Cardboard trees re-arranging themselves like a cartoon army. Cardboard waves as big as the performers holding them. That tactility of these objects in the vastness of the warehouse. Do people talk enough about the beauty of Forced Entertainment? Their sweetness? The delicate wonder they can so suddenly conjure amid the mayhem and the carnage – those moments of sublimity that feel all the more wondrous for how thoroughly they have been earned? Those cardboard clouds. Maybe this is the show, more than any other, that I wish I'd seen.

The Notebook (2014)

In 1940s South Carolina, mill worker Noah and rich girl Allie are desperately in love. But her parents don't approve. When Noah goes off to serve in the Second World War, it seems to mark the end of their love affair but when Noah returns to their small town years later, on the cusp of Allie's marriage, it soon becomes clear that their romance is anything but over.

Real Magic (2016)

It is said that the definition of insanity is doing the same thing over and over again and expecting different results. It might also be said that this is a workable definition of theatre. As an art form it is uniquely dependent on this curious combination of repetition and indeterminacy. All those actors orbiting like satellites, caught in the same loop night after night, disappearing for literal years into *The Lion King* or *Billy Elliot* or *Thriller Live*. 'How was it?' someone asks you. 'Really nice', you say, 'they were so warm tonight, it was actually a really nice one.' It is important to remind myself that for all that they might be children of the television era, Forced Entertainment are a theatre company and they fully embrace its distinctive peculiarities, its threadbare costumes and its naff razzle dazzle, the stage fright, the missed cues and the drudgery of its ceaseless repetitions. Probably this last one most of all. Have Forced Entertainment been making the same show for thirty years? A Dadaist soap opera of an unprecedented scale and duration. A cast of thousands: clowns, skeletons, kings, game show hosts, a crocodile, more than one murderer, magicians, trees, clouds, a man in a chicken costume, a lost tour guide, three people on a bed, Jessica in a room of lights. They enter and they exist, they live and they frequently die. The lights go up and down. Their stories meander, overlapping one another, eventually getting lost or just petering out inconsequentially. They repeat themselves, over and over and over again. It is maddening and it is wonderful. It is never-ending. This show expands and expands, reflecting ever more closely the vertiginous strangeness of the world. Or perhaps what is happening is that the real world is slowly bending itself into the distorted shape of Forced Entertainment's funhouse mirror reflection. Sometimes it's impossible to say. After all these years we're all a little lost, a little delirious, but then isn't that the definition of liveness, when safe passage back to the everyday no longer seems assured?

(AF)

Further reading

Certain Fragments: Contemporary Performance and Forced Entertainment, by Tim Etchells, published by Routledge
forcedentertainment.com

Tim Crouch and Andy Smith

Early in our meandering friendship, Andy (Field, that is) sent me a photograph of Tim Crouch in his underpants. I was feeling essentially hopeless about basically everything and so he gave me a pep talk – the first of many – using this photograph to illustrate his point that life can always melt into new possibilities. The image was a screenshot of a shonky TV drama called *Mile High*; Tim's character, a 'sleazy captain', had been caught in black leather underpants, cap askew. It was in this desolate moment, Andy told me, that Tim made the decision to start writing his own work.

Everything I've seen of Tim's comes from a place of profound moral seriousness: the kind of seriousness a person would bring to their work when what they're doing is seeking and making meaning in life. The twist, as I see it, is how morally disturbing his work is as a result. I'm thinking, for instance, of Tim playing Malvolio in *I, Malvolio*, one of a series of shows he's made dedicated to individual (and difficult) characters from Shakespeare plays: dressed in a dirty, ripped onesie, a sign reading KICK ME swinging at his back, his Malvolio stands on a chair with a noose around his neck and calls up a child from the audience – this is a show for schoolchildren! – to enact the hanging. I'm thinking of Tim playing a writer called Tim Crouch in *The Author*, slumped late at night at his desk with a grotesque scene of child pornography looping on his computer screen. I'm thinking of Tim playing another Tim-not-Tim in *what happens to the hope at the end of the evening*, visiting his friend Andy – Smith, that is, sitting beside him on stage – during a lurching traipse around the country participating in anti-fascist protests. This Tim-not-Tim has his politics in the right place but not his aggression: exacerbated by alcoholic tendencies and souring misanthropy, it fizzes acidic inside him, makes him short-tempered, judgemental, sarcastic, makes him stand at Andy's window growling at some boys idling on the street outside, all too ready to attack.

In other hands – I know this from various experiences over the years of watching fucking awful theatre that thinks it's commenting on or satirizing the worst of the world but in fact is producing exactly that worst in how it

speaks and moves – each of these moral disturbances would constitute an act of not-thought-through violence. Or, they might make it easy for me in the audience to distance myself, to say no, this isn't speaking to or about me. But the question Tim asks most seriously and passionately in his work is: what are we, specifically those of us in the room right now, doing in the theatre? What are we making? How does it relate to the society we are making? Do we recognize the ways in which we contribute to making society? At what point do we – specifically those of us in the room right now – recognize that we're prancing about in leather underpants, caps askew, desolate, and need to take action to rewrite our shared future?

Perhaps it's a coincidence or perhaps not but A Place of Profound Moral Seriousness *was the title of the show at which I met Tim and Andy for the very first time, a work-in-progress performance in a small black box studio at Battersea Arts Centre back in the days when they still had small black box studios at Battersea Arts Centre, which would make it I would guess about 2008.*

The show was by Andy though he went by the name 'a smith' at the time, which I remember thinking was incredibly enigmatic. Why 'a smith'? Was it meant to evoke the figure of a smith, as in someone who smiths? Are we meant to picture calloused hands toiling at the furnace of ideas, the quiet nobility of honest work, the sound of metal on metal echoing across a valley in a remote part of Norway or Iceland or somewhere, hammering white hot truth into the shape of art?

Or is a smith instead meant to imply a kind of humility, an ordinariness, like Joe Bloggs or John Doe? Simple, without ego or adornment, humbly lower case. He's just a man, we might imagine, just an ordinary man, just an ordinary man sitting here with his microphone, just an ordinary man sitting here with his microphone, ready to share with us some ideas he forged in a cottage in Norway or Iceland or wherever.

So I was sat there in this modest black box theatre at Battersea Arts Centre, looking out at the empty stage with just a chair and a music stand and wondering about the meaning of a smith when I couldn't help but notice that among the no more than twenty or so people in the audience there was Tim Crouch sat right in the middle of the row in front of me, his bald head kind of reflecting off the house lights in quite a distracting way. I'd never been introduced to Tim but I knew who he was. I had seen My Arm *and I'd heard about* An Oak Tree *and even on the basis of those two shows he was already this semi-mythic character, really tall and really bald and kind of blurred around the edges by the fictional selves he had created for himself.*

Eventually Andy arrived and sat on the chair holding a guitar and told the story of a man, also called Andy, who was once part of a musical double act – a duo of hard-core satanists from the black metal scene of the early 1980s with a name like Throttle Grease or Splinter Death or Anal Jesus or something like that, only as Andy tells it this guy had never believed it, the

satanism stuff, it had all been an act, a way of selling records, all the face paint and the cross burning and everything. And so his story really is not about black metal per se but is more an opaque reverie on the meaning of truth and the responsibility of an artist to his audience and whether evil really exists in the world. But then suddenly about halfway through all of this Tim, who I had noticed had been kind of grumbling and muttering under his breath, stands up in the audience and starts screaming and cursing at Andy, which was initially incredibly uncomfortable to watch until you realize, he is not being Tim at all but is in fact meant to be the other guy from the black metal duo and that he really had believed in Satan and The Cause and everything that Andy had just explicitly disavowed. At this point Tim sort of wades through the audience and takes over the show with this genuinely remarkable and actually quite affecting story about a night he tried to set fire to a church and ended up giving himself third-degree burns over like seven tenths of his body, then at the very end the two of them resolve their differences and end up playing this beautiful, gentle cover of Robert Johnson's 'Me and the Devil Blues' and after that it was over and we all just went home.

There's an old evil spirit prowling at the edges of Tim and Andy's work, the thing that all of us are making, all of the time, intentionally or not. Andy invokes this blue devil (the blue of flame that alchemic heat turns white), naming it to create a counter spell, the first step in dousing its magic and neutralizing its power. 'I want us to stop making all this capitalism. To stop making societies that operate on the principle of winner takes all,' he says outright in *All That Is Solid Melts Into Air*, a work I watched him perform to definitely fewer than twenty people in Camden People's Theatre, no stage decorations except a chair he'd found in the building and a music stand that could be folded into his rucksack. 'I'm not a communist, if that's what you're thinking. [But] I still think it would be good to . . . imagine some of the things that communism imagined. Like say a fairer, more collective society.'

Stripped of all fripperies, this is theatre as manifesto, as agitprop, as plaintive direct address. It comes from a similar imaginative landscape as plays by Clifford Odets and Bertolt Brecht, but also sits there differently, because everything has been stripped from it except the intimate connection of one human speaking close to another. The impact of that is potentially huge, in theatrical terms but also activist terms. I say this because Andy's impact on me has been huge. Watching him at CPT, I thought something I very rarely think: that I could sit on a stage and say those words. I could do this too. In the event I sat in my kitchen and read out *All That Is Solid* to a group of friends, noticing how the play speaks as much to domestic space/ activity as theatre space/activity, speaks into the place most tightly woven where personal and political mesh. Afterwards I thought: if I could do that, what else could I do?

That question, or one like it, sits beneath the title of *what happens to the hope at the end of the evening*, the work that most schematically but also delicately captures the differences between how Tim and Andy approach the problem of making theatre in a capitalist world. Tim is the artifice, the actor, to Andy's straight guy; Andy sits in another chair found in the theatre, in front of another music stand (or maybe the same music stand that travels with him show to show), and talks of his real marriage, his real move to Norway, and his real PhD on 'dematerialized' theatre – put as simply as possible, theatre stripped of fripperies. Meanwhile Tim bounces off the walls – the fake walls of the set, the fourth wall of imagination – trapped in his role as Andy's aggressive friend, whose fake marriage has broken down, partly because he fake fucks any skirt that moves.

The contrast works, brilliantly, because it contains something true to both of them. Tim likes the fripperies of theatre, likes playing with the artifice of it. *Adler and Gibb* was a frenzy of artifice: gaudy, intoxicating, flitting like a mischievous will-o'-the-wisp in front of its audience, leading us hither and thither through twisted overgrown garden paths and thorny tangled brambles. *Total Immediate Collective Imminent Terrestrial Salvation* dispensed with physical set design (apart from two orange chairs) and instead gave each member of its audience a book meticulously illustrated by Rachana Jadhav, an exquisite collection of drawings that also draws attention to the ways in which theatre is collectively imagined. Given that the same book is held by two characters on stage, apparently controlling everything they say and even think; given that the book – within the world of the play – has been created by a cult leader (played, obvs, by Tim) convinced he has foreseen an apocalyptic event, and who insists on complicity, including from the audience, this book is a complicated object, its invitation also a curse. There is a way in which Tim knowingly reproduces violence, does so the more effectively to hold it up for examination. I'm always a little trepidatious walking into one of his plays.

They seem such an odd couple, yet their work emerges from an ongoing symbiosis of support, triangulated by Karl James, creator of The Dialogue Project, through which Karl mediates difficult but restorative dialogue, recognizing this as a path to healing and reparation. What binds them in mind and heart is something Andy says in *what happens to the hope at the end of the evening*: 'Theatre is a place in which we can clarify thought around some of our expectations of community, of democracy, of citizenship.' He says this earnestly to the audience then turns to Tim-not-Tim and delivers the agitprop manifesto as plaintive direct address to him too: 'Maybe we just need to stop and think for a minute. Maybe we can become better people just by living better lives. Or at least by trying to live a better life.'

And it's integral to the genius of that work, its belief in theatre and also its suspicion of it, that Tim-not-Tim replies: 'Right now, I know I want to become a better person by kicking your fucking face in.'

The last time I ever saw Andy and Tim was in 2019 in a small room somewhere at the Edinburgh Fringe Festival. I can't tell you exactly where partly because of promises I made and partly because I don't precisely remember but you have no doubt yourself been in similar rooms – navy blue carpet tiles, tired white walls streaked with abrasions, unforgiving iridescent strip lighting and a pair of very tiny windows that looked out on precisely nothing.

A group of us had been convened by a major public funding body whose name I am also not allowed to mention; suffice to say it is probably the one you are thinking of. We were there to discuss the impact of Brexit on the independent theatre sector and to devise an actionable strategy to mitigate the worst consequences in the event that we were to fall out of the EU without a deal. People were happy to see each other and happy to escape the drizzle outside but otherwise the mood was fairly bleak. We ate our complimentary biscuits in despondent silence.

I have never been to an AA meeting but this meeting felt like how I imagine being at an AA meeting would feel. We sat in a circle and listened as one by one each attendee introduced themselves and described how decadently futile making theatre felt right now, sat as we were on the edge of a disintegrating continent at the tipping point of unredeemable ecological obliteration with the country's most shameless, incompetent, self-serving grifter newly installed as prime minister. We nodded along, our arms resting on our knees and our shoulders folding into our chests like we were all slowly trying to place ourselves in the recovery position.

I think it was Tim who first suggested, largely in jest, that we would be considerably more successful in our stated aims if we just gave up art and formed our own revolutionary movement from a secret base somewhere in the Peak District. We all laughed, the kind of grateful half-manic laugh you do when someone tells a good joke at a funeral or literally anything funny happens in a dance show. But when the laughter stopped we all sensed with some discomfort a new possibility had entered the room and was now drifting through the empty space in the middle of our circle of chairs.

Eventually Andy broke the awkward silence. He looked at us with his warmly twinkling eyes, waiting until it was clear that he had everyone's attention, and then quietly he said:

Theatre is just the collective name we give to all the many different things we do, and we call them theatre in order to make those different things feel like the same thing. In order to make it feel like we are all working on the same thing together. Theatre is not defined by an empty space or a playscript. Theatre is the hope we share. And as long as we still share that hope then we are all still making theatre.

Even now I have tingles remembering it. That was undoubtedly the moment that started everything. All the violence. So much history. If you remember

the eventual show trials, you'll probably recall that those of us who had been identified as present in the room on that fateful day committed to the defence that everything that we did afterwards – the civil disobedience, the guerrilla campaign, the declaration of independence – that all of it was just theatre. That it had always been theatre. Nothing more than theatre and nothing less.

The brilliant thing about this defence was of course that it was true and upon realizing this to be so, the judge was forced, grudgingly, to dismiss the case.

(MC and AF)

Further reading

Adler and Gibb, An Oak Tree, The Author and *Total Immediate Collective Imminent Terrestrial Salvation*, by Tim Crouch, published by Oberon
Summit and *The Preston Bill*, by Andy Smith, published by Oberon
'This is it: notes on a dematerialised theatre', by Andy Smith, in *The Twenty-First Century Performance Reader*, edited by Teresa Brayshaw, Anna Fenemore and Noel Witts, published by Routledge